TWO LOOKS TO HOME

If you lived in eastern Tennessee you would be given directions using the word "look." It is a distance you journey. For example: From where you are standing, look as far as you can see, then go to that spot. You have now traveled the first "look." Your second "look" follows the same as the first — with one exception. You are now viewing a world you couldn't see from where you originally stood. A world encompassing the unknown. A second landscape, abundant with adventure, new definitions, fresh experiences, and unexpected purpose. A captivating sight of intrigue and beauty. This second look is the view I love, a home for my eyes, a home for my work, a home for me.

Two looks to home.

— Tommy Simpson

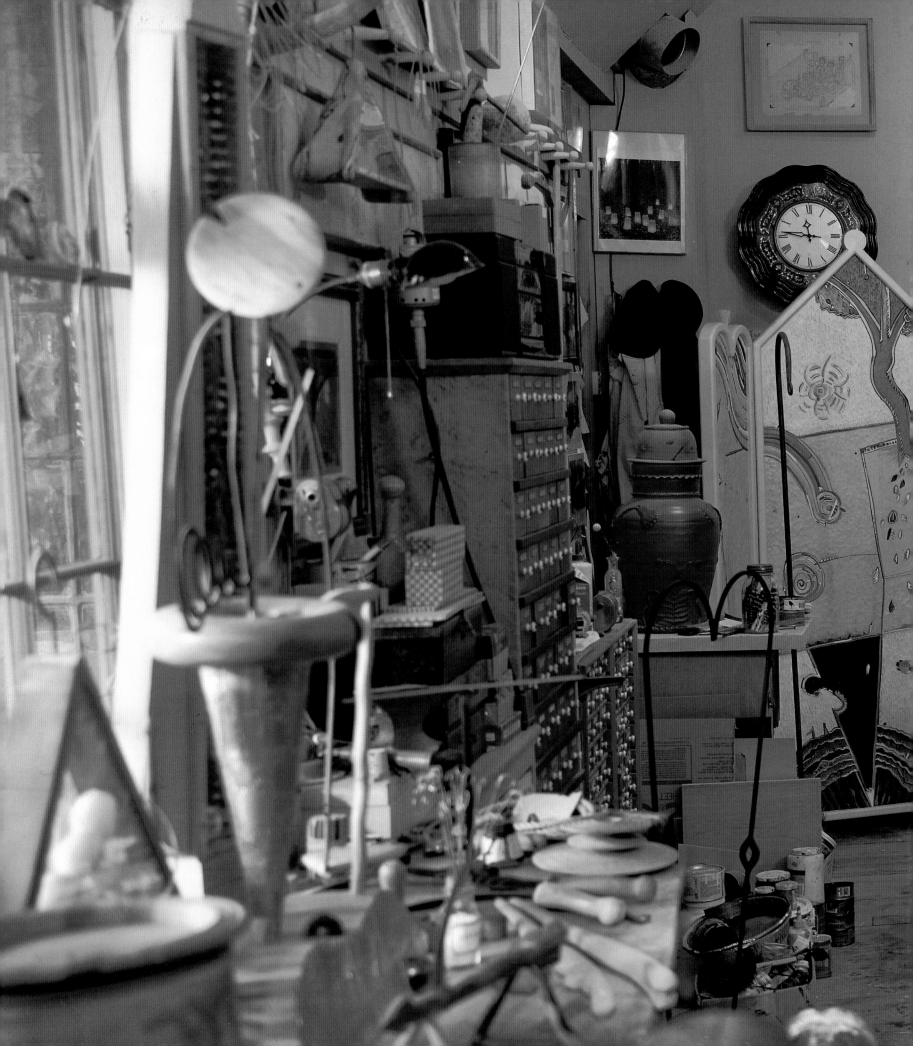

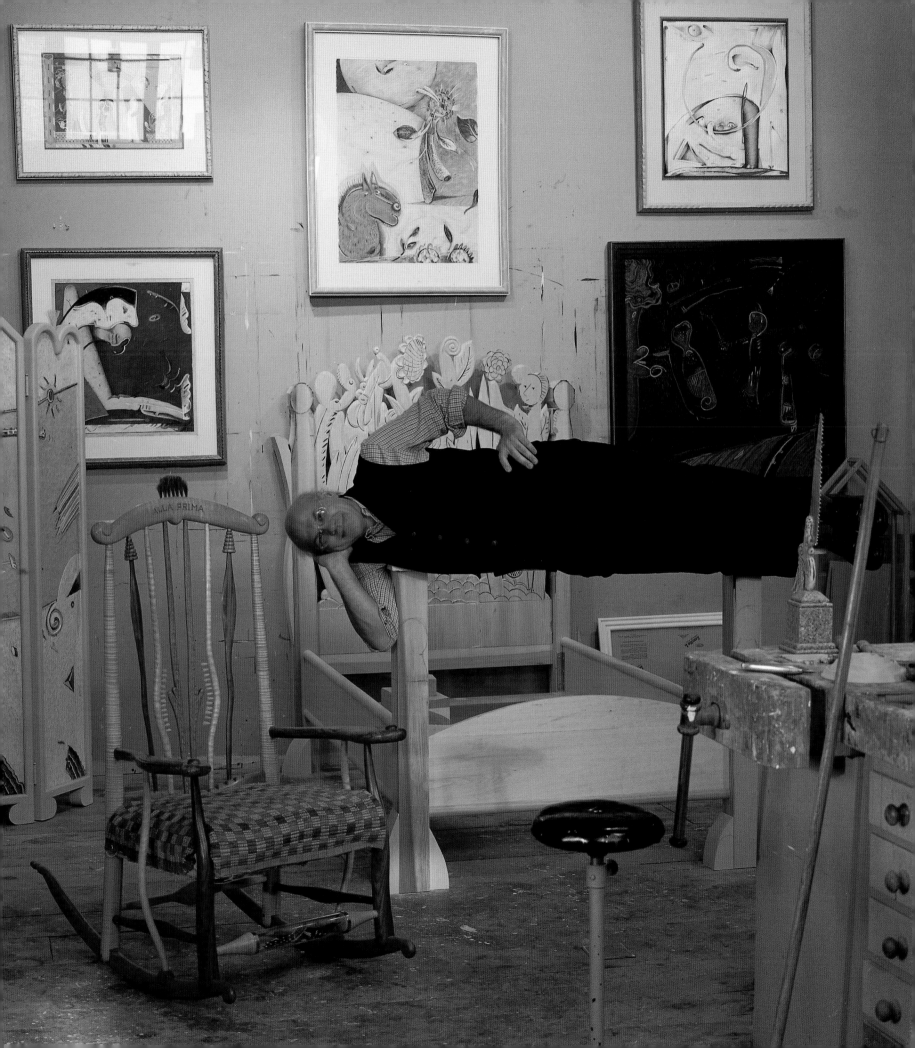

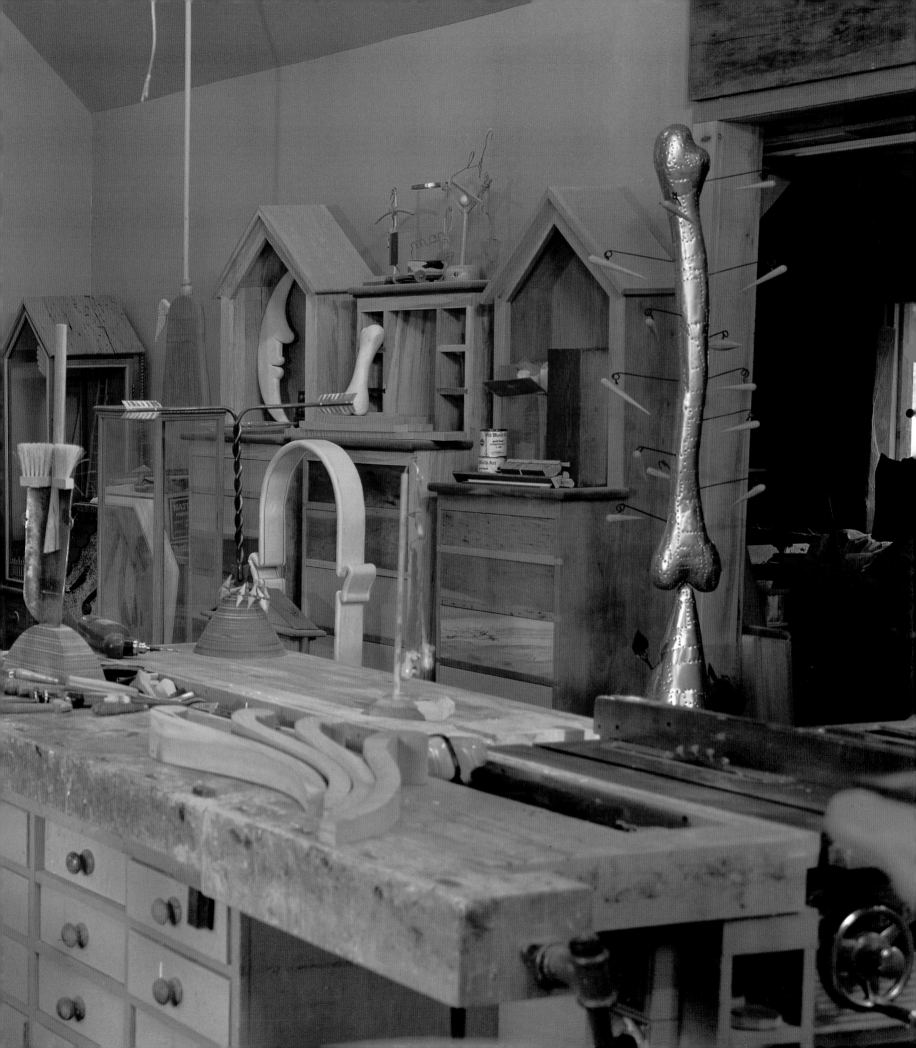

TWO LOOKS TO HOME

THE ART OF TOMMY SIMPSON

TEXT BY TOMMY SIMPSON

INTRODUCTION BY PAM KOOB

A BULFINCH PRESS BOOK

LITTLE, BROWN AND COMPANY

BOSTON NEW YORK LONDON

FIRST EDITION

Grateful acknowledgment to the following photographers, who took most of the

pictures in this book: William Bennett Seitz, Bibiana Matheis, Garry Burdick, John Kane,

Sally Andersen Bruce, David Caras, Michael Meken, Gretchen Tatge

LIBRARY OF CONGRESS CATALOGING-IN-PUBLICATION DATA
Simpson, Tommy.
 Two looks to home : the art of Tommy Simpson / text by Tommy Simpson ;
 introduction by Pam Koob. — 1st ed.
 p. cm.
 "A Bulfinch Press book."
 ISBN 0-8212-2508-1
 1. Simpson, Tommy. 2. Artists — Illinois — Dundee — Biography.
 I. Title
 N6537.S556A2 1999
 709'.2 — dc21 99-12041

Bulfinch Press is an imprint and trademark of Little, Brown and Company (Inc.)

PRINTED IN HONG KONG

FRONTISPIECE:

Panoramic view of Tommy Simpson's studio with typical works in progress, 1998

TO MOM AND DAD

FOR THEIR THOUGHTFUL LOVE AND MANY KINDNESSES

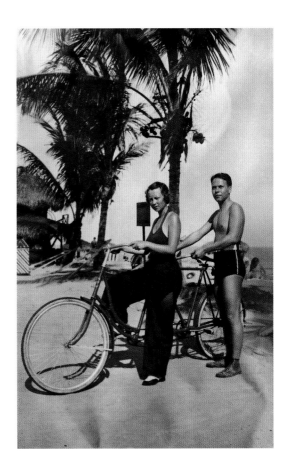

MOTHER, FATHER

HOLLYWOOD, BEACH, FLORIDA, 1934

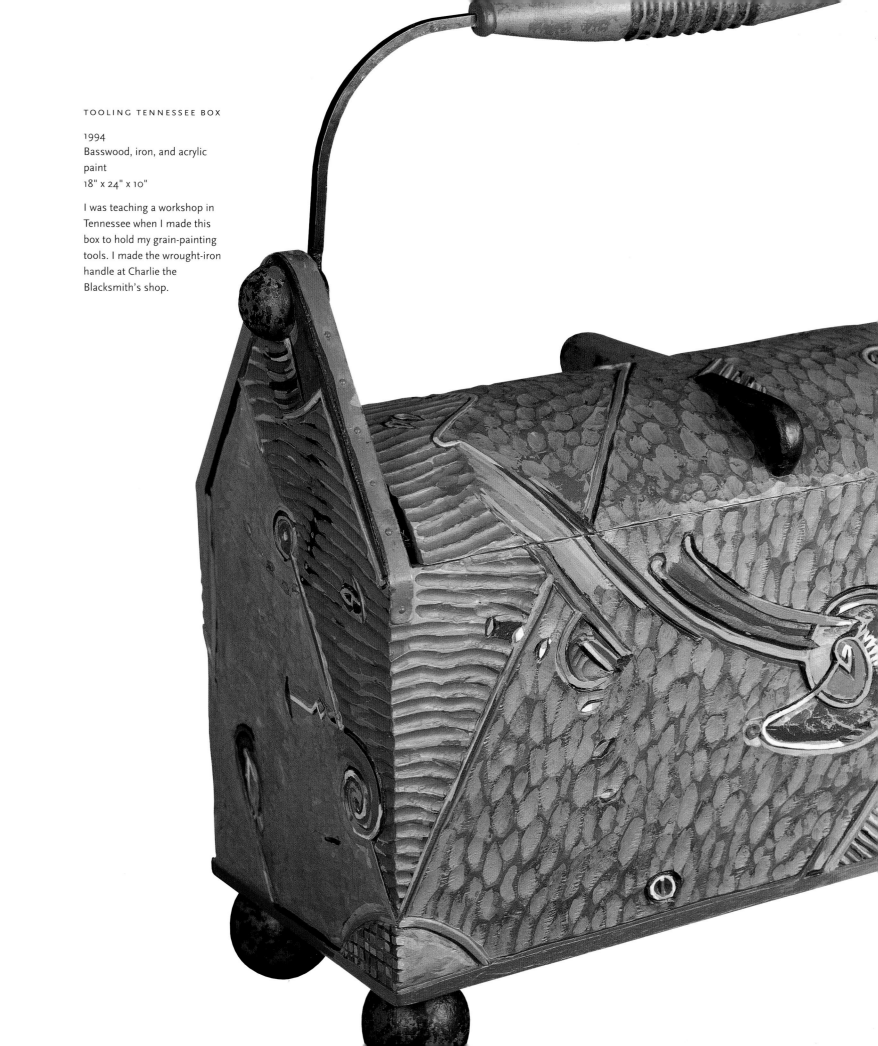

TOOLING TENNESSEE BOX

1994
Basswood, iron, and acrylic
paint
18" x 24" x 10"

I was teaching a workshop in
Tennessee when I made this
box to hold my grain-painting
tools. I made the wrought-iron
handle at Charlie the
Blacksmith's shop.

CONTENTS

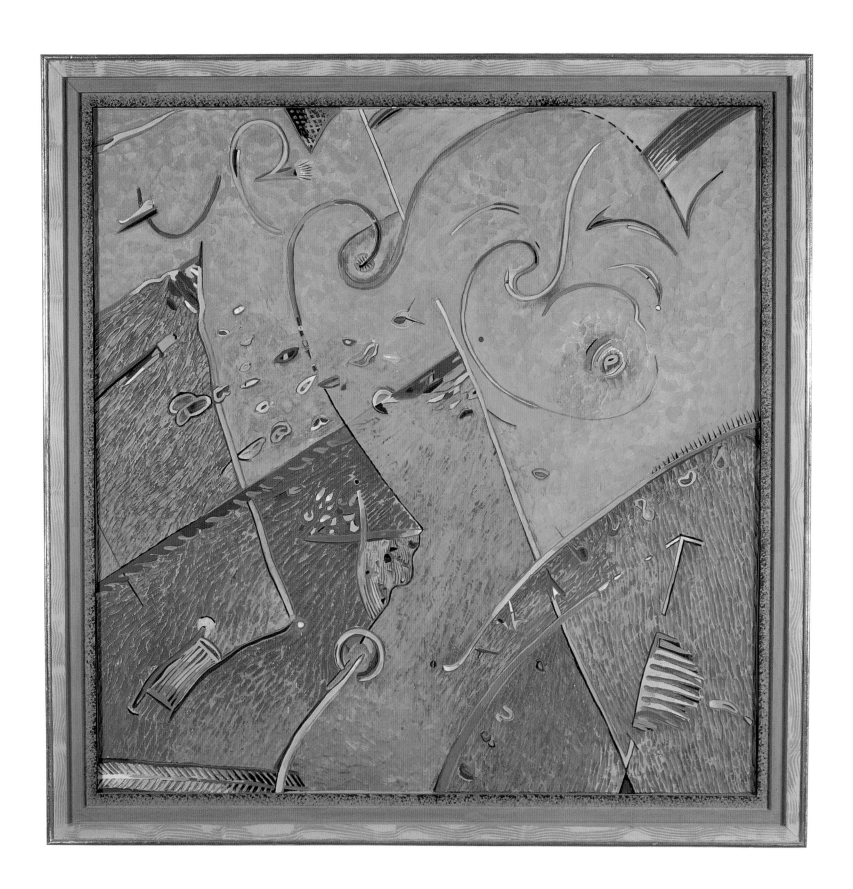

MARKED BY JOY

BY PAM KOOB

More comfortable with images than words, artists rarely comment upon their work. Even less often do they reflect upon its origins, fearing that such inquiry will destroy the potency of their inspirations. Tommy Simpson feels no such reluctance. In these stories he offers a privileged glimpse of the universe that nourishes his art, making his own discoveries in this regard as he takes "two looks to home."

Seeking connections between his life and work, Simpson recalls his Midwestern boyhood and speaks to its continued presence in his being. Describing the past with seasoned insight and humor, he nevertheless reveals that a child's agile imagination and sensuous response to life are still very much with him. Looking back, he understands the potent influences of his extended family and the constancy of small-town life — as well as the freedom to grow and explore that both allowed him. His is a positive memoir. In hindsight, a long bout with ringworm becomes a hidden blessing that took him "off the hero list." Even a family member's potentially hurtful teasing is recalled as a helpful nudge toward independence.

Simpson spent most of his early life in Dundee, Illinois, in the late 1940s and 1950s, in a home on West Main Street (page 14). It was the kind of place that lives vividly in the American psyche but that few Americans actually know. In fact, the artist feels he is unusual among his friends in having had such a joyous, carefree childhood. Born in 1939, he lived in a house where five generations of his family had lived. In that home, relatives had witnessed and celebrated the marriage of his grandparents, who had grown up as playmates in the neighborhood. Later, his mother and then his sister were married there as well. When his great-grandparents died, their funerals were held in the parlor.

"I lived in my grandmother's time," Simpson says, noting the Victorian decor of his parents' house and the genteel, easygoing pace of the lives around him. The attic, he recalls, was a fascinating trove of old books, strange objects, and clothes like beaver hats that had endured long enough to achieve costume status for school plays and games of make-believe. His great aunt Mary, who also lived in the neighborhood, still used a tin bathtub and saw no need to make changes in a home that her parents had decorated in 1904. Another aunt taught him to paint wildflowers gathered in woods nearby and always capped off their afternoons together with a piece of homemade pie.

Dundee was a place that honored the rituals of childhood. It offered a spacious, supportive realm where risks could be taken and discoveries made. As Simpson notes, the town closed certain streets to traffic on some winter nights to

OPPOSITE:
SHE WAS AN EVENING
WINDOW

1993
Painted and carved
wooden panel
40" x 40" x 2"

A photo of my grand-
mother (second from
right) and my great aunt
Mary (third from right).
Photograph by my
grandfather Guy Hall.

FAR RIGHT:
SUNDAY BEST, 1895

Herb Walker and Guy
Hall (on right). Here is
proof of a family gene for
playfulness.

make way for youngsters on sleds. Boys were al-
lowed to test their resourcefulness on overnight
canoe trips up and down the local river. Without
parental hand-holding, they could sample a bit of
the world beyond Dundee when it arrived in the
form of carnival sideshows. Free in the after-
school hours, they invented roller-skate racers
and concocted firecracker rockets from juice
cans. Not surprisingly, Simpson now treasures
books that speak to this bygone age and those be-
fore it: volumes like *The American Boys Handy
Book: What to Do and How to Do It* (1882) offer-
ing instruction on such forgotten pastimes as
fashioning war kites, rearing wild birds, and
building snow forts, "including ammunition
sleds."

This remarkable world surely lends itself to
remembrance, but it is also clear that Simpson's
memoirs, like his work, reflect a unique open-
ness, a child's capacity for wonder still intact.

Like Disney's *Fantasia,* the artist's earliest years
seem peopled by objects that appeared to have a
life of their own, that spoke to him. He recalls en-
tering the parlor of his grandmother's seam-
stress, where "a chair of humble vintage asked
[him] to sit down." Evoking the temptations at
the local bakery, he describes "cornucopic creme
horns [that] begged for small tongues to lick out
their innards." Come summer, the bridge across
the town's river "sprouted" fishing poles. The
imagination that registered these experiences
would years later produce rocking chairs that
beckon the sitter with wooden seats shaped with
perfect, welcoming imprints of the human back-
side, and tall clocks that seem to stride or dance
in place (pages 18, 72–73).

A tour of duty in the South Pacific kept Simp-
son's father away from Dundee sporadically dur-
ing World War II. It is the women in his ex-
tended family who loom large in his memories

of this period — mother, grandmother, great aunts, and Billie, his mother's live-in helper for twenty-seven years, a cook-housekeeper-nurse whose anchoring, blithe spirit completed the family circle and to this day remains with the artist. Among the discoveries Simpson made in writing these entries were the subtle influences exerted by this family of women. From the plateau of his own adult years, he can perceive and appreciate the emotional nourishment offered by their contented lives, unchanging routines, and reassuring confidence. He credits his mother, grandmother, and two great aunts with cultivating his love of flowers, their remarkable diversity and powerful display of renewal. He comes to understand that the images of blossoms in his work embody these four "curators of . . . enlightenment." Theirs is a soft, gentle influence that emerges in Simpson's stories as a strong current, offsetting the harder realities that he also discovered, inevitably, in the schoolyard and on the outlying farms of Dundee.

Eventually, Simpson's father became an equal presence in his life, more through action than word. A doctor, he attended to the problems of ear, eye, nose, and throat. According to John Sutfin, the artist's lifelong friend, he hoped his son would embark on a medical career as well. However, Simpson abandoned his initial premed direction in college, a decision that Sutfin feels was difficult because of the disappointment he anticipated in his father. Before and after this turning point, Simpson shared his father's enthusiasm for antique cars and clocks, and a restorer's fascination with their mechanics. These interests echo in Simpson's sculptures and furniture, with their references to the mechanical and celebrations of craftsmanship. More subtly,

his father passed along the idea of enjoying the whole process of a *project,* from conception to completion to the inevitable reward (most often food) for a job well done. Simpson says he has found it a most valuable lesson to reward oneself, to offer some kind of positive feedback that may not otherwise be forthcoming in the solitude of the studio.

If Dundee afforded youngsters space and freedom, Simpson's friends and relatives recall that he was equipped with the ingenuity to make the most of that inheritance. Sutfin, who has known the artist since nursery school and lived a block from him in Dundee, says that Simpson was always the one to supply ideas for class skits and the paintings done on downtown store windows at Halloween. Remembering distinctly the people and animals his friend could draw by second grade, Sutfin remarks, "It was obvious that he had something special." Another friend, Barb Olin, was equally impressed, and she surprised Simpson years later with one of his early drawings, which she had saved (page 4). Signed and dated, the sketch portrays six young adults whooping it up in a wood-sided pickup truck remarkably like the one driven by the artist today. "Hi chicken" is written across the front of the vehicle, which sports a fancy horn and a hood ornament resembling a small umbrella. The passengers are portrayed as distinct individuals in dress and appearance, and they reveal the young artist's full command of expressive facial features. A storyteller also emerges behind this drawing: All but two members of this fun-loving crowd seem unaware of the impending collision with an open manhole designated by a "Men at Work" sign. The young man perched precariously on the side of the truck will undoubtedly

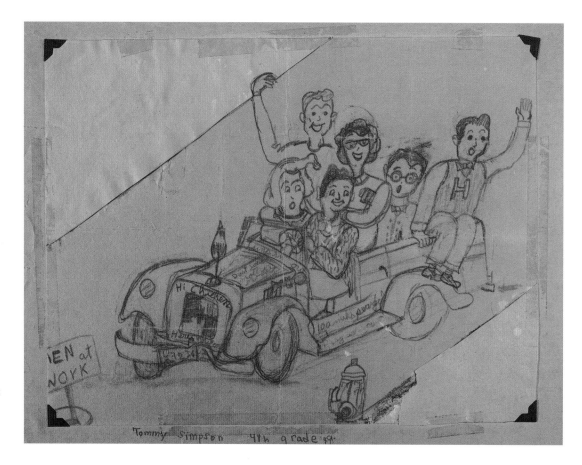

slip off when the collision occurs. Yet it is clear that all of this will play out in a harmless, entertaining manner, like so much of Simpson's childhood.

Humor is one of the keynotes of Simpson's life, informing his memories of the Dundee years and his adult existence. It further infuses his art and is already evident in a second drawing, also done at about the age of ten. With springs protruding from its seats and rags tied around its tires, a driverless vehicle belches steam and assorted objects from its radiator cap. There is an air of jaunty independence and fun in the flag waving off the contraption's rear bumper, the "S.O.S." and "Keep Out" messages painted on its side, and the resourceful tool kit perched on its back. One could argue that this ap-

pealing, humorous sketch is one of Simpson's earliest self-portraits.

His creative spirit emerged in many ways. "Tom was always doing unusual things," recalls his mother. At one point in grade school he made a pair of high-laced shoes from a piece of leather he found, explaining that he just wanted to see if he could do it. Later, when his older brother Fred had to attend his high school Latin class in costume, Tom outfitted him in the same shoes, a toga, and a homemade laurel-leaf crown; he then transformed a farmer's triangle plow into a chariot, which was towed to school with Fred in it, behind the family car. Fred won first prize.

Simpson's younger sister, Susie, remembers him as a neighborhood leader, organizing games with ribbons for awards and personalizing every-

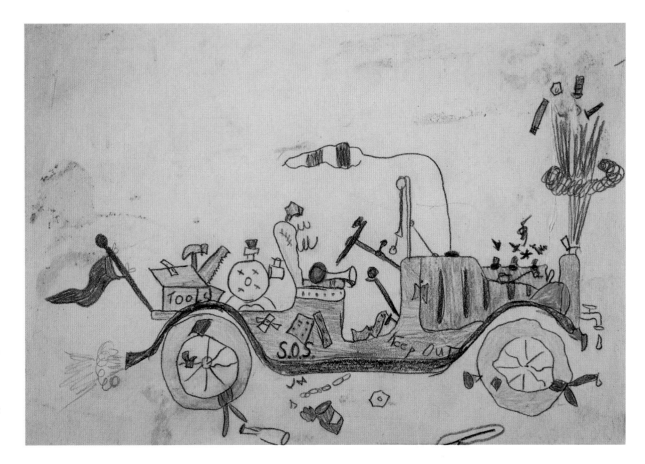

one's skateboard with painted designs. He could also be counted on to brainstorm his way out of a tight spot. As young boys, he and John Sutfin decided to canoe to the next town to take advantage of its public swimming pool. Returning at the end of the day, they realized that it was going to be difficult to paddle back against the river's current. But a strong wind was with them, and Simpson improvised a sail with the oars and a raincoat they had brought along. The two adventurers each held an oar and safely made it home.

Confidence seemed to go hand in hand with his ingenuity. Ellenor Simpson now laughs at herself when she relates how worried she was about a particular watercolor that her son brought home from kindergarten. "It looked like a surrealist painting, splashes of color with no design, all different sizes and directions, and the colors were so dark — purple, mustard, brown . . . not the primary colors that most kids used." She went to a friend who taught elementary school and shared her worry that there might be something wrong. The teacher advised her to ask young Tom to explain the painting, which he did, quite confidently. Mrs. Simpson also remembers her son's ability to entertain himself and spend time on his own. Though the stories here do not reflect this quality, Simpson heartily confirms it, noting how well it has served him as an artist who spends eight to ten solitary hours at a stretch in the studio.

Independent-minded, the young Simpson impressed his sister with a sense of "inner direction." As a teen, she wanted to try her own

hand at painting but felt intimidated. She still appreciates and marvels at his gentle encouragement not to worry about the "meaning" of a painting. "What does it mean to you?" he would ask her. "That's all that matters."

In high school, these qualities made him a natural leader. He excelled in the classroom and on the football field and in wrestling matches. Elected to the student council each year, he served as treasurer of his senior class. He was inducted into the National Honor Society and received the Son of the American Revolution award at graduation. Five years younger, Susie remembers him as one of the "cool" guys. Fellow football player John Sutfin remembers him most as a loyal friend, then adds that he was "creative but *real*. There wasn't a pretentious bone in his body."

After college in the late 1960s, the two reunited in a business venture that Sutfin still recalls with admiration for his friend's "creative genius." In the nearby town of Elgin, Illinois, Simpson decided to transform a derelict factory and deserted grocery store into a key club. Forming a partnership with eight other friends, Simpson decorated the place with quirky memorabilia and antiques, creating a soda-fountain setting for a bar and restaurant. The Grocery Store, as they named the place, did a thriving business for two years. In the end, however, Simpson says the project taught him that he had a great deal to learn as an entrepreneur.

Before that, Simpson had already embarked on the difficult process of discovering who he was. As a freshman at the University of Illinois, his first extended time away from home, he became unsure about his pre-med plans and deliberately flunked his first-semester exams. "It was a way of quickly resolving my uncertainties," he

recalls, "and avoiding the inevitable discussion with my parents." After Christmas, he set out to go around the world, literally, and made it as far as Hawaii, where he spent six months on a construction team. Eventually, he returned home and enrolled at Northern Illinois University.

Simpson notes that while his mother attended theater and his brother took piano lessons, the arts had received no particular emphasis in his childhood home. At Northern Illinois, curriculum requirements led him to a class in calligraphy, which he enjoyed and which prompted him to enroll in a printmaking course. There, he says, he realized for the first time that what he had been doing all of his young life was engaging in art. In the remaining year and a half, he says, he "crammed in four years' worth of art history and studio art classes." He became friends with his first teacher there, Keefe Baker, a student of Max Beckmann. Baker not only gave him practical artistic advice but taught him about composition and formal elements; in addition, says Simpson, "he opened a door to what an artist's life is about: long hours, commitment to one's spirit, and love of visual expression." Emerging from college with a B.S. degree in education, Simpson found himself wondering if he was good enough to pursue an artistic career, whether he could support himself doing it and "whether there was enough room for growth in the endeavor to sustain a person for a lifetime."

The facts trace an answer. He went on to earn an M.F.A. in painting from Cranbrook Academy in Michigan and later taught for three years at various institutions, coming east in 1969. Thirty-six of the years since then have been spent in the solitary pursuit of his own artistic goals. Awards, exhibitions, and acquisitions by major museums

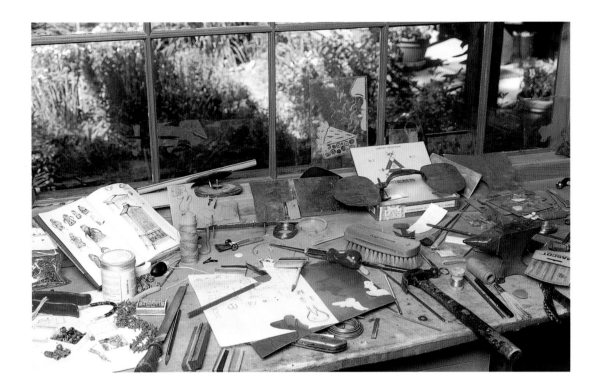

WORKBENCH, 1986

Materials for making jewelry. This part of my studio has a grand view of the front garden. Lucky me!

marked his growing success. But the art itself expresses the enduring currents and growth from the early days in Dundee, which offered the physical and spiritual nourishment that continues to ground his work. Maturity now allows him certain insights: that there is no separation between past and present; that it all flows together as one realm. Nor is there a division between life and art. Describing the creative act, he notes:

I believe all life has a wonderful, inherent need to create, to bring new forms into existence. I have chosen wood, paper, paint, words (the common materials around me), as the vehicles to express this creative desire. My need for hands-on building is the core of my life. The act of making brings to me an awareness of my body, my heart and my mind. When I start to work, I can let go of everything, the everyday world is released from my consciousness. The most intimate me flows open, unobstructed, infusing itself with the work at hand. The how's and

why's of this exchange have always been a mystery to me. Nonetheless, this gift of giving over to the creative force allows the waves of life to pass from inside of me to the outside world. It is my sure way to find and give love.

For Simpson this rapture fuses heart, head, and body in a state he compares to an athlete's being "in the zone," to the ecstasy of making love, and to a young child's euphoric lack of self-awareness. The creative process offers release from one's ordinary condition, like the frightening, exciting free fall that he recalls in his memories of the enclosed spiral slides that served as fire escapes in his elementary school. This total engagement of mind and heart is what he strives for, and the joy it produces marks the work of artists he admires, from Giotto to Matisse to Klee.

The process of working toward this state is more important than the final goal, Simpson notes. In the service of this quest are his four

fundamental requirements: work, love, food, and sleep. In these he finds, respectively, absorption, expression, nutrition, and access to the subconscious. At any given time, his studio abounds in creative efforts at different stages of evolution. "I work on many projects at one time," Simpson says. "You might say that I go with the flow. While the paint or glue is drying on one piece, I'll work on another. If I don't know the next move, I go to where the answers seem apparent" (pages ii–iv, 116–127).

Not surprisingly, Simpson has never looked for answers in popular trends, which he feels limit creativity and individuality. He finds the jargon of academia and the commercial art world only marginally useful for his own work. Beyond the rich reserve of his Dundee childhood, he draws upon a wider inheritance: the works of Picasso, Calder, Kandinsky, Rousseau, and Bonnard, and beyond these to Fra Angelico, Raphael, and Botticelli. Further inspiration comes from

Indian Mughal miniatures; the folk arts of the South Pacific, Africa, and the Northwest Indians; and, of course, popular culture from an earlier America, which he regards with a certain nostalgia. In his words, he "puzzles together" these references with personal and cultural symbols to express his playful and insightful reflections on the human condition. Laughter, he contends, is not only compatible with serious intentions in art but emerges from that enraptured state in which both idea and feeling have been set in motion by an aesthetic encounter.

Simpson's sculptures, marked by inventive methods and skilled craftsmanship, implicitly refer to the simple, can-do approach he admired among his Illinois neighbors. Employing time-honored techniques such as faux finishes or punched tin, he manages to honor the past and gently poke fun at it and high art, all in one complex piece. In a construction called *Firsts* (1988), Simpson plucked a common item from an earlier

FIRSTS

1988
Painted wooden cabinet,
zinc sheets
59" x 38 1/2" x 18"

A cabinet with punched
tin sides is the unique
form known as the pie
safe. Punching motifs
included tulips, eagles,
and graphic designs,
depending on the maker.
This one has a list
of firsts.

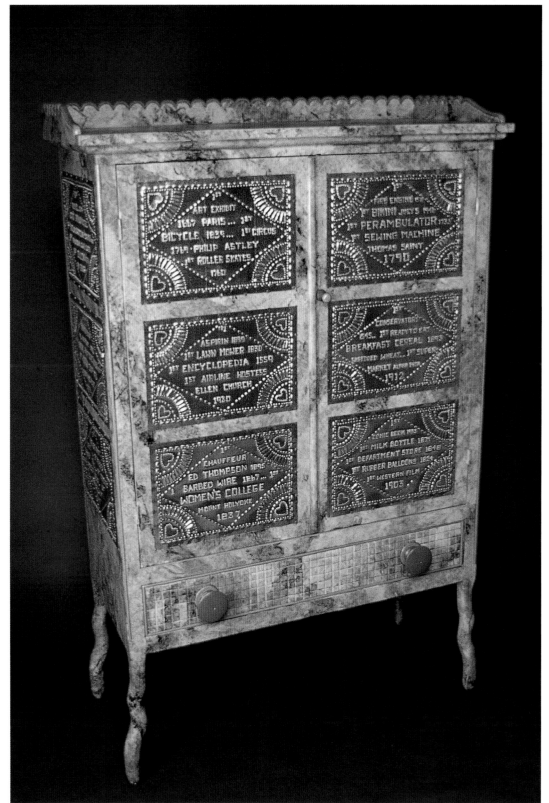

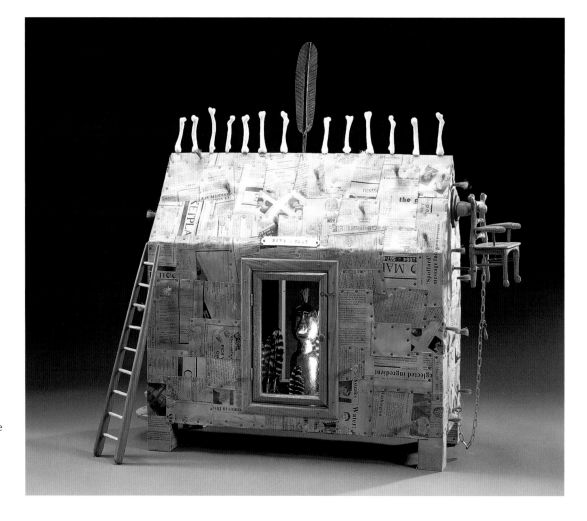

time — a pie safe — and produced an entertaining commentary on the impulses to embellish and to register information (page 9). Its panels of punched tin, decorated with hearts and designs, humorously announce a series of groundbreaking events, from first aspirin to first airline hostess.

In a similar vein, his *Reliquary for St. Chippendale* (1993) updates the medieval chamber used for holding religious relics in a piece that questions the canonization of the eighteenth-century furniture maker (above). It should be noted that Simpson himself has made fine art furniture, from desks with fantastic inlays to his

own dining-room chairs with elegantly carved wildflowers on their backs. The *Reliquary*, covered with newspaper clippings photo-etched on aluminum, small bristles, and a row of bones dancing along its roofline, houses a silver-leafed head staring out beneath a command to "Have a seat." A miniature Chippendale chair is shackled to and dwarfed by this unusual chamber. Chippendale's original achievement seems lost amid the cultural fuss about it.

One of the more engaging aspects of Simpson's work is its animate character. In *Air Horses* (1993), the common sawhorse becomes a humorous, elegant, and fantastic insect poised for

takeoff (page 22). The tensile grace in the "legs" of these sculptures reflects Simpson's command of expressive line and shape, something he appreciates in the cutouts of Matisse and the dramatic gestures of Giotto's religious narratives. In the same vein, his *Architectural Dogs* (1993) are as much sculpture as furniture, chairs that claim their space with assertive character.

Air Horses reveals Simpson's delight in the sheer beauty of natural wood, incorporating cherry, walnut, and two varieties of maple. Much of his furniture, however, is painted and carved, becoming a canvas for a distinctive visual language that reflects his wide-ranging interest in the arts of many cultures, past and present. The artist's library, just off his studio, contains books on Art Brut, the folk arts of the South Pacific, Africa, and America, Botticelli, and the court paintings of India, to name just a few. His work also attests to a keen enthusiasm for the liberties of Wassily Kandinsky's and Marc Chagall's paintings and the playfulness of Paul Klee, Joan Miró, and Alexander Calder. Not surprisingly, René Magritte's surrealist paintings and Joseph Cornell's imaginative constructions also intrigue Simpson. His own work combines an appreciation for these diverse traditions with a love of the natural world and a spirit akin to that of Norman Rockwell, whose approach to the human experience Simpson also admires.

His paintings are more abstract than his furniture but equally idiosyncratic, speaking through line and especially color, that powerful language he encountered as a boy. Simpson describes his paintings as "abstract narratives." While the protagonists in these adventures are often fantastic creatures or shapes, they clearly make reference to the classic genre of landscape, with foreground, middle ground, and distance. In a typical work, such as *She Was an Evening Window* (1993), these images invite the viewer to engage in his or her own imaginative free fall, a willingness to enter a realm where unfamiliar, beguiling forms and vibrant colors embody thoughts and feelings (page x).

Simpson's memoirs become a journey with the artist back to his roots. In the critical period between three and eighteen years of age, he now discerns a progression, comparing his development to a day on earth, from dawn to evening, from the child's first, sensual encounters with the world to the acts of a fully realized, aware being. Uniquely his own, this coming of age is yet deeply familiar. Along the way, there are the inevitable moments of wonder and harsh discoveries that mold the person, and crucial decisions perceived sometimes only in hindsight. Simpson notes that only as he wrote down these passages did he fully understand the power of his past. For the reader, his art and his memories create a portrait of the artist as a very human being. This is entirely appropriate for an individual who regards himself not as a renowned Artist but "an individual expressing his own joyful response to life through the act of creating," one who views his art not as work but "a way to live."

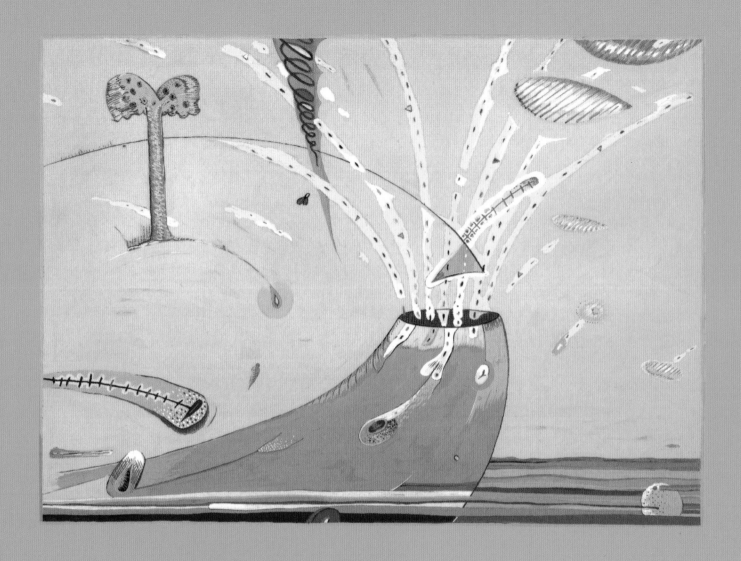

The
 morning sky
 jumps forth with
 wonderous leaps
 bouncing me
 anew anew
Calling me
 open your eyes
 pick up your heart
 head for the hills
 it's a new start
 Age ten

youth new inventive
senses excitement
surprise awareness
unencumbered
looking finding

FIRST **LIGHT**—

discovery heart
beginning growing

MIDWEST

dawn

optimism love
open light gentle
energy source
connections
emotion search start
flight definitions
learning experience
sharing energy
cellular

When I was growing up in Dundee, it was a small, rural Midwestern village nestled in the hillsides of the Fox River. In those midcentury times, the town center was a block and a half long and one building deep.

Dairy farms radiated out in all directions. The townsfolk had created a livable niche that was secure, at ease, with compatability as plentiful as corn. The pace of the residents still lingered somewhere in nineteenth-century time. This world was a wonderful grab bag of experiences and adventures well-suited for a sprouting child. With a bicycle, a quarter, and a little curiosity, the day's full measure was at your fingertips.

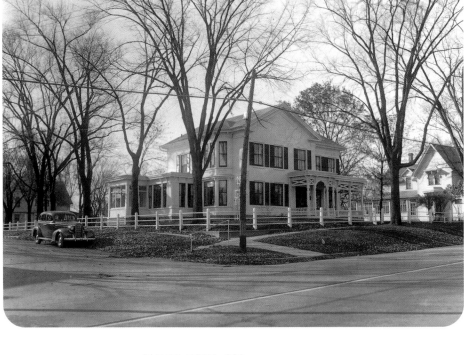

FAMILY HOME, 303
WEST MAIN STREET,
1940S

This is the house where five generations of my mother's family lived, including mine. My grandmother, mother, and sister were married in the parlor; the same parlor gave witness to several funerals. My grandmother and grandfather grew up diagonally across the street from one another. When they married they built their house on the third corner.

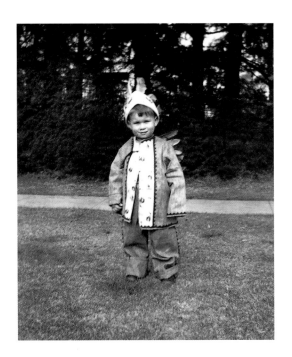

TOMMY SIMPSON,
1942

This picture was taken by my mother when I was about four years old. On second look, I noticed this semiwild Indian had very short arms. Then I remembered that my practical mother always seemed to buy my clothes a size or two too large. I guess I was an Indian for a number of years. I still like my clothes a little loose.

Our house had this view of downtown Dundee. It looked much like this when I was a youth. The only difference was we had 1950s automobiles in the streets.

Halfway down the block on the left side of the street was my great-grandfather's department store. It burned down in 1912.

The bushes in the right foreground were along the north side of the town hall building. The library was on the second floor, where my mother learned to knit from the Red Cross women. The jail was in the basement.

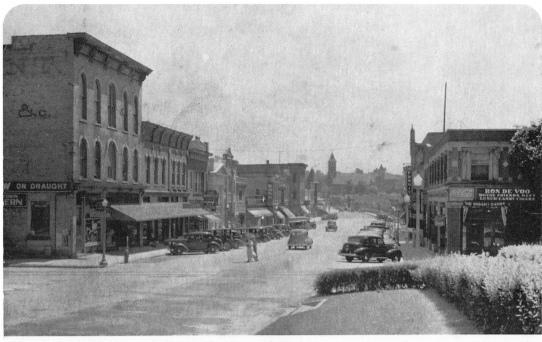

MAIN STREET - LOOKING EAST, DUNDEE, ILLINOIS 5605

Dundee was a place where:

Chickens and goats still lived within the city limits
Ducks stopped in on their migration south
Coal trains flattened kids' pennies and pins for good luck
People escaped the summer heat or the family on their porches
Stuffed birds were encased in a huge glass display at the grade school
Ice cream sundaes: twenty-five cents
Haircuts were a source of conversation and entertainment
One heard "Ah, gee!" "Oh, gads!" "Good gravy!" and "Oh, boy!" a lot
 Kickstands on bikes meant parking anywhere
 Church socials rained strawberry shortcakes
 Librarians read to children on Saturday mornings
 Someone would push out his false teeth for a laugh
 Fly balls were found in the vicinity of small boys
 Most people's history was common knowledge

15

A block away lived my great aunt Florence.

The house was filled with her oil paintings of flowers. They leaned against or sat upon every available object and space. This is where, at the age of six, I sat next to her to paint. We drew the black-eyed Susans that Aunt Mary and I collected in the woods earlier in the day. The afternoons were always framed with a piece of homemade mincemeat pie and a glass of milk. I grew fat with flowers. *YUM!!*

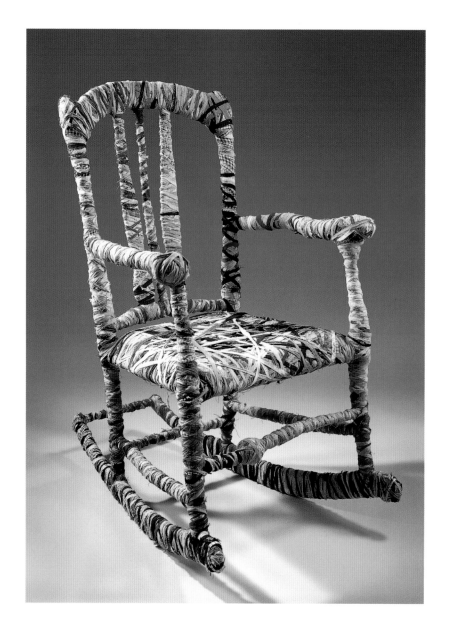

MY MUMMY MADE ME
DO IT

1982
Rag rug rocker of wood
and cotton fabric
43" x 26" x 38"

To intimidate a workshop,
I built this rocking chair in two
days to help them realize that
object making need not take
forever. Only indecision can
take that long.

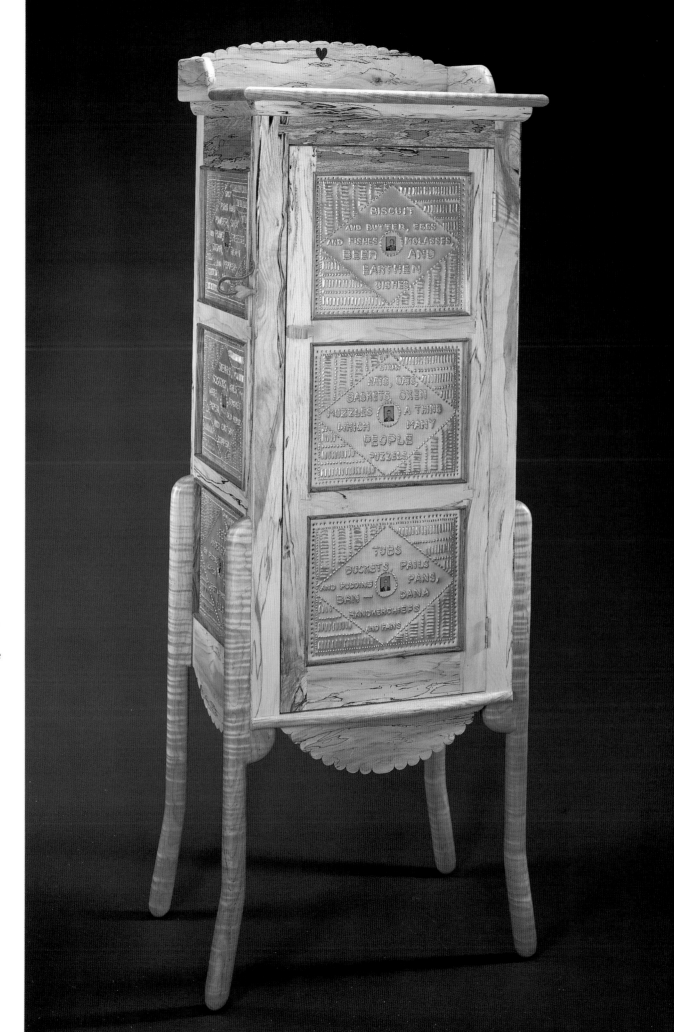

HALL'S PIE SAFE

1985
Maple wood, tin plate,
tintype photographs
66" x 18" x 18"

Tins are punched with an
awl or chisel. The rhymes
are taken from country
store advertising from the
late 1800s.

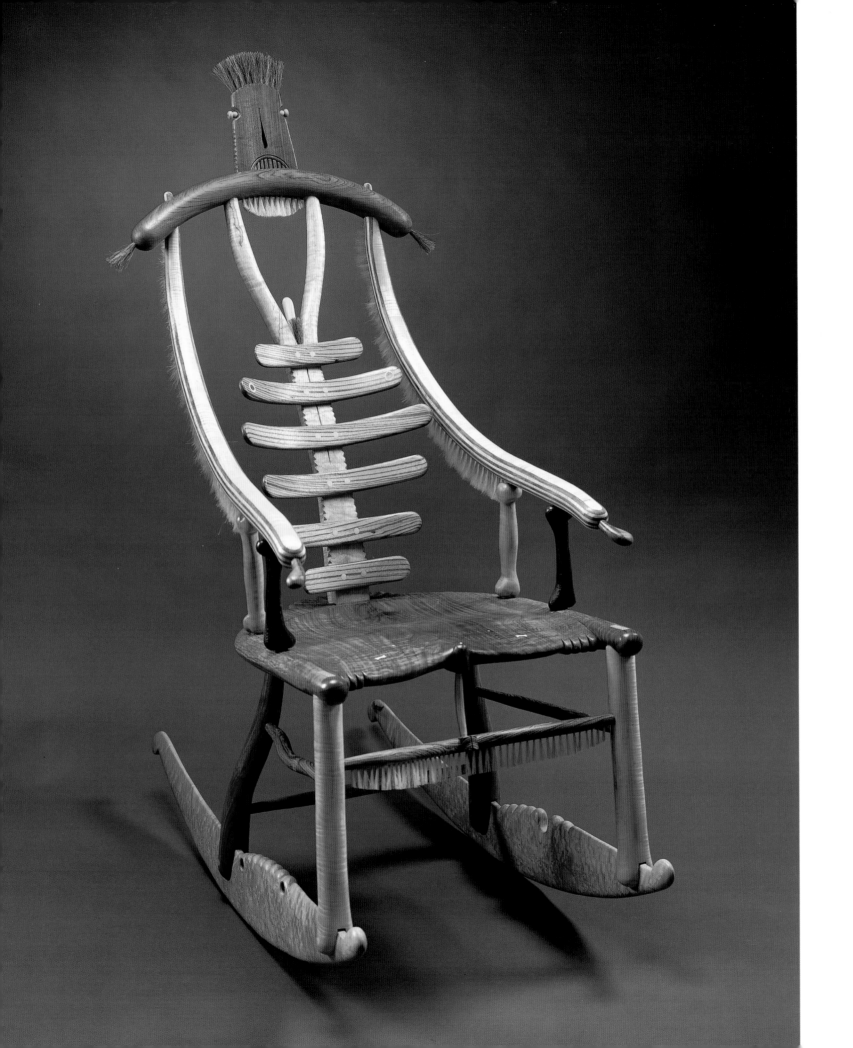

SAILOR'S VALENTINE

1993
Ladder with mixed
woods, shells, clock,
drawer
82" x 23" x 4"

Many an American
seafaring man made
small boxes on long
voyages. Inside these
boxes they arranged
small shells from around
the world. These became
loving gestures to their
sweethearts on their
return home. Carved on
the rungs of the ladder is
"So blow your winds . . ."
Inspired by a wonderful
painting, *Treasures of the
Sea,* by Jacopo del Zucchi
(1542–1590).

OPPOSITE:
EARTH SPIRITS

1992
Rocking chair of mixed
woods
48" x 24" x 36"

Inspired by the book
Heart of Darkness, by
Joseph Conrad. Carved
into the wooden seat are
the words "walk the
walk," "talk the talk," and
"bone the bone." Earth
spirits are the creatures
you sense around you.
As you rock back to catch
a glimpse of them, they
are gone.

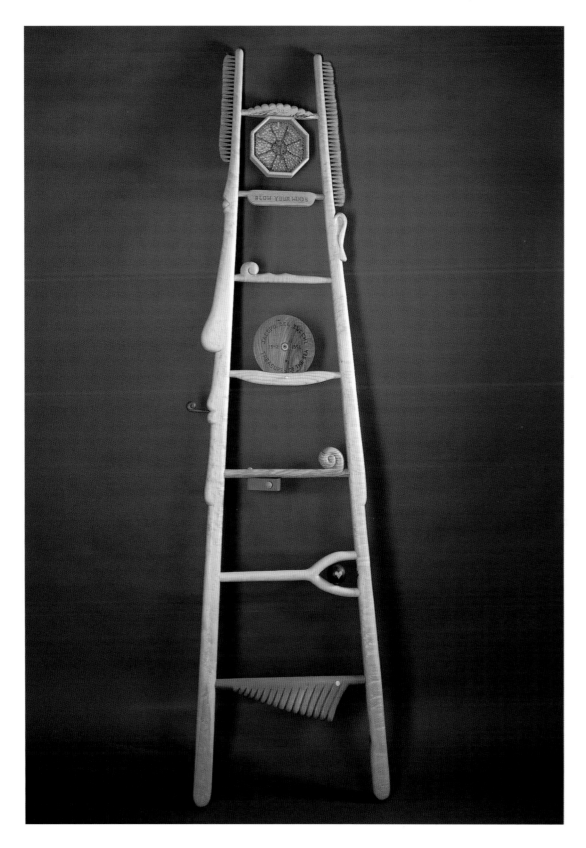

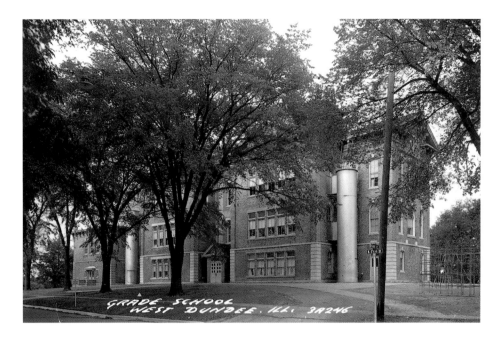

GRADE SCHOOL WEST DUNDEE, ILL. 3A246

DUNDEE GRADE SCHOOL

The Dundee Grade School was six blocks from home. The water was clear. The halls were straight. Growing up started on the ground floor of the school; graduation was realized on the third floor. Many a day these school windows lured children's faces away from the blackboard to follow cloud follies in the sky. My grandparents, my mother, and her children all attended this school.

FIRE ESCAPE

Standing beside the town's grade school were three large silver cylinders.

Inside these three-story structures were spiral slides that served as the fire escape or, to the many generations educated in Dundee, a joyride, a badge of honor. This shared experience helped knit a community together in thought and deed. It's now a small memory, but when I question old friends, it is difficult to find someone who wasn't "born again" in that dark tunnel of pleasure. Remembrances of that ride bring wide smiles to their faces.

My life's pursuit now demands many emotions; sometimes I can see myself standing in front of a work in progress with my arms and legs in motion, head and heart fully engaged. This activity somehow recaptures the thrill of starting down that dark passage and bursting out into the light at the end. That joyfully scary ride in a time when life gave pleasurable escapes can still work its magic. *WHOOSH!*

ICED

The Fox River has a long concrete and iron footbridge, which I crossed on the way to grade school. In the summer the bridge sprouted fishing poles, but the winter brought a temptation a small boy couldn't resist. When the long silver railing shimmered with ice, it found my small, curious tongue frozen to that lure. It took a lot of fast and profuse spitting to free that appendage. I learned a lot on the way to school.

GUTH HILL

Guth Hill was four steep city blocks long. In the winter it was frozen hard with packed snow from automobile traffic. The town blocked off the cross streets on certain weeknights, and the sleds flew. At the bottom of the hill were three sets of railroad tracks that traversed the run — not to stop the forward movement, but to create a rooster-tail display of sparks from the sled runners. *Fireworks in December.*

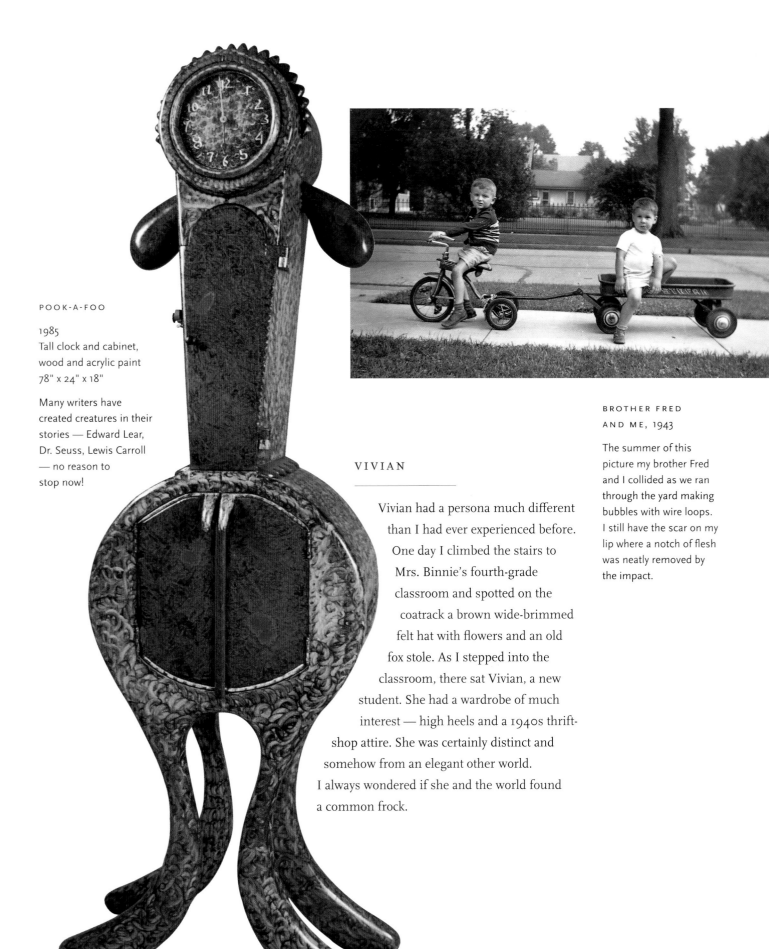

POOK-A-FOO

1985
Tall clock and cabinet,
wood and acrylic paint
78" x 24" x 18"

Many writers have
created creatures in their
stories — Edward Lear,
Dr. Seuss, Lewis Carroll
— no reason to
stop now!

VIVIAN

Vivian had a persona much different
than I had ever experienced before.
One day I climbed the stairs to
Mrs. Binnie's fourth-grade
classroom and spotted on the
coatrack a brown wide-brimmed
felt hat with flowers and an old
fox stole. As I stepped into the
classroom, there sat Vivian, a new
student. She had a wardrobe of much
interest — high heels and a 1940s thrift-
shop attire. She was certainly distinct and
somehow from an elegant other world.
I always wondered if she and the world found
a common frock.

**BROTHER FRED
AND ME, 1943**

The summer of this
picture my brother Fred
and I collided as we ran
through the yard making
bubbles with wire loops.
I still have the scar on my
lip where a notch of flesh
was neatly removed by
the impact.

21

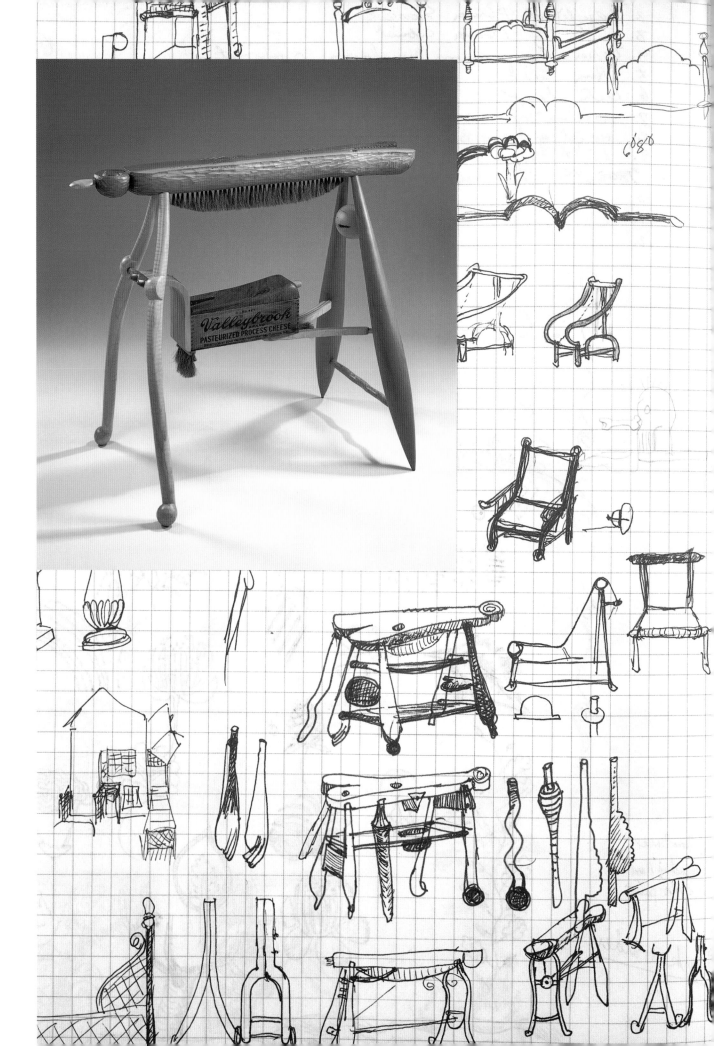

AIR HORSES

1993
Sawhorses with mixed
woods, antique cheese
boxes, wrought iron
29 1/2" x 36 1/4" x 20"

The walnut wood on the
tops of these sawhorses
came from a tree felled in
1932 on my great-
grandfather's Meadow-
dale Farm. The insect
character of these horses
suggested the title.
Perhaps a twenty-first-
century Pegasus could be
a sawhorse.

BACKGROUND:
TOMMY'S
SKETCHBOOK

1990s

Pictured are sketches of
Air Horses, Moon Clock,
and Skeleton Chair. These
drawings function as
visual notes to myself, a
quick way to explore
variations on a theme.
A place to capture those
fleeting thoughts for
another day.

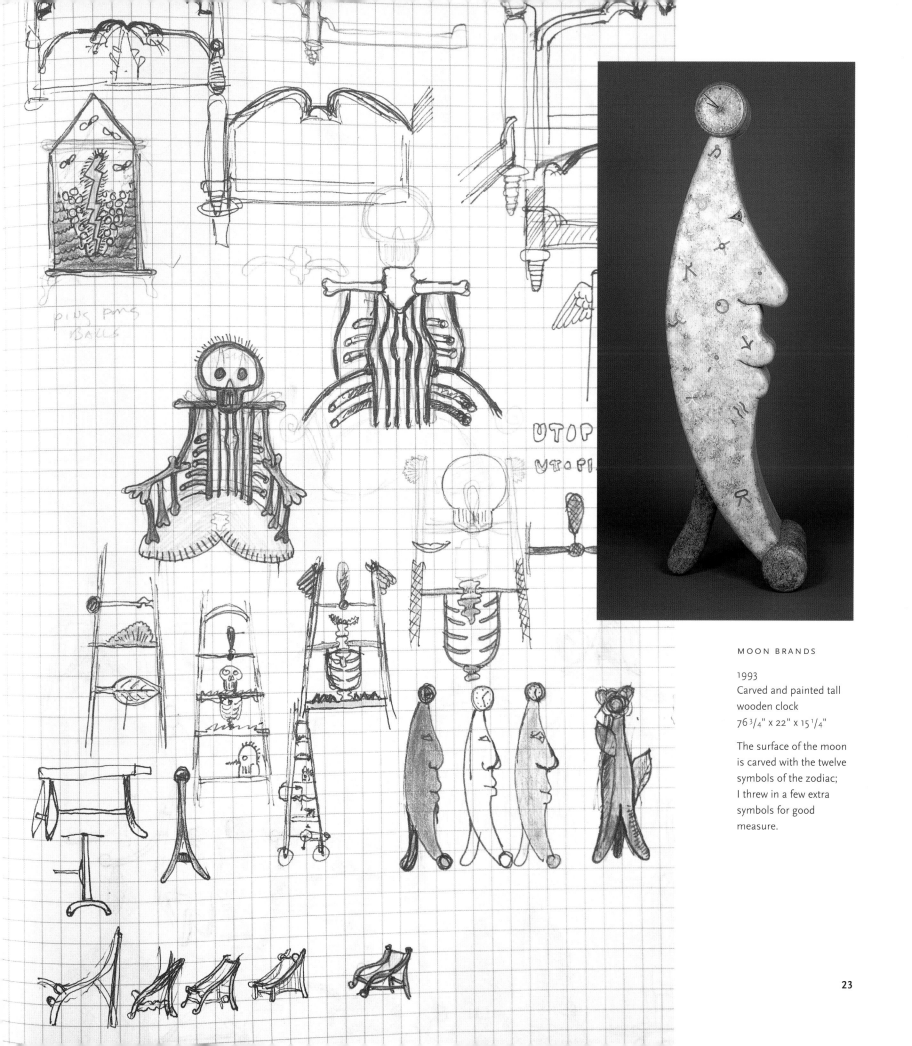

MOON BRANDS

1993
Carved and painted tall
wooden clock
76 3/4" x 22" x 15 1/4"

The surface of the moon
is carved with the twelve
symbols of the zodiac;
I threw in a few extra
symbols for good
measure.

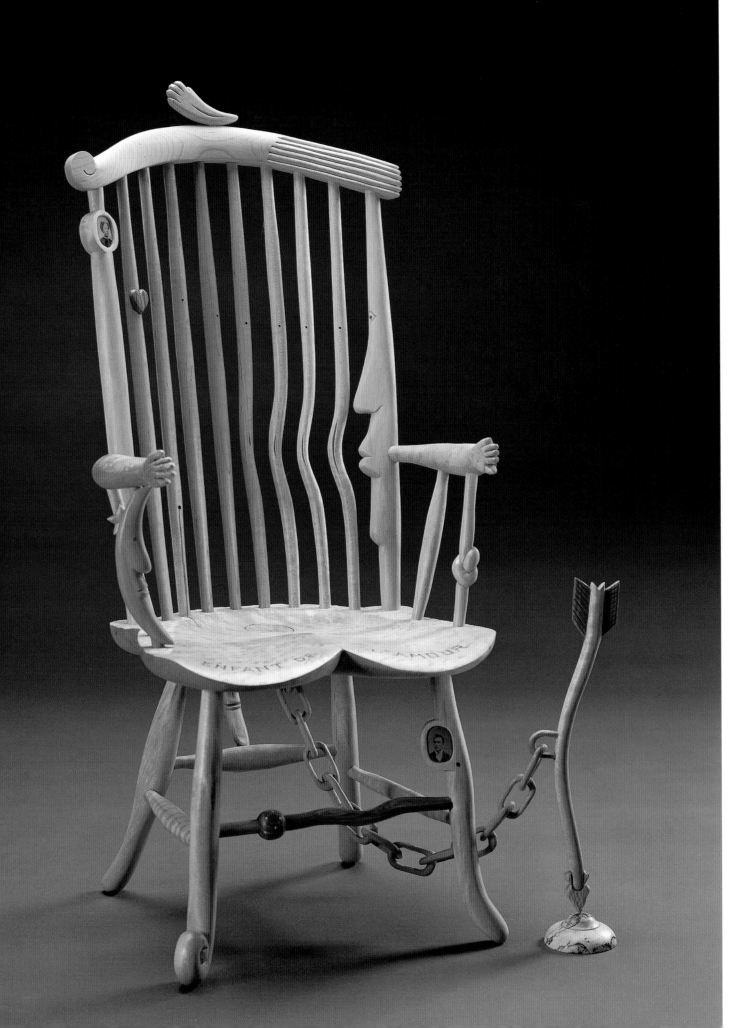

MUSEUM'S
AFTERNOON CHAIR

1983
Mixed woods, paint,
ceramic plate (millerites),
antique lithograph
38" x 26" x 28"

Objects and elements
found on a cold afternoon
at the Metropolitan
Museum of Art in New
York. The chair has its
own pair of crocheted
mittens, as those halls
can be drafty.

OPPOSITE:
ENFANT DE L'AMOUR

1992
Mixed woods with tintype
photos
24" x 14" x 12"

Cupid works in mysterious
ways, for even a chair
back conveys kisses from
sweethearts.

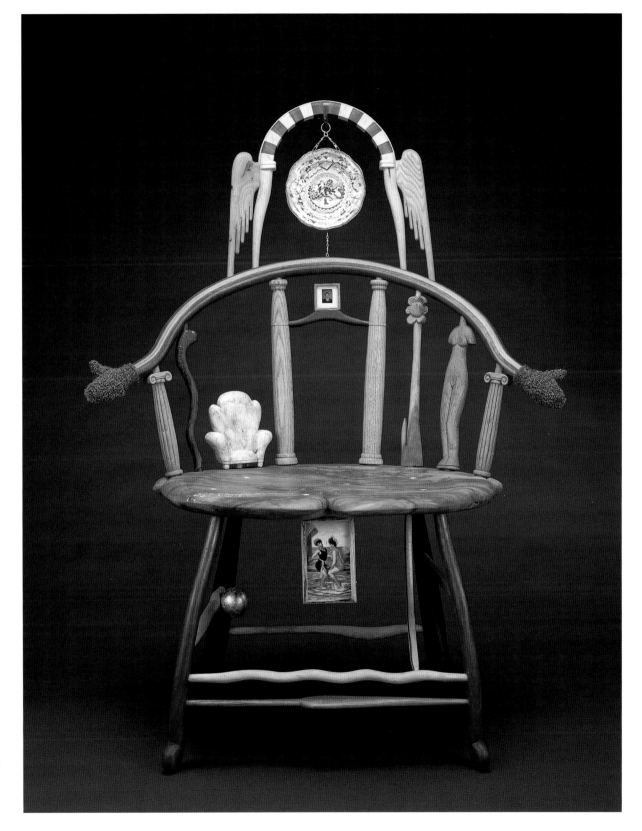

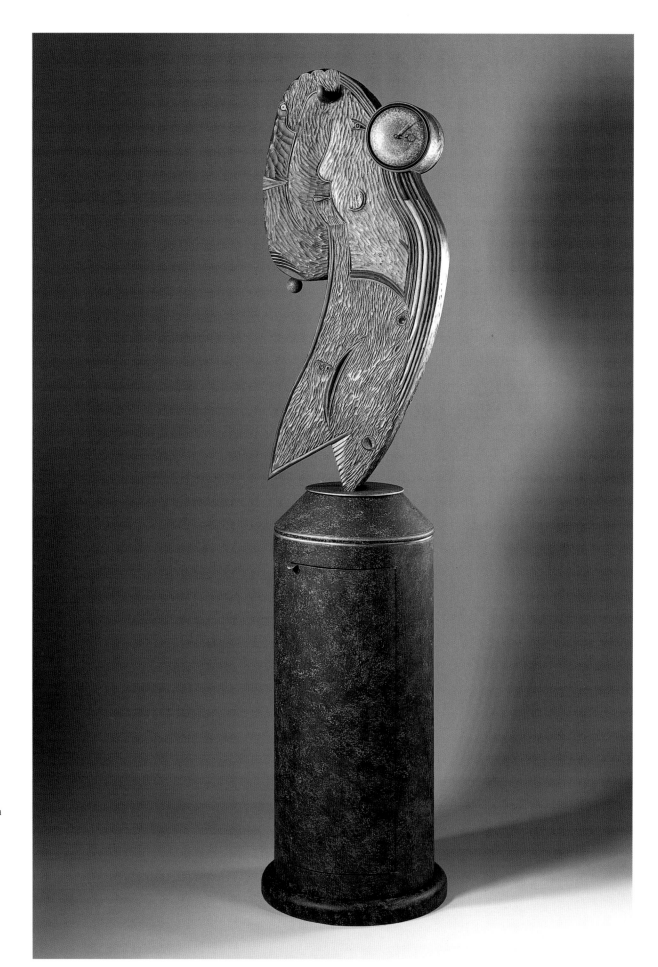

WING

1994
Carved and painted
wooden clock cabinet
77" x 18"

This piece was built as a
woodworking demon-
stration for NHK
Enterprises (Japanese
high-definition TV).

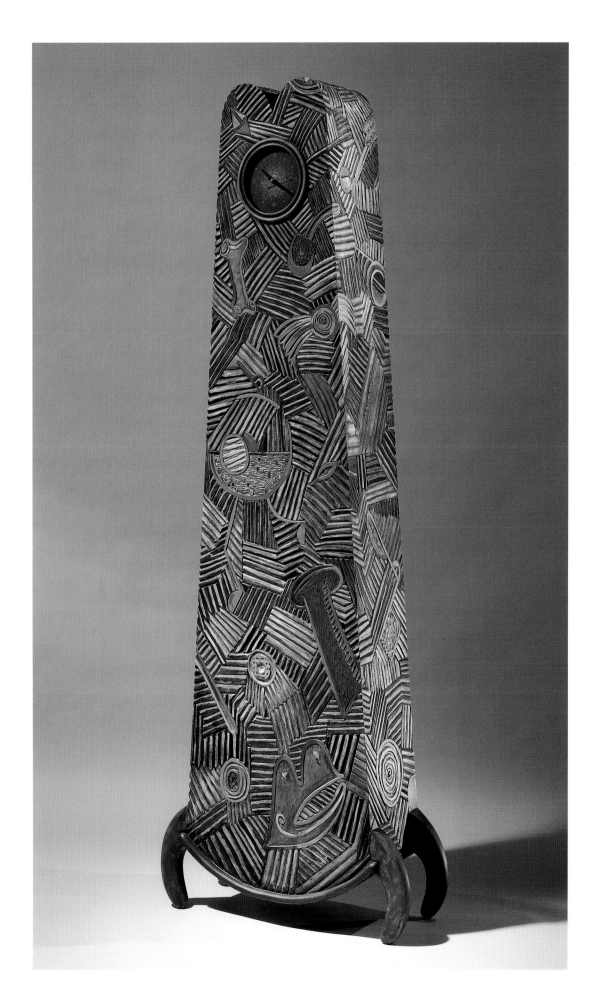

DREAM TIME

1992
Tall clock of wood and
acrylic paint
75 1/2" x 20 1/4" x 14"

Based on Australian
aboriginals' use of
concentric circles drawn
into the earth to
symbolize the place
where the sun and their
ancestors once arose.

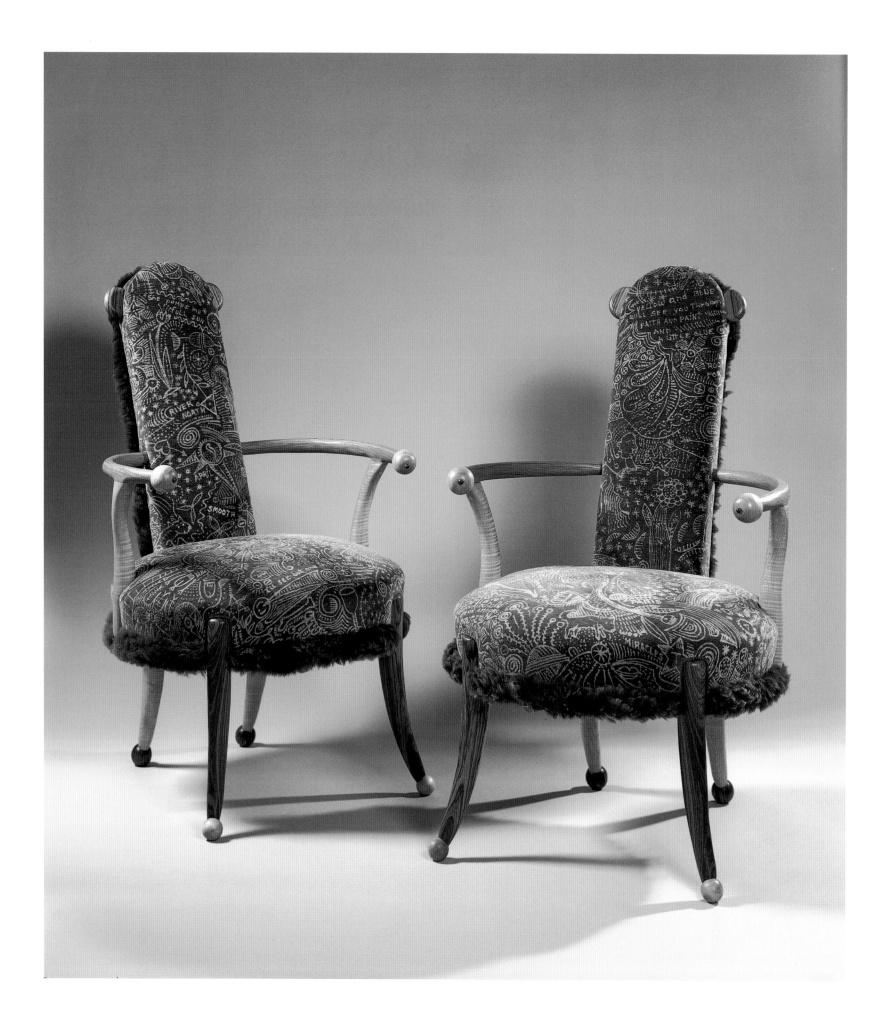

MAINTAINS SUPPLE
KISSABILITY

1997
Upholstered bench with
discharged drawing on
velvet
43" x 30" x 30"

Somewhere in the 1920s,
a Paris boudoir squeezing
sofa is missing, only to
reappear in the kissing
dreams of a curious
artist.

OPPOSITE:
WHISPERS IN BLUE

1997
Oak, maple, cotton
velvet, and sheep's wool
40" x 25" x 28"

We have all seen those
wonderful Tibetan and
Chinese hats trimmed
with fur. For me they
bring to mind the
romantic bohemian
world of Europe in the
1920s and '30s. I drew on
the blue cotton velvet
with discharge paste,
removing the color and
creating a drawing with
poems.

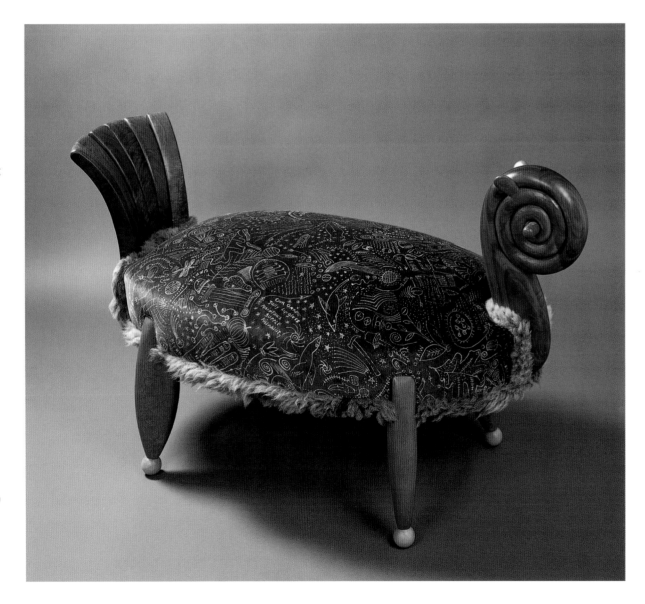

The White Cross Bakery was housed in a small white wooden building.

It could be seen from the far side of Water Tower Park, halfway between home and school. This mogul palace of smells and tastes beguiled young minds more intensely than any mythical siren. Inside this royal place, glistening elephant ears were neatly overlapped, awaiting the arrival of a hungry Hansel and Gretel. Lemon meringue pies peaked higher than the Grand Tetons. Brown hermits were covered with pink sugar blankets. Cornucopic creme horns begged for small tongues to lick out their innards. Chocolate cakes seemed like sculpted fragments from an ancient Nubian princess. And the heavy, sweet air positioned itself low to the floor, putting dogs to sleep. Such wonderments, such flavors, such a heavenly nose — and all within arm's length. I guess if I were asked to express what I'm doing now, the answer would sound a lot like those feelings I had standing in front of the glass cases at the White Cross Bakery.

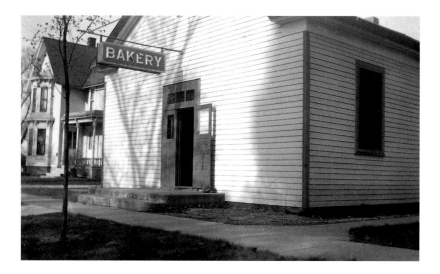

WHITE CROSS BAKERY, CIRCA 1948

An old schoolhouse was made into the White Cross Bakery, on the edge of Tower Park. Its appearance was as straightforward as a bellybutton. Its open-door welcome flowed out, sweetening the neighborhood.

This captivating power of sugar led me to learn a valuable lesson. These urges for

sweets can simulate the compelling push that may be necessary to jump-start you down the road to creativity. In this unencumbered state of giving over to the forces, be they sugar, desire, or vision, one can work by the light of one's own heart's flame. It's that addictive lusciousness of just being alive in the release of self-consciousness that is so bewitching, so seductive, so sweet.

OPPOSITE:
COOKIE CUTTERS

I have made cookie cutters with tin plate and solder over the years for celebrations, for remembrances, for fun. I am convinced from exhaustive experimentation that unique shapes can make the cookie taste different, even better. The alligators and the vases are especially tasty. There are punched words on some of the cookie cutters, made with an awl or chisel. Early American pie safe tins were rendered in the same manner. (*Hummmm Dinnger* is written on one of the cutters; if you are good at reading backward, you can find it!)

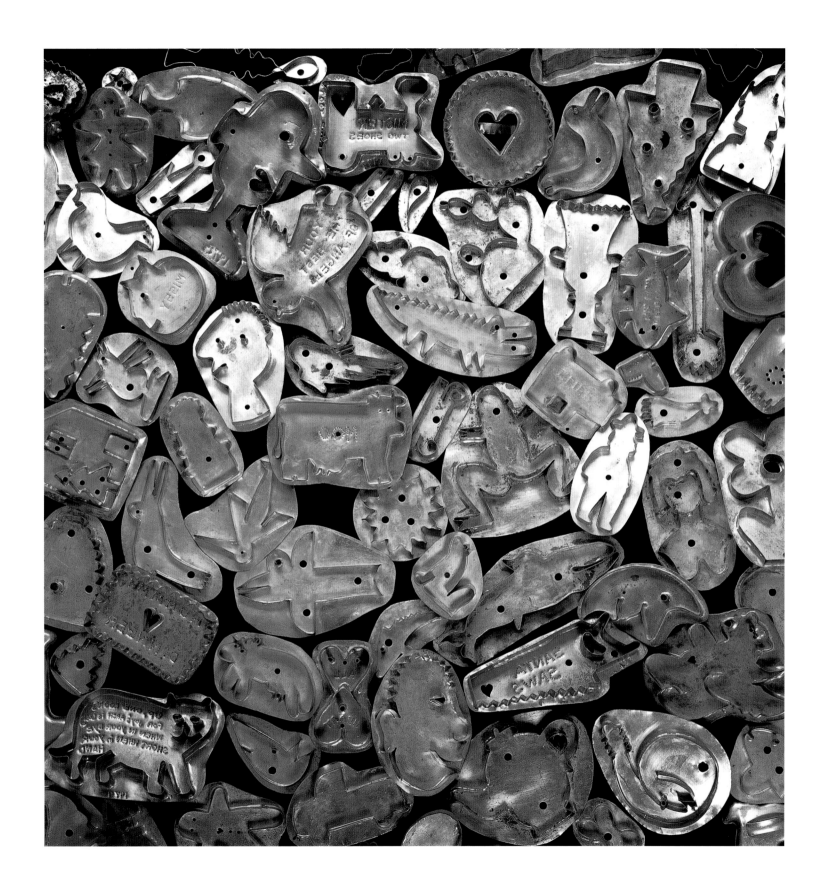

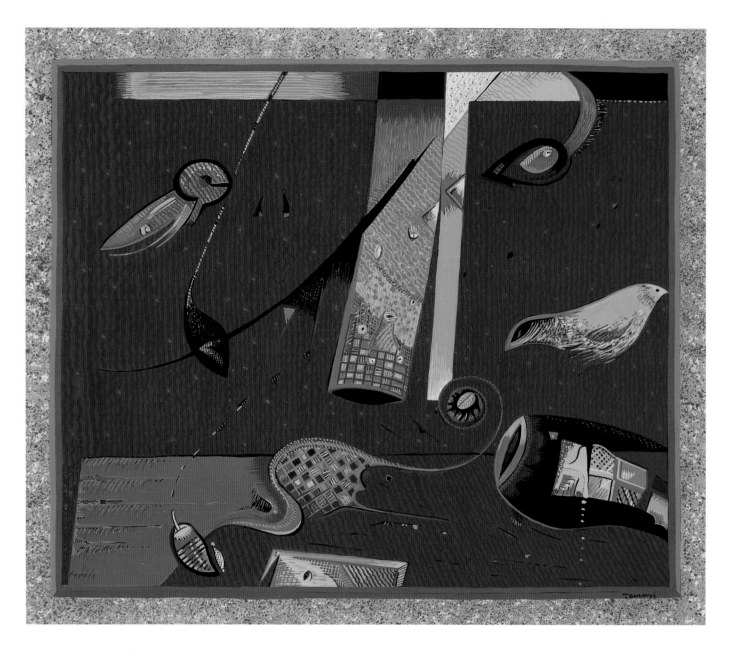

THINKING OF YOU/BIRD SMILES

1995
Gouache on paper
14" x 12"

This composition was based on the proportions and
elements of the human face. Some faces read like
landscapes, well traveled and full of scenery.

OPPOSITE: A LITTLE BANG

1992
Painted wooden box
29" x 23" x 3"

Orange skies
Silent birds
Storm coming,
boom, boom, boom.

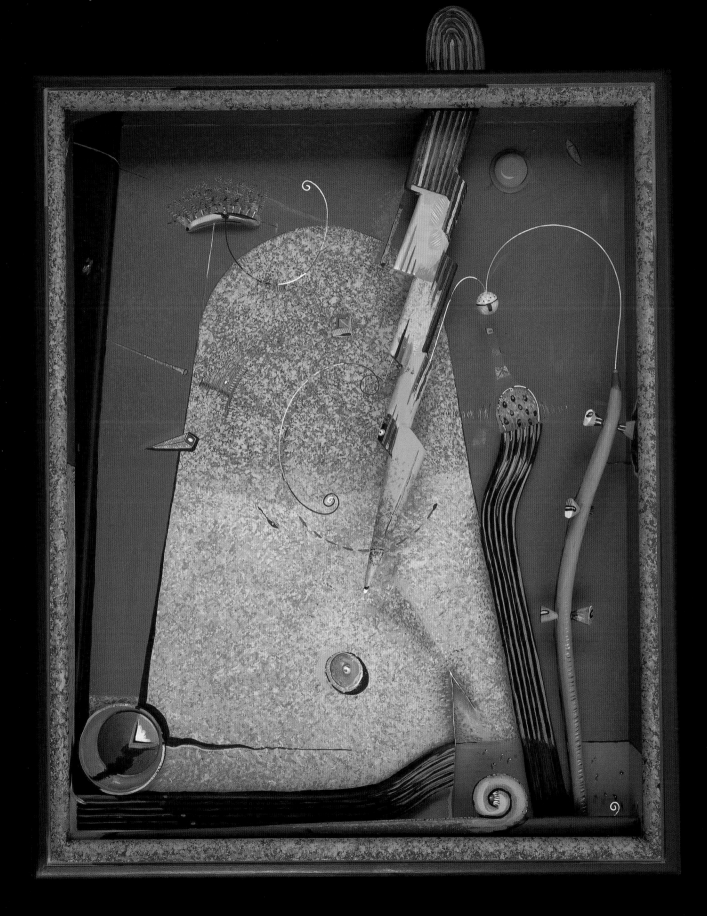

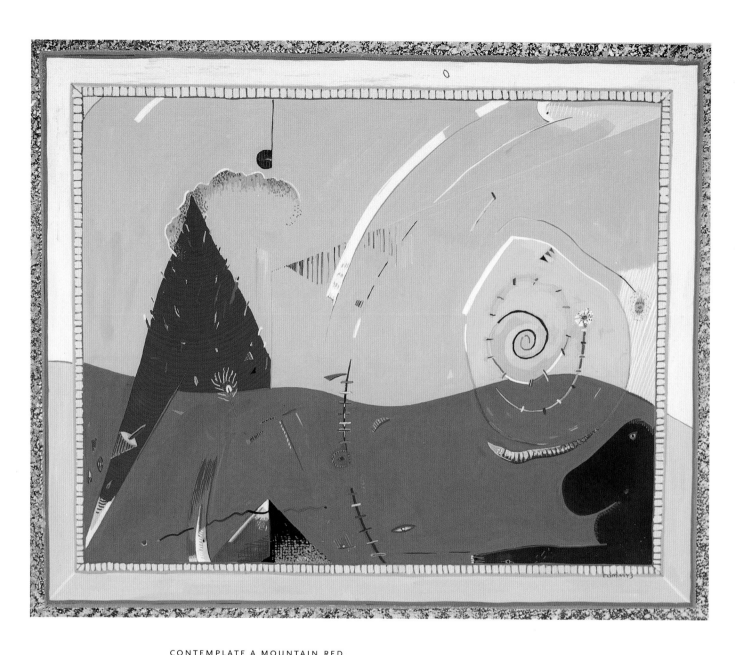

CONTEMPLATE A MOUNTAIN RED
TREES UPON A YELLOW HEAD
THINK OF GOOD AND JOLLY TIMES
STOMACH PIE
EYES OF PINE
THINK OF SKIES WRAPPED IN TWINE
WISHING YOU A KISS OF MINE
REMEMBER THIS
MY VALENTINE

1997
Gouache on paper
13" x 10 1/2"

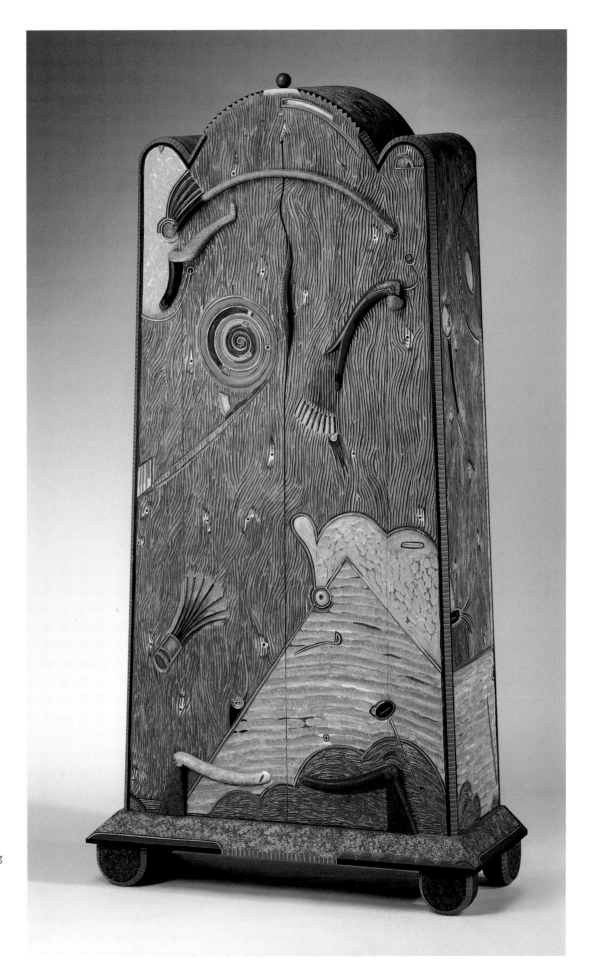

SHE WAS AN ITALIAN
EVENING

1995
Basswood cabinet
(surface carved in relief
then painted)
79 1/2" x 42" x 18"

She was sheaved in hot
colors, with only the
slightest hint of those
luscious shelves reclining
on the inside.

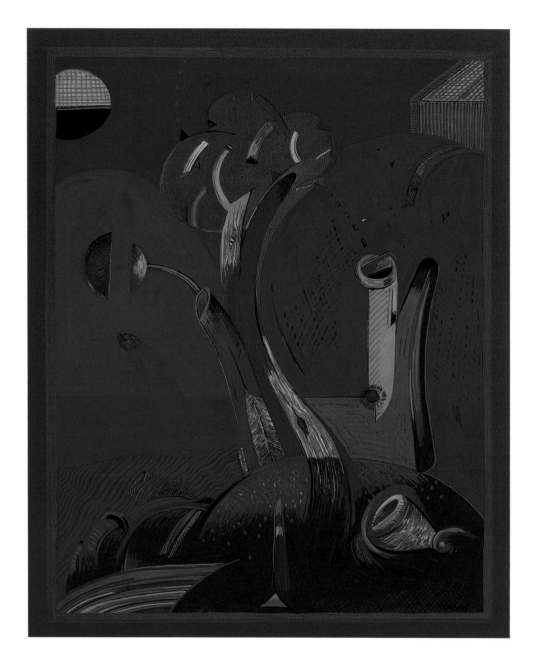

To Tom, illuminating an early bout with art:

Dear Tom,

Memories are wonderful! Many times in my "old" age I get such *joy* remembering the many "happenings" in my earlier years with you three boys and one "little Susie"! and of course, your Dad!

Have I told you this one? We were living in Oceanside, Calif. You brought home a water color painting from kindergarten. It looked like a Surrealist painting, splashes of color, with no design, large splashes and small, all different sizes, and directions. The colors were so drab, dark, purple, mustard, tans, browns, dark and light blue, etc. I looked and wondered why you hadn't used the primary colors that most kids used. You and Freddy always had a large box of crayons with *all* kinds of colors. I was thinking that maybe there was something *wrong mentally*, that a five year old would pick such odd colors. I was worried enough to go next door to ask friend Verna — ex-grade school teacher, about my fears! Her answer to me was: Just casually ask Tom to explain the painting to you! So that's exactly what I did. You said, "Oh, why, it's a puzzle! Here, I'll show you! Here's a bee, here's a bird, here's a bear, here's a butterfly!" I was aghast and I myself felt so dumb!! *But,* all your hidden creatures began with a "B"!!!???

I'm sorry, Tom, I didn't have it framed because, although my intentions were good, it got lost!

Love you!

Mom

TOMATO BLUSH, PLANETS HUSH

1996
Gouache paint on paper
11" x 9"

Sometimes, when I am working late into the night, my exhaustion turns clouds red and plants tell stories.

OPPOSITE, INSET:
SOON TO BE

1996
Gouache paint on paper
11" x 9"

The inspiring Flemish painter Simon Bening (circa 1540) created enchanting calendar miniatures of amazing small scale. I do enjoy working with his compositions in mind.

Delray Beach,
Florida

Dear Tom,

Memories are wonderful! Many times in my "old" age I get such joy remembering the many "happenings" in my earlier years with you three boys and one "little Susie"! and of course, your Dad!

Have I told you this one? We were living in Oceanside, Calif. You brought home a water color

... It looked like a Surrealist ... with no design, large ... ferent sizes, and directions. ... , purple, mustard, tans, I looked and wondered ... primary colors that most kids ... had a large box of crayons ... thinking that maybe there ... , that a five year old ... was worried enough to ... ma — ex-grade school teacher ... me was: just casually ask ... ! So that's exactly what I ... puzzle! Here, I'll show ... , here's a bear, here's ... I myself felt so dumb!! ... began with a "B"!!!???

I'm sorry, Tom, I didn't have it framed because, although my intentions were good, it got lost!
Love you!
Mom

My Muna's
 main street
 green leaf blanket
 embroidered with white bells
 was spring's first renewal
She
 lily-of-the-valley
 fragrant
 brought a clear constant reassurance of good
 A grandmother's spirit
 that bathed me in grape jelly and angel food cake
 remembered

food pleasure comfort
sensuality gratify
possession feminine
inclusion words fulfillment
language earthy mood

WINDOW

joyful whimsy delight
unimpeded lively

BRIDGES

morning

satisfaction spontaneous
change alteration dynamic
charm music vibrations
harmony flow dreams
movement melody rhythm
mystery fantasy quest
romance values price
knowledge community
self aesthetics

In our home on Main Street, the laundry room was next to the kitchen.

Here two white cubes, a washer and a dryer, plus an extra refrigerator resided. This was the place where debris was carried away and life got refolded. Across the room was a large built-in wall cabinet. On one of the shelves sat an old tin container that no one had opened in years. It looked age worn, lost in time. Somewhere along the way I became curious enough to take it down, place it on the washer, and open it up. Inside were several squares of old, dried cake, carefully wrapped in waxed paper, with the slightest whiff of brandy. Of course, I broke off a piece of each one for a little taste.

When I got to the bottom of the tin, there lay a handwritten note describing the

contents: "Mother's wedding cake, 1863, my wedding cake, 1901, and Ellenor's wedding cake, 1935." I had been nibbling on my great grandmother's, grandmother's, and mother's wedding cakes! What a delicious surprise!! Imagine a taste of family celebration — a tactile bridge to the past. Three joyful moments recaptured in three bites.

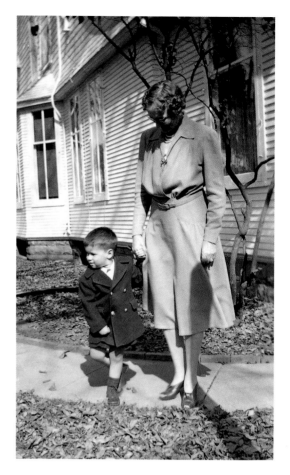

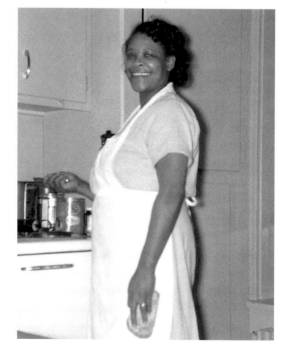

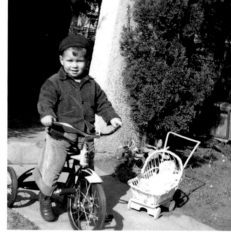

GRANDMOTHER MUNA AND ME, CIRCA 1942

In the spring the ground behind us is a fragrant carpet of lilies of the valley. A hand hold tells it all!

CHRISTMAS, CALIFORNIA, 1942–43

My mother tells me the doll and stroller are what I wanted for Christmas.

BILLIE, 1956

A mile-wide smile and a heart to match.

Here is a grandmother who helped define who I am without my ever being aware of this deed until now. A realization too potent for my words of thanks. So I end up saying, "Did Mrs. Thompson make that dress for you?"

MRS. THOMPSON

Mrs. Thompson lived a half block from old Carpentersville Park,

where she had applied her craft for many years. My grandmother, Muna, drove her late-forties blue Ford there more than once. The day I went with her, the Ford knew to stop at exactly the right house, an unassuming dwelling where the living room housed a coal stove radiating warmth — the same warmth as in Mrs. Thompson's blue eyes and round, spectacled face. I remember entering the front door and turning left into her small workroom, where a curtain hung in the doorway and a chair of humble vintage asked me to sit down.

From this vantage point, I watched and waited while "the ladies in time" went about their business of pins and tucks — Mrs. Thompson was a seamstress.

She had been making clothes for my mother's family for many moons. Muna would sketch pictures of various fashions she had seen or bring photo clippings from magazines and present them along with some fabric she had purchased. Mrs. Thompson would say, "Let me sleep on it," and as miraculously as Rumpelstiltskin, she fashioned those garments. All this was done on a small raised platform in the center of the floor, which acted as a stage for the performance. It was a paced production — quiet, efficient, the smell of kindness perfumed everywhere. She had skill in her fingers, confidence, knowledge, and integrity. The ballet of the hem soon took form as on the lid of an antique music box, the tune played the old "comfort and security." As the time passed, the lights grew dim, and the skirt came down. We said our good-byes and returned to the car. On the ride home, the automobile was filled with Muna's feeling of "something new, something resolved." I never knew how much I loved the simple, straightforward, "can-do" approach of the world I grew up in.

My reward for being patient came in the form of a cold glass of juice, perhaps a cookie, or a tomato from the family garden. My true reward came in the discovery of an age-old meaning to soft time, soft attitudes, soft light, soft fingers, soft cloth — soft.

RINGWORM

*Ringworm, ringworm, ring around the head,
worm head.*

Arriving home from my second-grade class, I was informed by my parents that I had contracted ringworm. *Okay. But tell me, what is it? Well, it's having to have all your hair shaved completely off, then it's painting some purple goop down to your eyebrows using cotton swabs; next it's taking one of your grandmother's old, long, cotton, mostly white and tan stockings and pulling the open end over your head and down to your ears; the final act is cutting off the foot end of the stocking and tying the remaining hosiery in a knot.* I felt upside down. I guess the worst part was the slight suggestion that this might be my fault. *Yeah! Like I had nothing better to do than look like this!* I wore these stocking caps for an extralong three months, until my parents took me into Chicago to get my head x-rayed — *the final zap, you might say, of that nasty fungus.*

My memory of this little episode is a bit vague, but in hindsight, I am thankful that it pushed me into a select company — a group that was a little fat, a little cute, had a few too many eyes, and was just a wee bit afflicted — off the hero list! This experience set me off on an unexpected path with many new directions, journeys where I had no footprints in the sand to follow. I was lucky that Mother Nature's childhood experiments on me were only temporary. But she left me with those wormy feelings in my back pocket that have given me sustenance on the road.

Butterball was a nickname given to

me for my rotund . . . not to say "plump" . . . features. If I had been a baseball game, I'd have looked like a doubleheader. This all came about through nonchalance — a large spoon and a healthy youthful unconsciousness. But what I had failed to notice, my father had not. He had a bad streak of teasing in him that endeared him to some people but was very off-putting to others — as I was about to learn.

My family and I were living at my grandmother's house while our home was being built on the other side of town. In that wait for a new dwelling, my eighth Christmas came with cold and snow in the air. Christmas Eve arrived, and we knew that tomorrow, after breakfast, was the hour of gifts. We gathered around the tree. . . . There were gift boxes, ribbons, and rumpled wrappings. Finally, a large, flat box came my way. Upon my opening the tissue paper, there it was in all its lacy whiteness — not a pocketknife or a wallet, or something I recognized right away, but, after holding it up — *a bra! Could there be a mistake? No. My name is on the tag.* As I recall, tears welled up in my eyes, and I could sense that the hair on my mother's neck stiffened. I never knew what price my father paid for this practical joke, but I bet it was one expensive piece of lingerie.

ME, SUSIE, FRED, 1949

According to Fred's expression, mother must have dressed us for the occasion.

I knew then there was a change, a shift in my outlook, although the *how* of it was

unclear. Nevertheless, a change took place. On reflection, I believe awareness, self-reliance, emotional independence, a willingness to go it alone, took root at that point. My first steps of separation. Strangely, these attitudes seem to fit well with the activities of my world of art — a pursuit that asks you to work long hours, year after year, by yourself in enchantment and alone. Perhaps this gust of poignant jest blew away some of the clouds covering my path and gave me an early start to being myself. If so, *Thank you, Dad.*

LEFT:
DAD, LATE 1960S

Looks like he just swallowed a month full of mischief.

GEORGE WASHINGTON

For someone who had a hard time reading and standing in front of a group,

it was baffling to find myself cast as George Washington in the sixth-grade pageant. I certainly tried not to learn my lines. I tried to be uninterested and even pointed out that my nickname, Butterball, was a good reason to question the extremely tight fit of my costume. My reluctance was thought of as "getting into the part." Finally the lights went up, the characters unfolded, and the plot got resolved. When the final bows commenced, a very loud rip was seen and heard from the seat of my pants. I'm happy to say this brought down both the house and the curtain!

OPPOSITE:
COMMENTS OF A
HOUSE SHADOW

1995
Gouache paint on paper
9 1/2" x 9 1/2"

This simple house form speaks to everyone, especially children.

G. W. CABINET

1994
Painted wooden cabinet
76" x 32" x 19"

There are antique papier-mâché candy containers in the form of cherry tree stumps with axes. They were to celebrate George Washington's birthday. Since I couldn't afford one of these little boxes, I created my own. The door closure is a black U-shaped piece of metal called a "dog," used by loggers to keep the fallen trees together on their river trip to the mill.

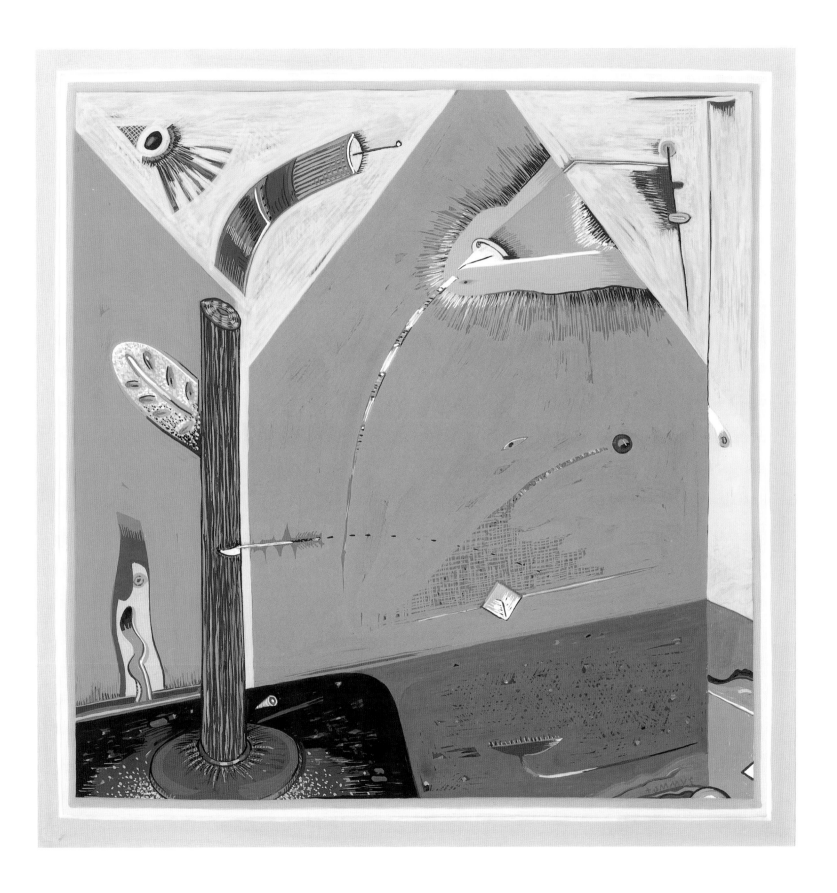

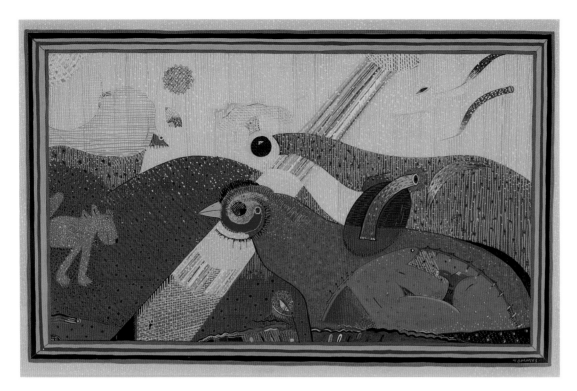

SNOW DREAM

1994
Gouache paint on paper
15" x 9"

Adoration of the snow
dog is the theme of this
work. An homage to the
religious painters of the
past.

OPPOSITE:
TILLY-VALLY

1965
Carved and painted
screen
72" x 60"

A screen that arrived one
day after I was reading
about Irish pookas.

ORANGE SHIRT

The forty-cent bus ride arrived at 10:15 a.m.

and stopped in front of the Dundee newsstand. *[Boy waiting.]* Next stop, Elgin. Stepping off the bus, I made a beeline toward the White Castle hamburger stand. Next, a stop at the shop with the small carved wooden objects; then to Wilson's Sporting Goods store, where fingers perused the bats, gloves, balls, and sticks. *[Boy contented.]* I hit the streets, but what happened next was a surprise to this small spirit. There, in the haberdasher's window, was a good-morning, hello, orange shirt. A color unlike anything I'd ever seen on this planet or any other, it also had light blue buttons that didn't travel from chin to belly but *from shoulder to shoulder in one straight row!* It was short sleeved, hypnotic, captivating . . . *holy cow!* It was raw

COLOR . . . BOOM! *[Boy awakened.]* Weeks later, on my return to Elgin, the store window was missing the shirt. *What? Where! [Boy enters. Finds shirt.] How much, mister? Eight dollars, sonny.* Back home, empty-handed. That vivid hue glowed in my mind. My small hands saved their money. Returning to store . . . *Sir, wrap it up, please!* That pigmented garment went directly home to my top drawer. It took several days before I got the courage to try it on. *[Boy seeing.]* Then, with reverence, I folded it back up and placed it in the bottom dresser drawer, where it remained untouched all through high school. It was just too formidable for my growing psyche. *[Boy wondering.] What a mysterious and powerful force this thing called color possesses. [Boy learned.] This creature called color is a tonic for the soul.* Even after forty-five years, I can still *taste* that orange. *WOW!!*

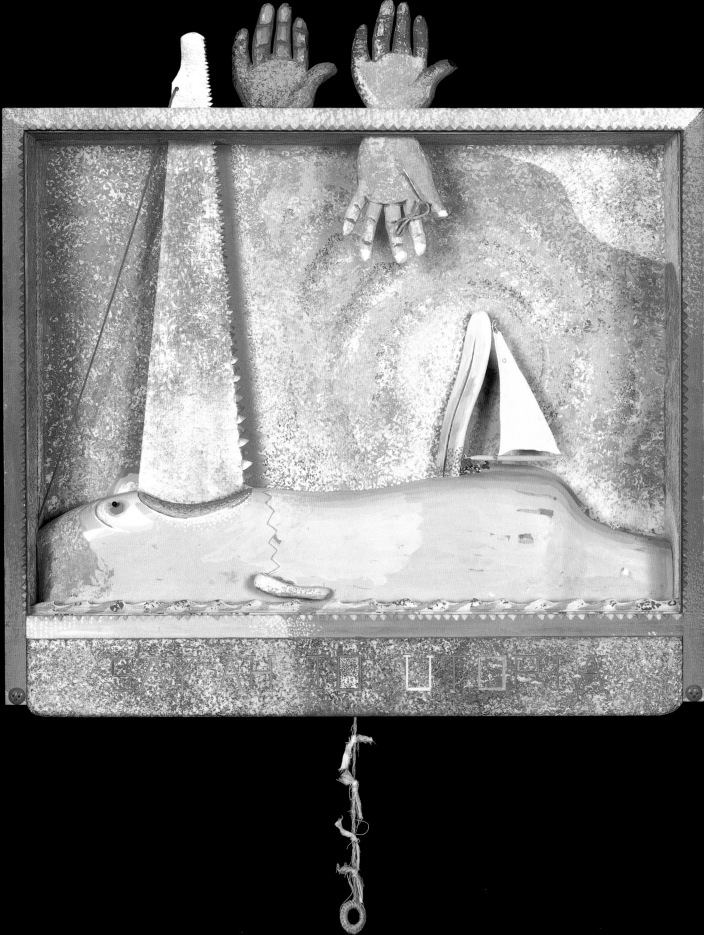

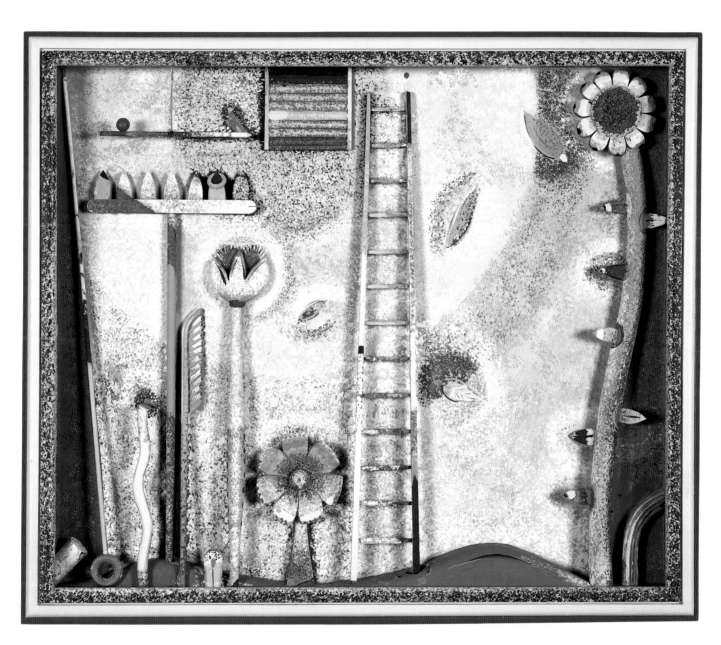

OPPOSITE: SAY AH! TO UTOPIA

1984
Painted wooden box
24" x 28" x 4"

hand over hand
the sharp nose
cuts its way for
sailing tongues
to reach utopia

.

a little nonsense can't hurt

CRISP LIGHT, WARM
AIR AND A VIEW

1985
Painted box
32" x 26" x 3"

Romancing the heart in
dreams of bliss.

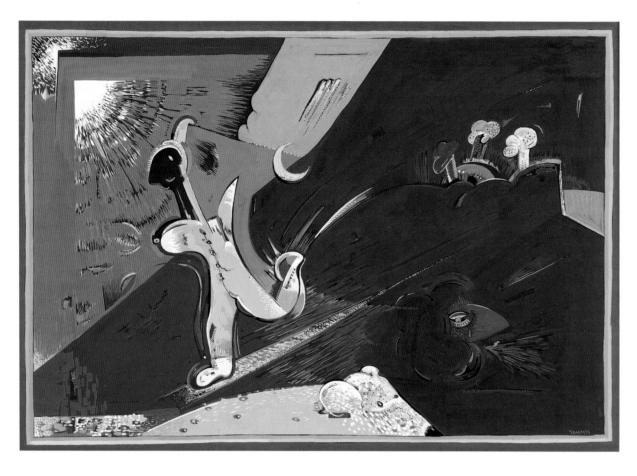

LAUNCHED

The Fourth of July brought forth the neighbor to show us how a pan of water, a firecracker,

and a small metal orange-juice can make a dramatic rocket launch. The instructions were to place the opened end of the can into an inch of water and push a small firecracker with the wick side out two-thirds of the way down into a screwdriver-punched hole on the closed end of the can.

After we gathered the materials together, we chose the intersection of Third Street and Oregon as a launch site because there were no tree branches to hamper the flight. The first shot zinged high into the sky, with our excited eyes glued to the projectile. On the can's return to earth, it found the hood of the local constable's vehicle and landed there. He shot out of his car with his hands and mouth moving as fast as our feet were traveling. Only a few unrepeatable words caught up to us in our own private and speedy Declaration of Independence.

IN FOR THE RUN OF IT

1979
Gouache on paper
12" x 17 1/2"

A dash in time is all we get,
ask Georges Seurat.

OPPOSITE:
DIG YA MAN!

1993
Metal and mixed woods
36" x 16" x 8"

Shoveling along.

BIRTH OF THE BREASTS

1993
Metal and mixed woods
57 1/2" x 16" x 4"

The early American saying
"handy as a shirt pocket"
is inscribed around this
domestic treasure.

ATOM AND EVE

1993
Zinc, mixed woods,
Plexiglas
46" x 12" x 6"

This is the rocket that
launched us all.

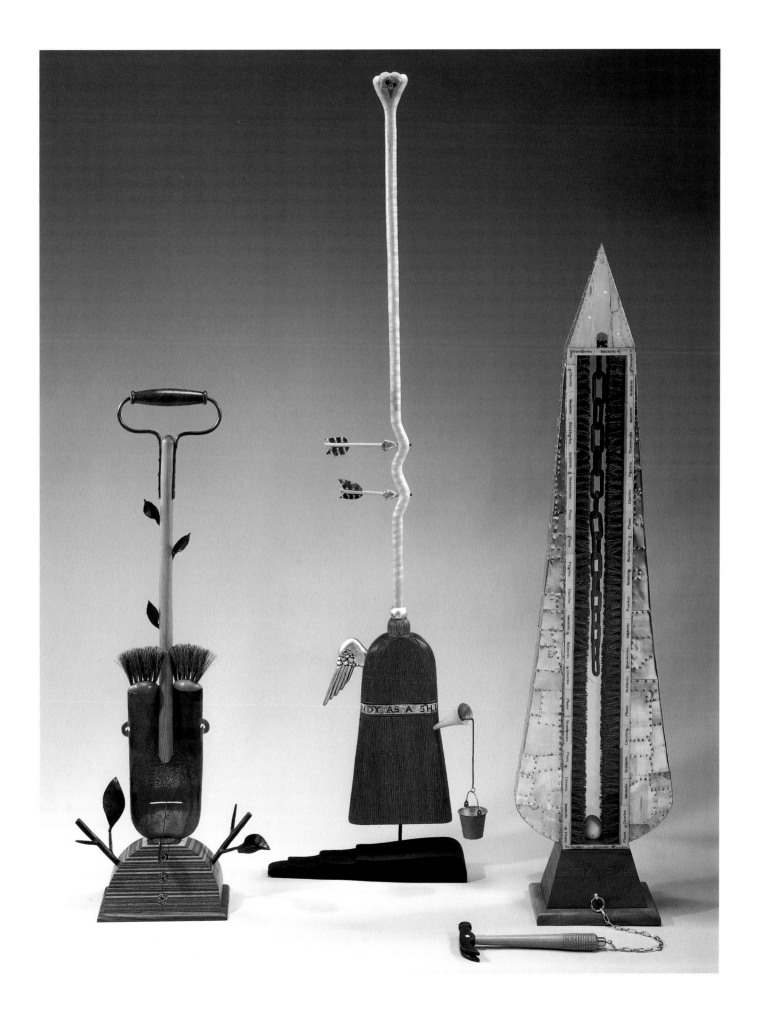

WIND SPROUTS

1992
Painted wooden
clock/cabinet with
brushes
76" x 20" x 14"

The painting on this
cabinet was
accomplished by using
colored varnishes to
cover the piece and then
drawing through the
varnish with rubber
erasers, rags, sticks,
worn-out paintbrushes,
and balled-up plastic
wrap. Thank you for
asking.

LOOK DOWN
MOON MAN

1993
Wood, brush, fabric,
bone, beads
22" x 9" x 5"

A collaboration between
Missy Stevens and myself
for a show of objects
made by artist couples.

SHE BLUE ME A KISS

1996
Painted wooden bed
85" x 80" x 72"

Where else do kisses become colors and wishes
become dreams but in the garden.

Yes

> *When we are close upon close*
> *all furrows to upward rising lean*
> *lush clouds billow gladden skies*
> *anticipating a hoop-plunge delight*
> *Our filling forms encircle*
> *pushing flows of sweet soft*
> *As the light is in*
> *and all our yearnings are out*
> *my love*

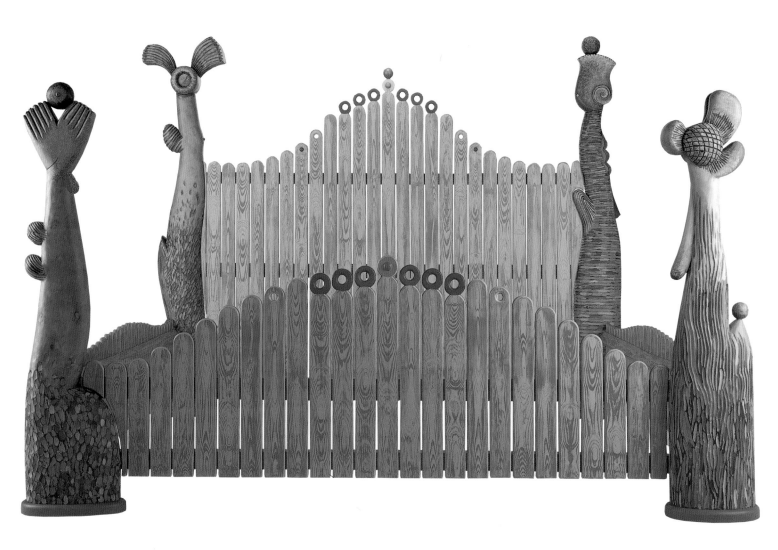

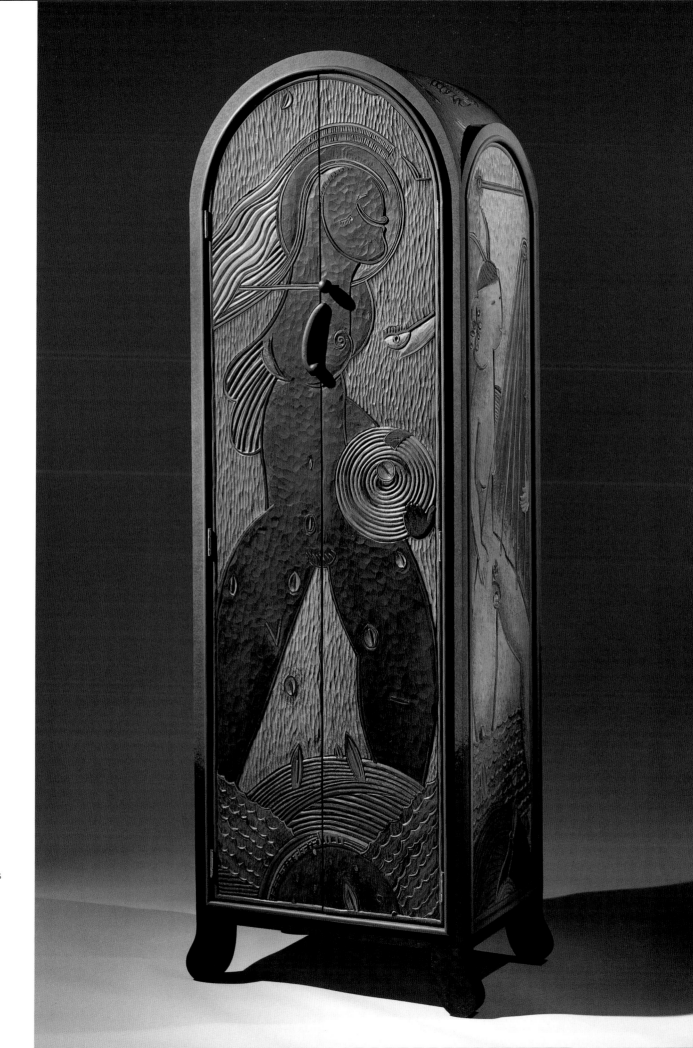

WATER NYMPHS

1992
Carved and painted
wooden armoire
75" x 25" x 18"

Nymphs reside in the
nuzzling corner of your
mind, where perfume is
turned into luscious
apparitions.

BLUE PRINTS

1993
Carved and painted
wooden clock
76" x 18"

The Hopi Indians of the
Southwest have created
many extraordinary
kachina figures.
My thank-yous for their
presence on earth
became this red column
of reverence.

**TOUCHING BLUE —
TOUCHING BROWN**

1997
Carved and painted
wooden armoire
80" x 39" x 18"

Between the sky and the
earth is a narrow band
known as the human
blush. Where howdy
hands reach out for wind-
about treasures.

I already had three sunnies and a bluegill,

and, after adjusting the bobber, I made another cast. This time a good bite and a quick jerk to set the hook. But I was not expecting the hook to snap back and lodge in my nose. My head was trying to tell my arm to stop pulling at the pole, and my tear-crossed eyes were straining to see a problem that was too close. I can't recall how I got the hook out, but a whole new chapter on fishing revealed itself through a painful surprise!

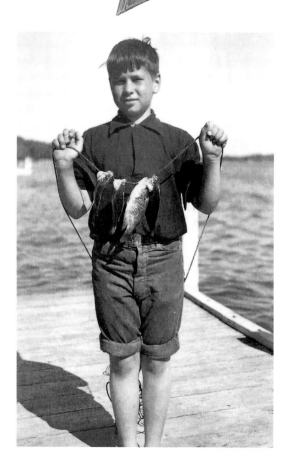

ELGIN CLUB, LAKE GENEVA, WISCONSIN, CIRCA 1948

Looks like dinner! I'm wearing my farmer's necktie; it's called a shirt's top button, fastened.

Novell

Dear Mr. smpson,

I like your work my fafrit pees of your work is Boy with fish I thogt ito was farry intersting I like the dusinse it look's like the fish is sticking out it's tving

Sincerely
Tess

BOY WITH A FISH

1994
Carved and painted wooden clock with drawer
73" x 32" x 11"

As time passes, fishing stories get bigger, longer, taller, wider, and fatter.

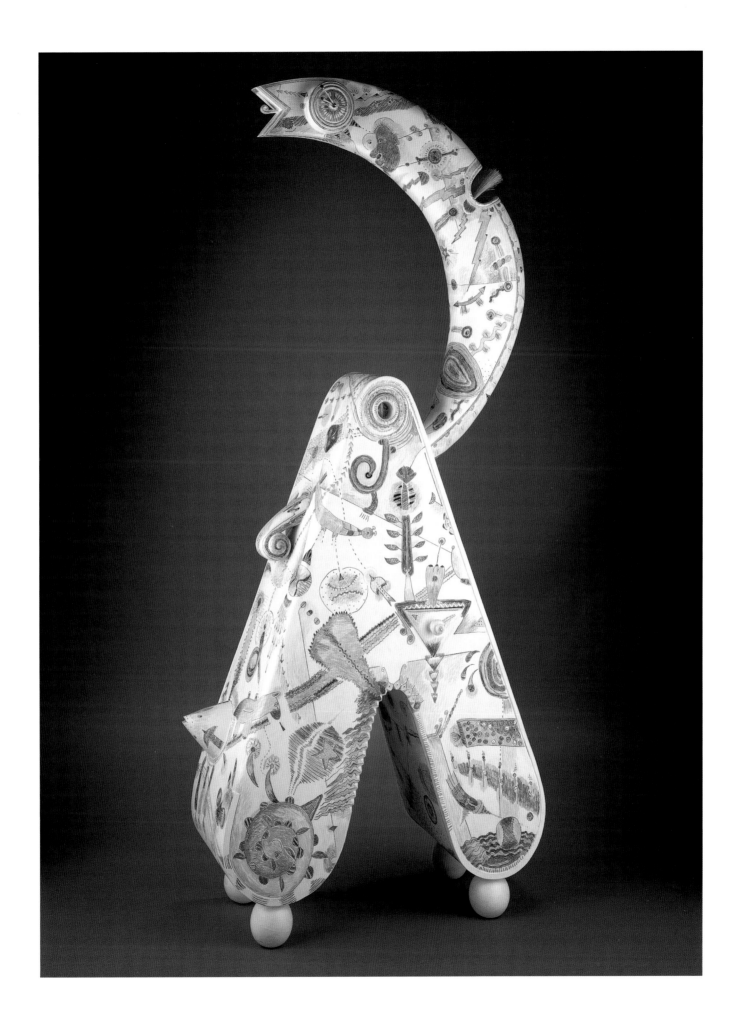

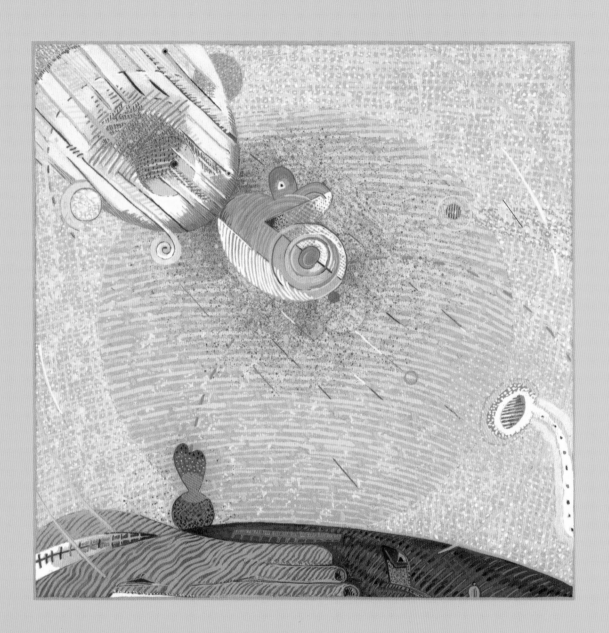

When sun bubbles
heat the sweet
dog bellies
caress shaded earth
sun circles
 roll
cut all patterns
 bursting color
red
creek-feet
become
 cool rivers
 and the in me
 melts

BOOM-BANG

noon

variation transition
line pattern path
outside/inside
start middle end
identification
scale routine
ritual sequence
culture form
elements bones
events
consciousness
opinions beliefs
attitudes thoughts
health series
alone
independence

The roller-skate racers we built in the barn were easy and just right for a pack of pals.

Two boards, two old skates, a rope, screws, bolts, paint, and brushes filled the bill for their construction. So as spring budded our enthusiasm, we pulled our speedwagons to Bray's Hill, near the school. This incline was steep, with a hard ninety-degree left turn, and continued for three blocks down to the river road. Perfect! I'm sure the orange-silver-black colors they were painted increased their speed considerably. Many an afternoon the breeze was filled with the sound of metal rollers on concrete.

But this unchallenged fun was too much for our nemesis — Kneebone. As we climbed the hill one day for another run, what did we see but the head and then the body of "Knees" coming at us over the crest. Soon we saw that he was pulling behind him his racing machine, with that "I know it all" expression on his face. His racer certainly matched our best efforts, and his had three magnificent balloon tires. WOW! He then positioned, oiled, strutted, polished, and, at long last, straddled the seat. Knees sailed down the hill, flying faster and faster in the "Liberty Street Special," as we called it. Halfway down, the racer started to buck and jerk. Then it made a quick turn to the right, went over the curb, and down into the woods. CRASH! Up came a cloud of dirt and leaves! In his haste for one-upmanship, Knees had forgotten to install a brake. So we walked the sweet cakewalk of delight to the site of demise, our faces grinning from corner to corner — the kind of grin only a gloat can produce. Up came Knees, dragging wreckage behind him — not a glance our way, only his backside disappearing over the knoll from whence he came. We guessed being "King of the Hill" sometimes meant getting crowned.

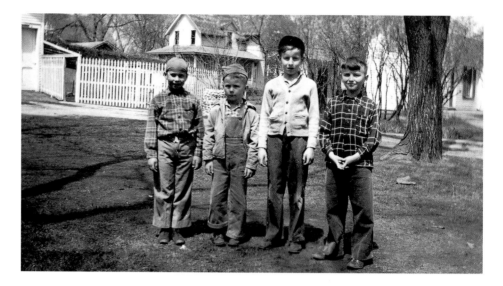

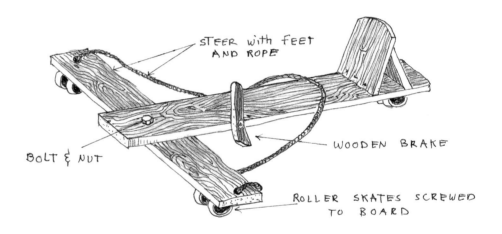

STEER with FEET AND ROPE

BOLT & NUT

WOODEN BRAKE

ROLLER SKATES SCREWED TO BOARD

TOP:
TYPICAL TEAM OF RACERS, 1949

Left to right: Tommy, Steve, Don, Fred. If you have sharp eyes, you will notice the dead baseball glove in the background.

ABOVE:
RACERS, 1946

Basic model: scrap board 1" x 6" x 8' long, nails, hammer, handsaw, one 2" bolt with nut and washer, four feet of clothesline, one pair of old roller skates, one steep hill, one tuff fanny

OPPOSITE:
DEAD SOAP

1993
Feathers, paper, spring, silver, brushes
24" x 18" x 9"

The Mexican festival Day of the Dead gives reverence to our family bones and puts our life journeys on better wheels.

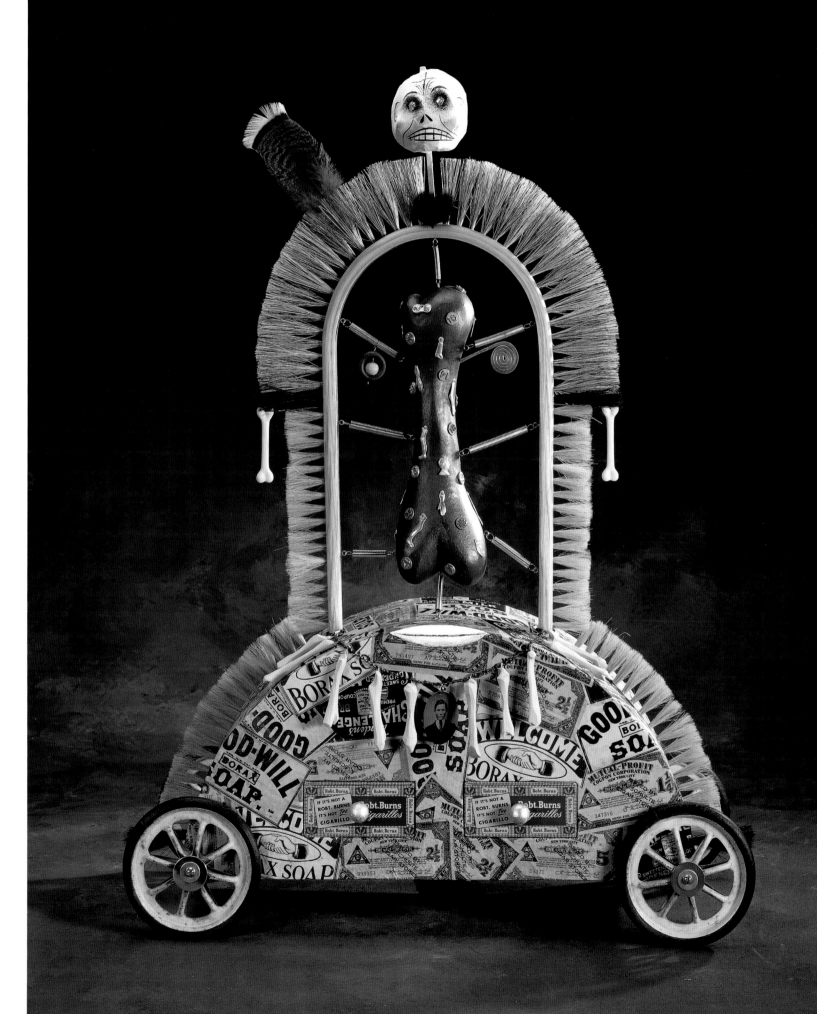

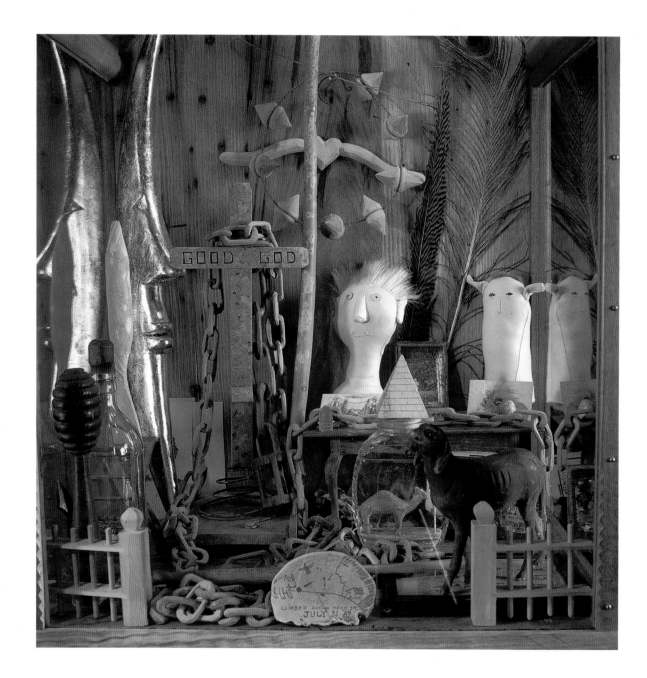

MARY'S MEMORIES

1986
Natural mixed woods
79" x 23" x 17"

When Aunt Mary died, she left me her curiosity cabinet; I now have my own full of ghosts, gifts, nature, and memories. The pogo-stick crucifix in the picture has "Good God" carved on the crossbar, my mother's reaction to such a thing.

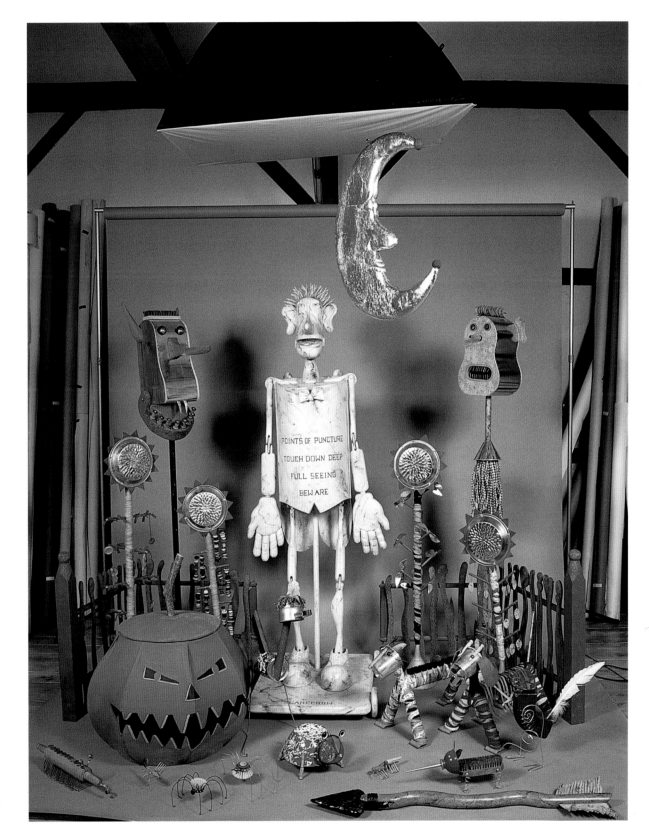

HALLOWEEN

1985
Mixed media

A window display for the Museum of
American Folk Art, Rockefeller Center,
New York.

I am full of funny flowers and gum
yardsticks, clover, rum-a-dumb-dumb
three feet, four feet, six and ten
funny flowers and some again
I am up in the air and through the not
with one to blue to fit the slot
I am betwixt the middle
and the in-between
where roost-hers are and presence seen
where rum-T-tum-tum, and ten and fine
The funny flowers and gum are mine

SKETCHBOOK

1990s
Ink and colored pencil

A place for thoughts, so
when they evaporate into
the world of forgetfulness,
their shadows remain.

OPPOSITE:
CHEESE GREEN AND
POOCH

1991
Painted wooden cabinet
74" x 18" x 36"
Wooden stool
30" x 20" x 18"

Cabinets need pets too!

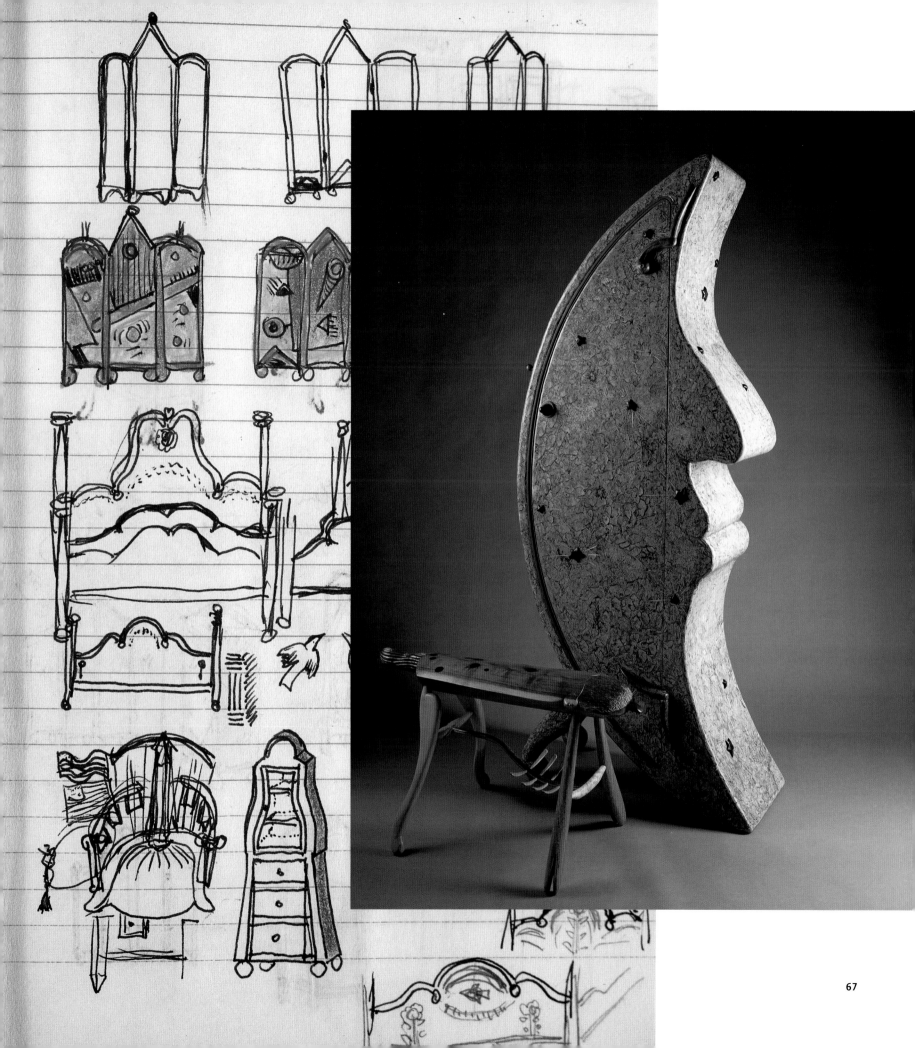

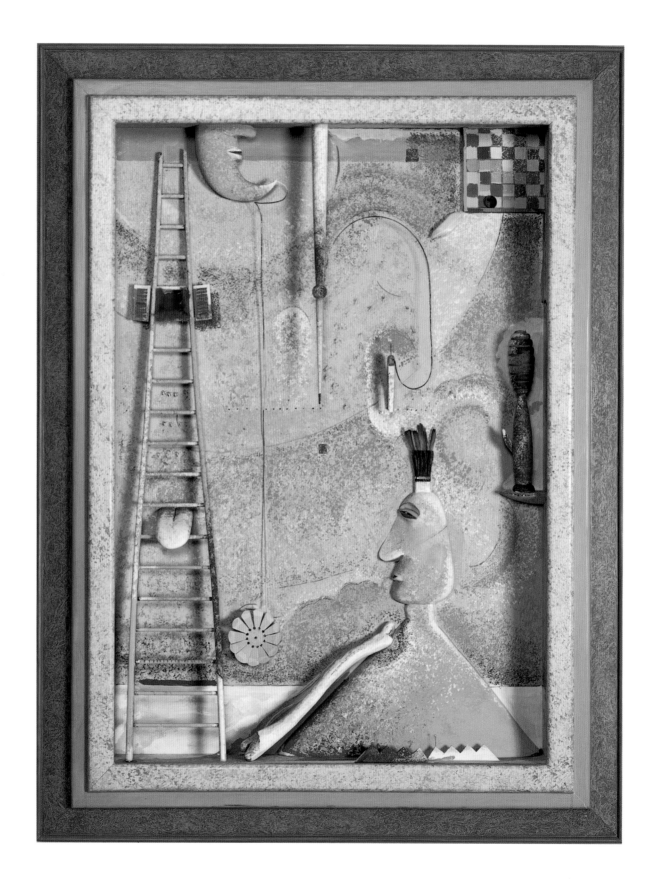

SLUMBER DUST

1983
Painted box, wood and
metal
48" x 36" x 5"

When slumber dust taps
us on the shoulder,
enchantment is close
at hand.

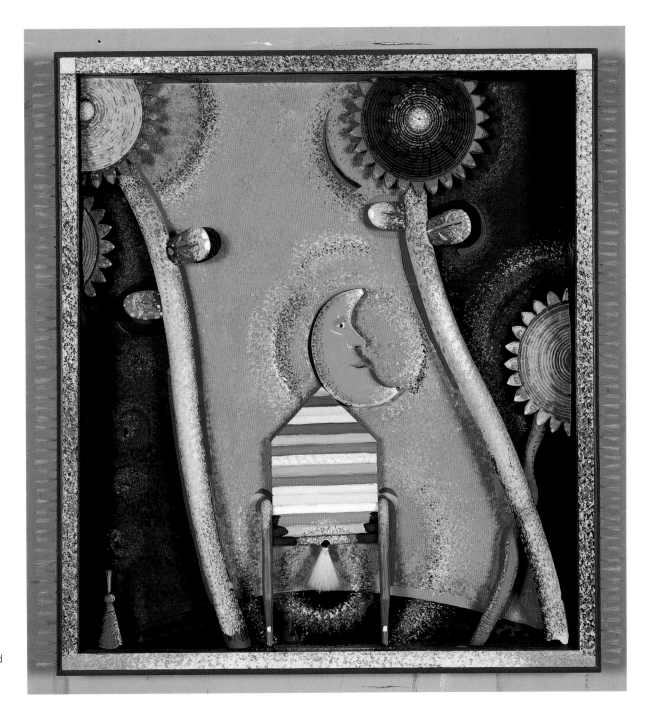

SOUTH OF THE
NIGHT BORDER

1986
Painted wooden box
30" x 30" x 3"

Where the flowers'
bosoms top the trees and
ribboned homes nudge
smiles from green loves.

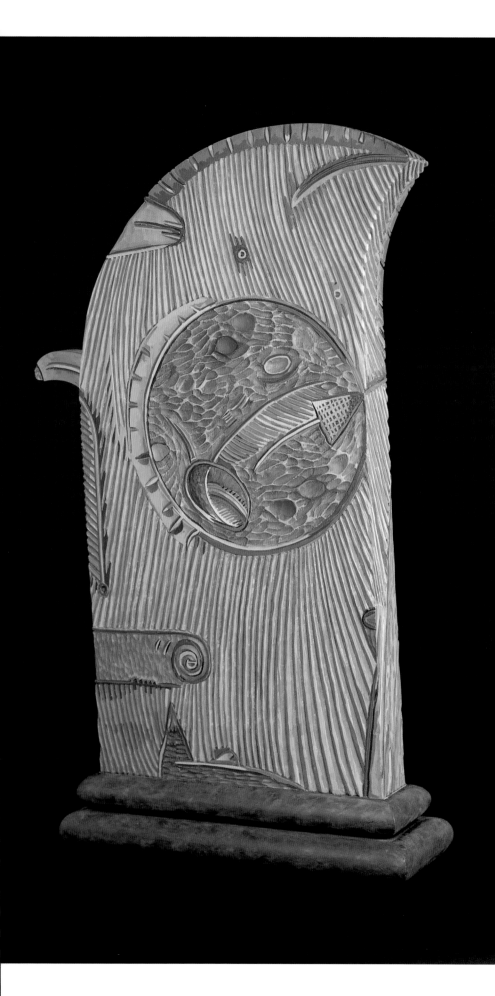

Barricades were placed at each end of the block, and three forty-yard

wire cables on stakes were stretched parallel along the curbing on both sides of the street to act as a protective fence. Fire trucks from neighboring towns and villages arrived to surround the immediate area. The truck sirens started to wail, enticing the young people, the old, and all the in-betweens. As the volunteer firemen gathered around their hometown fire engines, an empty fifty-gallon aluminum beer barrel was placed dead center in the street. From each end of the block walked the gladiators, suited from head to toe in black rubber slickers, glistening in the evening light. The guidelines for victory were to spray your jet of water at the silver drum and make it move past the nozzleman of the opposing team. The signal was given, and the combatants raised their weapon of choice — a four-inch fire hose made round and hard by the pumpers' revved engines. The water was now on full force, blasting on each side of the cylinder. *BANG!* went the starting gun. That barrel was hit hard and fast. It danced, jigged, spun, hopped, and flipped all over the street — a thing of wild beauty. The spray was wonderfully chaotic. Fifty feet in the air, rainbows in all directions, with patterns that were intense, amazing. As the action crisscrossed the road, so went the on-lookers, screams of fright and delight. "Wait, it's stalled on the cables! No! It's loose again. OUCH!" It was speed; it was furious. The slightest misstep or lapse in concentration and *ZIP!* that little keg sailed by the lead man! "There it goes. It's all over! RATS!!" Apparatus cools off, nozzles down, the canvas hoses lie flat again on the pavement. The extinguished throngs, wet with water and excitement, pause, take a deep-breathed smile, and wait for the second round. When feet and heart surrender to a shower of energy, bliss is not far behind.

IN CASE OF

1979
Painted box, mittens,
fabric, rope, pins
30" x 22" x 4$^1/_2$"

When life heats up and
you find yourself on all
sorts of tall ladders and
big swings, it is a relief to
know there are glass
boxes with fire hoses in
them, with the inscription
"In case of fire, break
glass."

OPPOSITE:
THE WAVE

1996
Carved and painted wood
30" x 16" x 6"

This painted stele form
was inspired by Hokusai's
woodcuts. Many of his
visual descriptions of the
elements took on linear
motifs; for example, rain
was described by long,
diagonal lines. With all
this in mind, *The Wave* is
my answer to a seashore
tide pool.

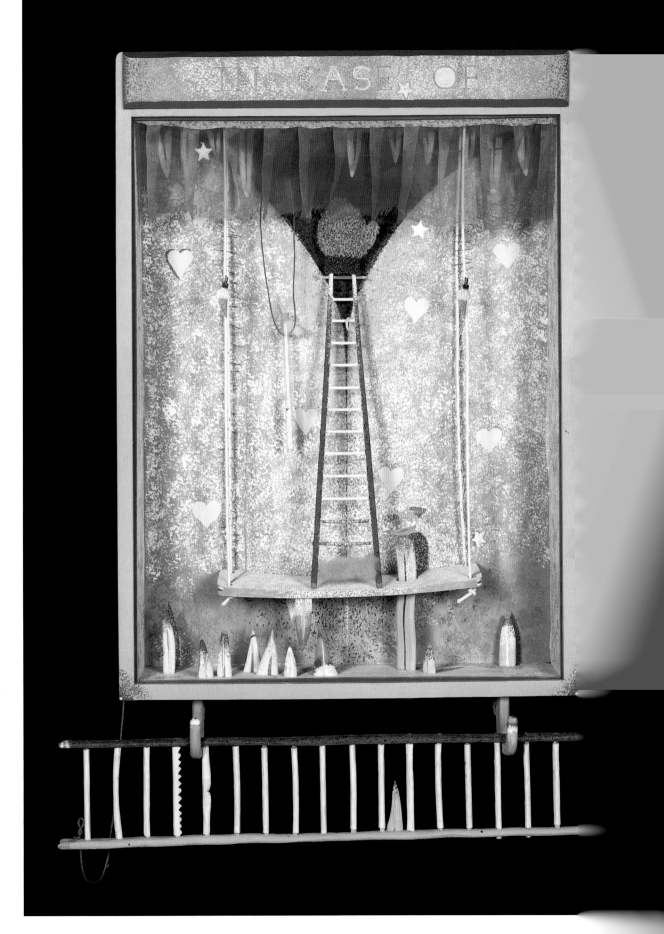

GALLIVANTING MUMS

1993
Painted tall wooden clock
75" x 20" x 12"

This represents the bee's part of "the birds and the bees." Lots of buzzing, a little flowering, and running around with your arms thrown to the sky.

Flow-her petals to and fro
 around the pistil for to blow
 stamen by her side pull toe
 till the color is a glow
Then the me-yous in full show
 attracting the be
 to honey's flow
Circles two
 a path to grow
 holding on to blossom's tow

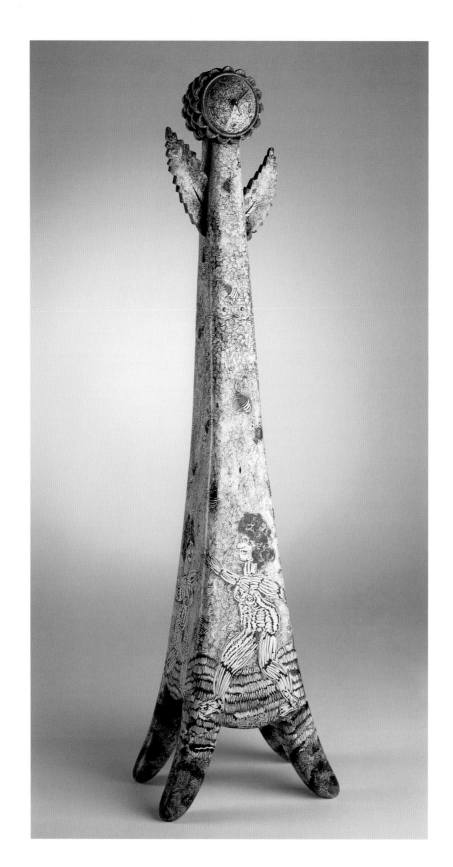

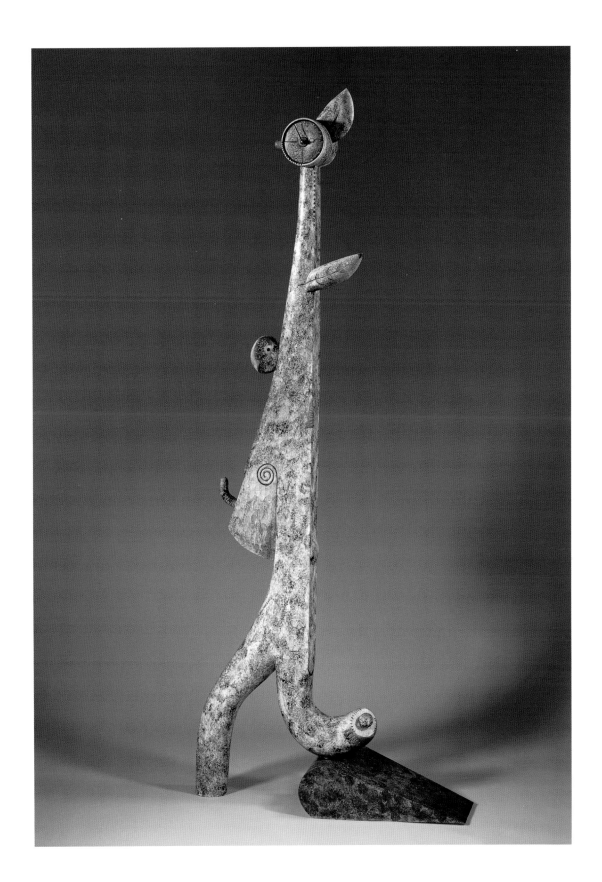

ESCAPE MEANT
FIGURE

1994
Carved and painted
wooden clock
79" x 32" x 11"

Gather and place
in stoppage haste
a captured toy
for the west wind boy

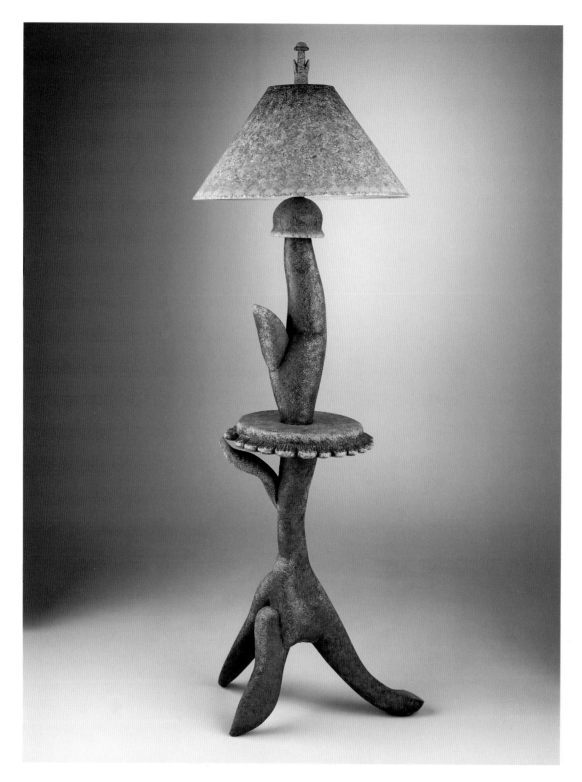

THE TOWN FLOWERS
OF BREMEN

1993
Painted wooden floor
lamp
63" x 20"

A remembrance for a
well-known musical
group.

OPPOSITE:
MERMAIDS' SHADOWS

1995
Carved wooden armoire
77 1/2" x 36" x 16"

Where the waters are
deep, mermaids sing
their rapturous tug and
the sea folk parade.

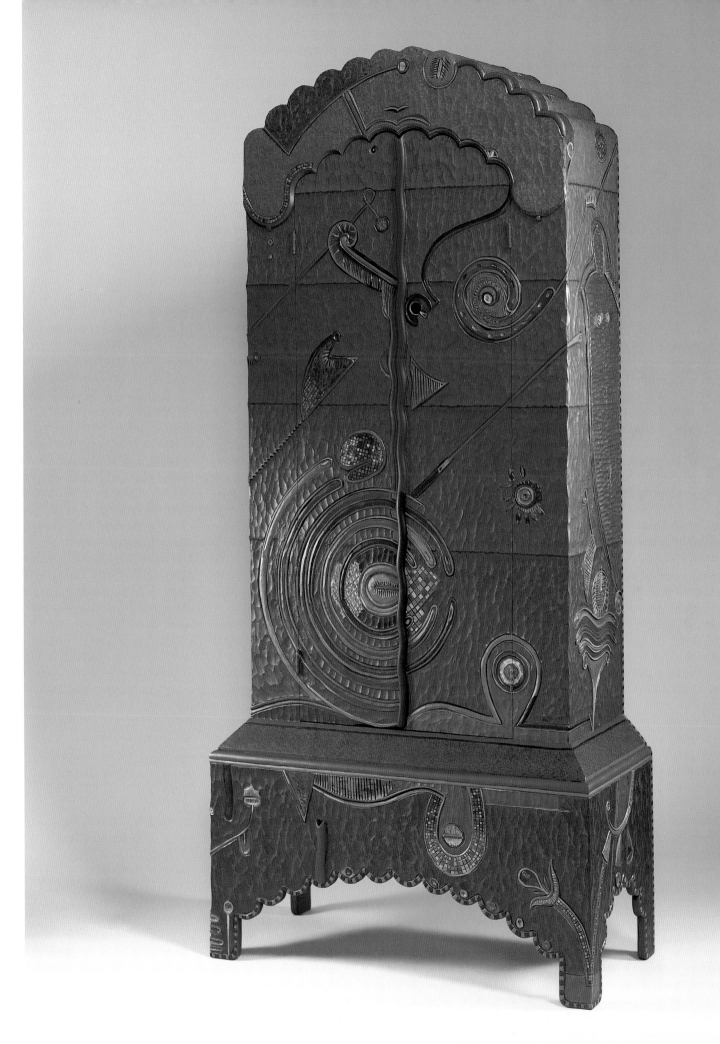

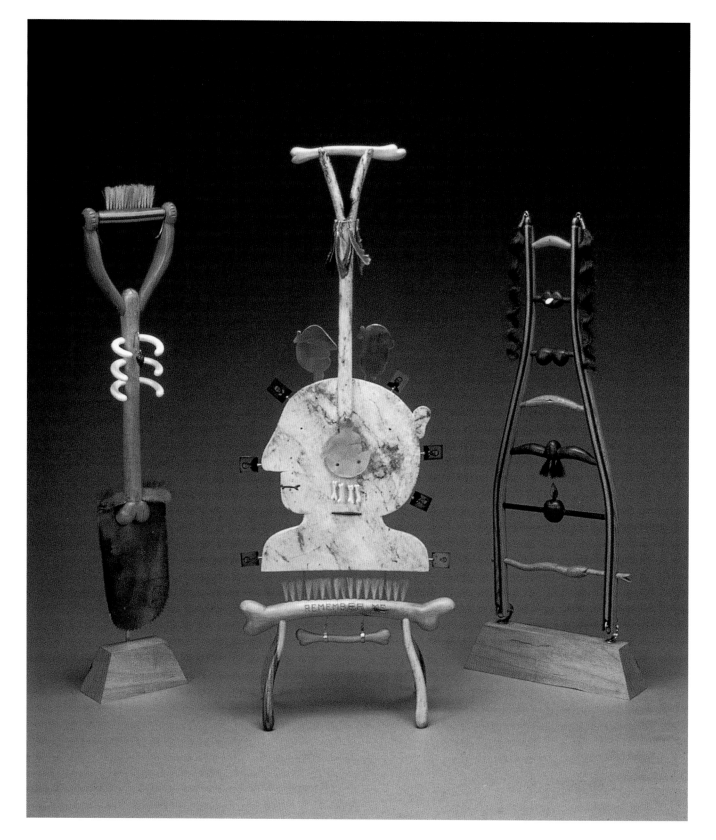

ADAM

1984
Mixed woods, bone,
metals, hair, brushes
20" x 6"

REMEMBER ME

1984
Mixed woods, bone,
metals, hair, brushes
25" x 11"

EVE

1984
Mixed woods, bone,
metals, hair, brushes
18" x 9"

Adam with his ribs, Eve
with her apple, what else
can we dig up about our
ancestors?

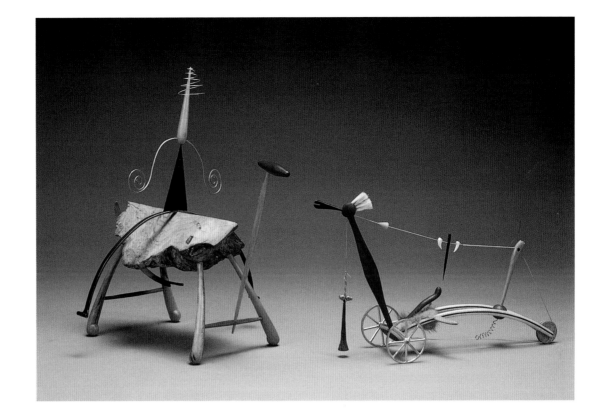

CALDER RIDING
A HORSE

1985
Mixed woods, wrought
iron
16" x 15" x 8"

Sandy loves a balance!

HUNG OUT TO DRY

1985
Mixed woods, metal,
bone
9" x 15" x 6"

Just toying with you!

OUCH

1986
Mixed media, metal wire
17" x 9"

THE DEPENDABLE
MAN

1986
Mixed media, bone,
metal wire, stone, feather
16" x 12"

Many of the small
sculptures derive from
drawings in the sketch-
books. They are also a
useful way to recycle
scraps from larger
projects.

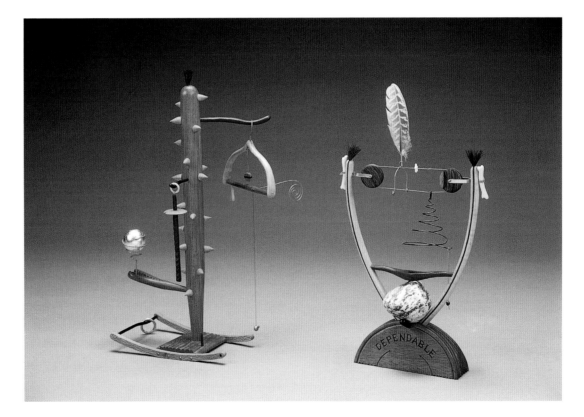

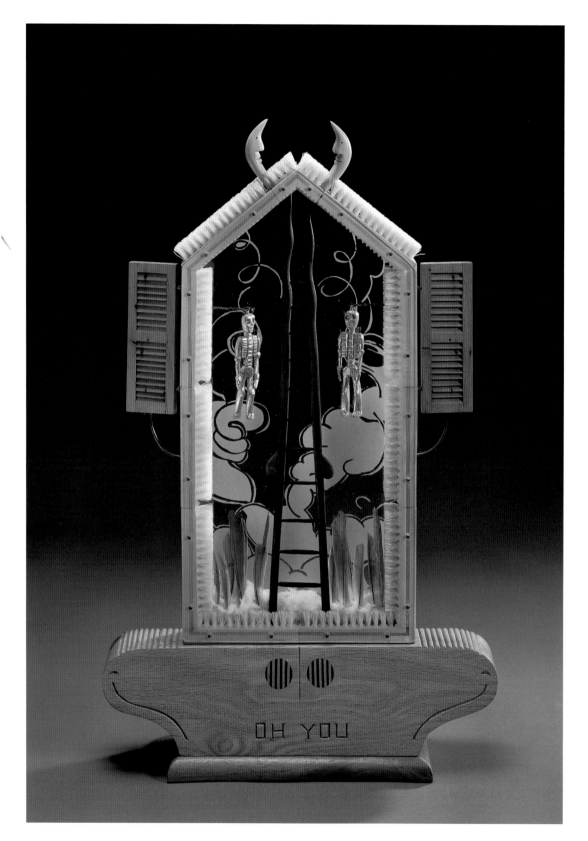

OH, YOU DEVIL

1991
Mixed materials
25 ¹/₂" x 16" x 5"

I can see it in your eyes
and the smoke from your
ladder!

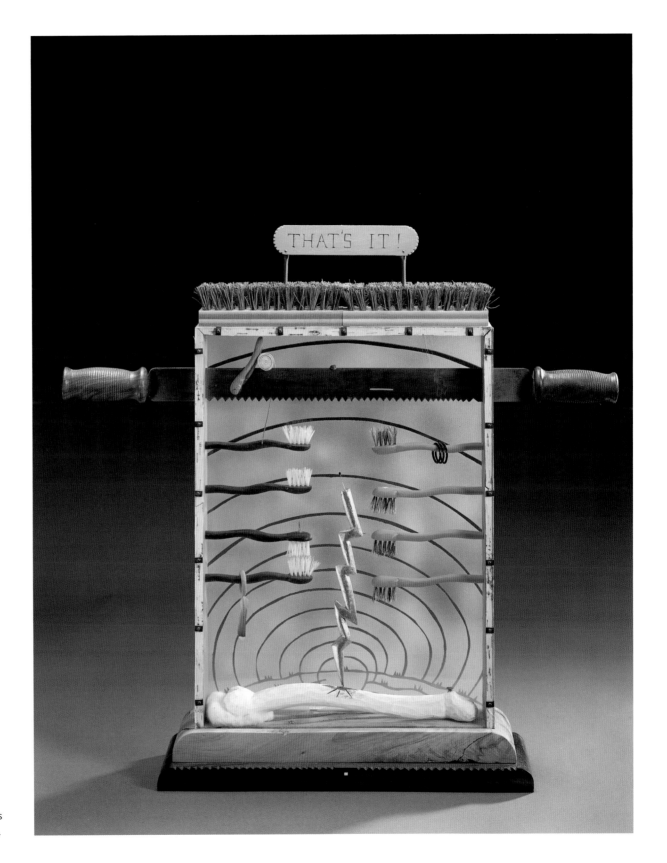

THAT'S IT

1991
Mixed materials
26" x 12" x 8"

When lightning strikes
your bones, ideas are as
handy as a scrub brush.

79

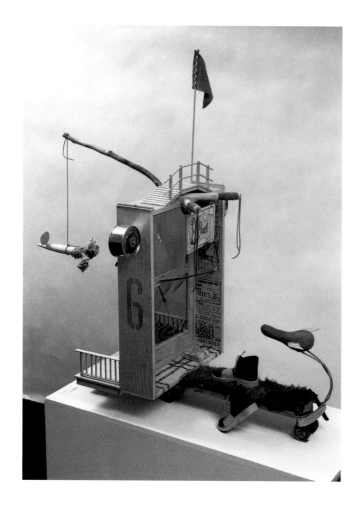

PINK PEARL

1974
Wood and found objects
30" x 26" x 16"

This is a cart of youthful nostalgia: screen doors, porches, orange crates, roller skates, green grass, and weeklong Saturdays.

TRUCKING OUR TROUBLES

1976
Wood, fur, feathers, fishhooks
30" x 16" x 8"

This work is from my New York show that dealt with puns, slang, and double en-ten-dre. With our many-wheeled vehicles we pedal our mysterious burdens until our legs tire.

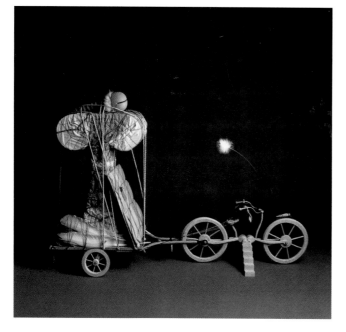

When walking home
I saw
Jimmy Davis
across the schoolyard
being pounced upon
by bullies
grabbing his bicycle
roping his handlebars
hoisting it
up the flagpole
letting it go
zoom
crash
Boys fun then run
Jimmy tears
from across the schoolyard
I continued on

RACE YOU
TO THE TOP

1995
Mixed woods, leather,
metal bell, marble
86" x 28" x 12"

As I was riding my bicycle
home from youth
fellowship, that evening's
song, "Jacob's Ladder,"
kept circling through my
mind with the imagery of
heaven and death. The
ride was the making of a
strange ladder to glory.

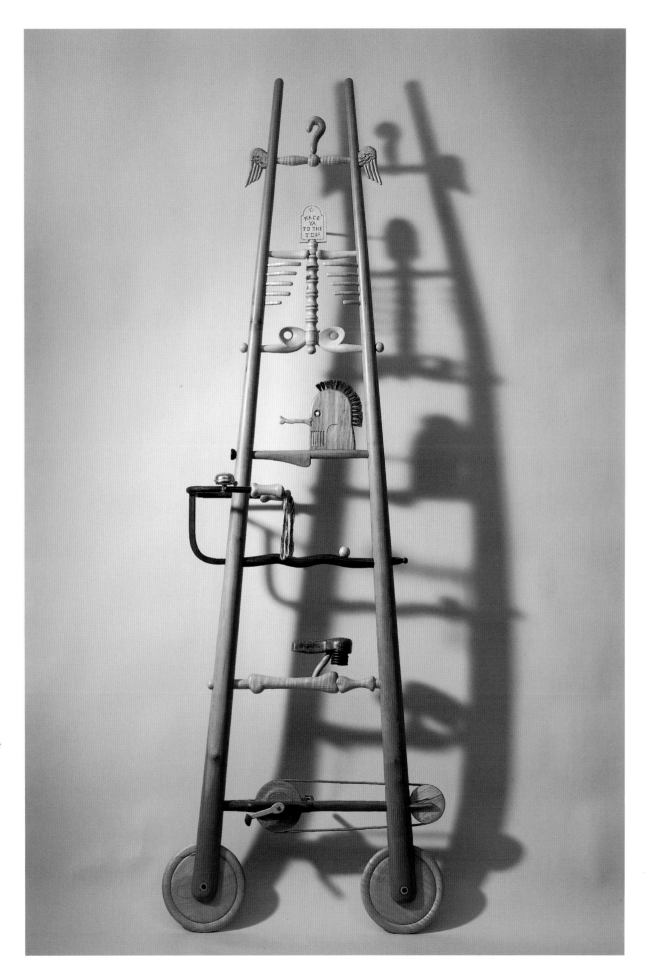

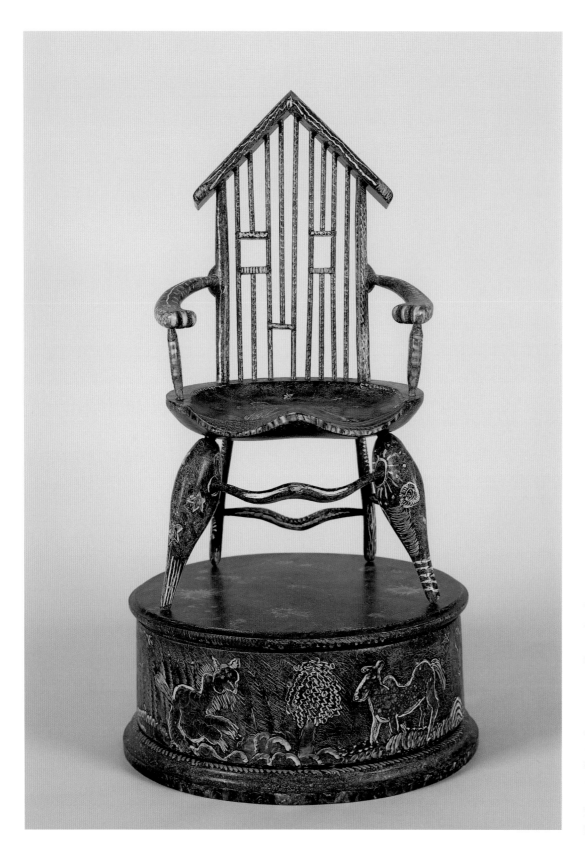

SEATED HOUSE

1996
Painted wood
24" x 12"

Be it sea
Be it land
Be it short or tall
rich or small
Be it town or glen
styled or blend
Be it a home
Be it unknown
you are the heart
you are the ALL

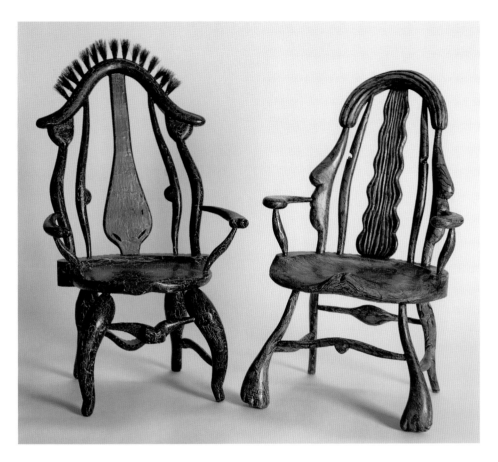

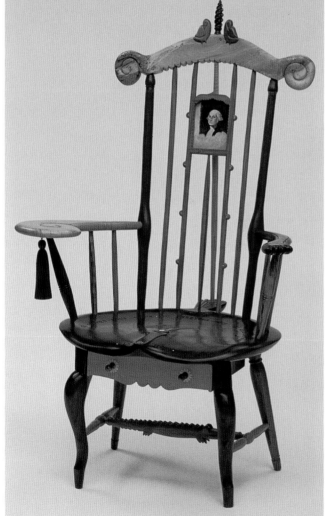

CHOCOLATIER
AND
WIND-SOAR

1997
Painted wooden chair
models
18" x 12" x 10"

Chocolatier — Lord
Godiva's taxing sit-u-
ation made a sweet seat
for his lady!

Wind-soar — The back of
the chair is a portrait of a
lady blowing life into the
arms of her Windsor.

BOSTON THRONE
CHAIR

1989
Mixed woods and
gouache paint
50" x 32 3/8" x 24 3/4"

All the motifs on this
chair were found on
various artworks at the
Museum of Fine Arts,
Boston. For example, a
carved maxim on the seat
says, "Ou sommes-nous
assis, ou asseyons-nous,
ou assierons-nous." This
title is adapted from one
of Paul Gauguin's South
Pacific paintings. It
states, "Where did we sit?
Where are we sitting?
Where will we sit?"

One gray December morning near Christmas, I lay under my bed covers coughing, headachy, and with all the necessary aches for a caring mother's protective instincts to click in. Without missing a beat, she made a call to the school nurse. "Tommy won't be in today." I was home FREE! This excitement lasted about fifteen minutes, until all variety of pills arrived bedside, with talk of Dad giving me a booster shot when he got home. This threat of a cure quickly put me on the path to good health. As I awoke about noon, in came Mother with a bowl of beef bouillon. But, but — no buts! Eat! By midafternoon I was stuck in bed, feeling much better and getting hungry. My main grief now was that I could only read a book or sleep; no food — house rules. These options seemed like no choices at all. Then, while I was lying in bed half awake, the word FUDGE, in large sugary letters, came into view. Yes, most definitely, FUDGE was the word. Wait. Mother would soon leave for her afternoon errands. As the door closed behind her, I hopped out of bed, threw on a robe, dashed downstairs. I grabbed the kitchen stool, pushed it up to one of the cabinets. Where's the cocoa box with the fudge recipe? Good! I gathered together all the ingredients, dumped them into the largest saucepan I could find. I needed the big pot, for my miscalculations ballooned the recipe to double size. The stool was now pushed to the stove, and "pot in hand," I turned on the heat.

After the desired amount of cooking, I found a large, flat cake pan, and into it I poured the silky, dark chocolate, making a glistening lake of fudge. Since I was doing all this on the sly, I quickly cleared a space in the refrigerator for the pan. After a half hour passed, I returned with cutting knife. It hadn't cooled off yet. So I slid the stool over in front of the fridge so I could open the top freezer. I placed the pan on the highest open space, above the boxes of frozen corn and peas. This time I gave the fudge an impatient hour to set up. I returned with confidence, licking my lips. I jumped up on the stool, swung open the freezer door, reached up as high as I could with both my hands. I eagerly tipped the pan. The next thing I knew, my hair and face were covered with a sticky, ice-cold, flowing river of chocolate. It ran into my ears, down my neck, into my pajamas, down into my pants, down my legs, pooling in my slippers and a final puddling on the floor.

Oh, fudge!!

In a life of making art for a living, there has been many a sweet dilemma.

TOUCH TILL
TOUCH FILL

1982
Mixed woods
40" x 36" x 27"

Some adventures last
because they rock back
and forth in time.

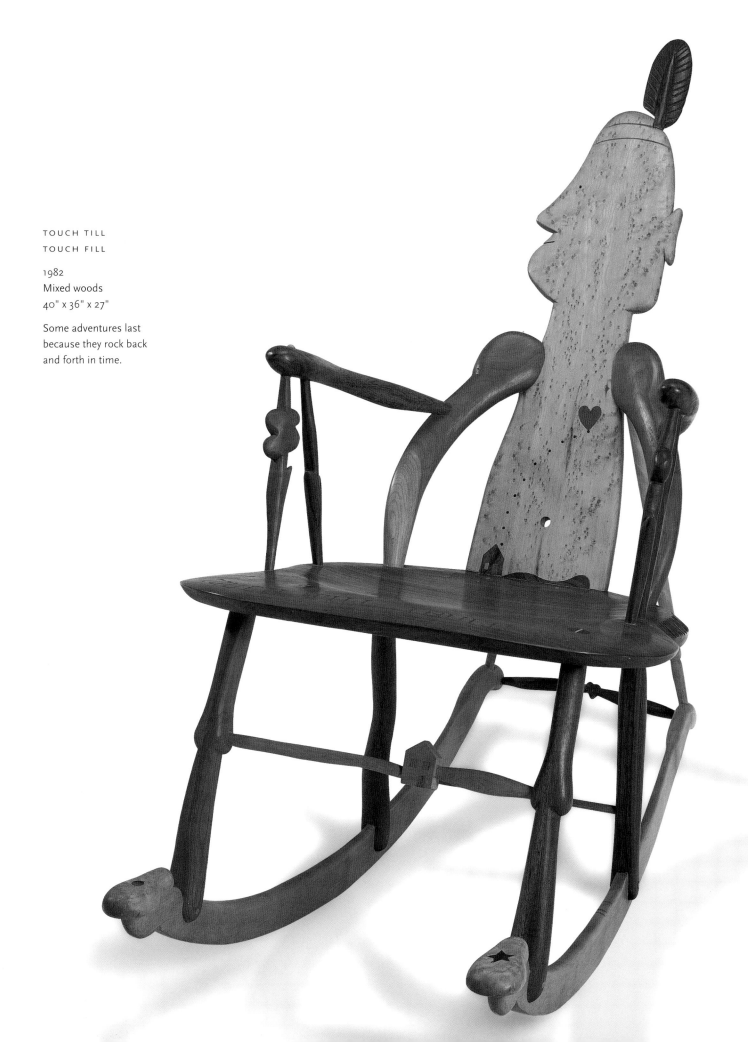

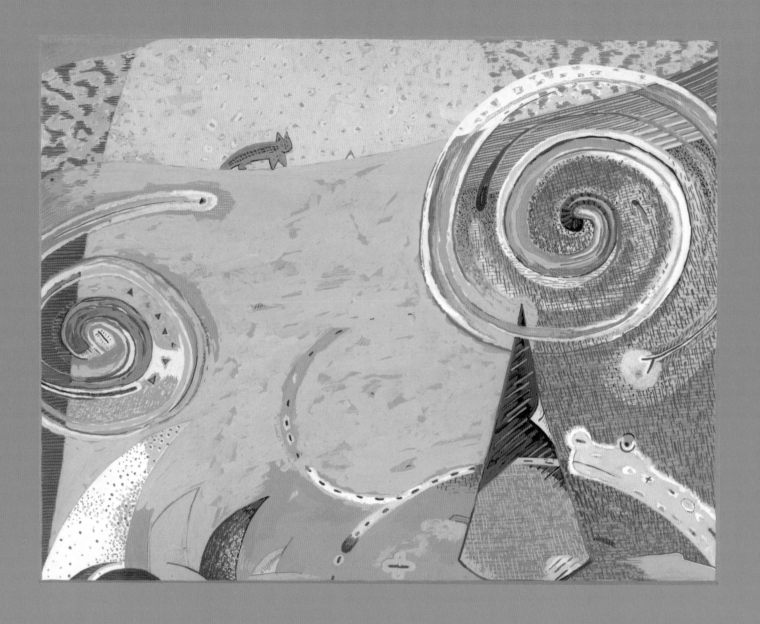

The blue of the day
 is a balmy soft time
 that bumps and nudges
 rolls you over in the wind
 floats you holds you
 in the full-ample kindness of mother nature
 gently opening our imagination
 to all ways
 w h o o o o o o s h

physical listening
group task
cause & effect
abandon earth
activity

mechanics parts

objects function

POINTING
THE WAY

afternoon

hands creation
focus alive
intuitiveness
fun instinctive
enjoyment
toward
vocabulary
engineering
fragrant

That wonderful life force called a flower has been in existence for a very long time, long before I made my modest entrance into a small corner of the world. As my budding years took hold, I gave little notice to these glorious, heavenly creatures. But in spite of my unawareness, I was being imprinted by their presence, by their charms, by their images, thanks to my mother, grandmother, and two great aunts. They were the curators of my enlightenment. My education wasn't achieved with a hickory stick. Oh, no! My teachers were much more insidious, applying sweet treats, affection, delight, concern, adventure, and those devilish curiosities from everyday life. The "ladies" of the task saw to it that I painted pictures of daisies, gathered peonies, ate nasturtiums, smelled roses, and cared for irises. They were relentless! Not until years later did I realize that the essence of floral beings had been forever cast into my bones.

During those growing years, I fell in love with blossoms, with their endless variations and continual renewal. The floral imagery in my work has come to represent nature's feminine force, an embodiment of my four graces. I will be forever grateful for their soft hands on my heart, their way of showing me the wonders of flowers. And for my surprise discovery — the gentle magnificence of my family guides.

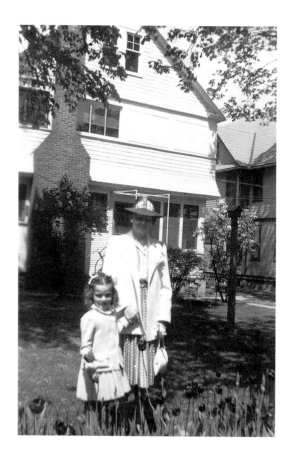

MUNA AND COUSIN CAROL, 1940S

Muna's backyard — tulip and iris patch, lilac bushes, birdhouse on clothesline post, second-floor sleeping porch, third-floor attic windows. A snap of the past.

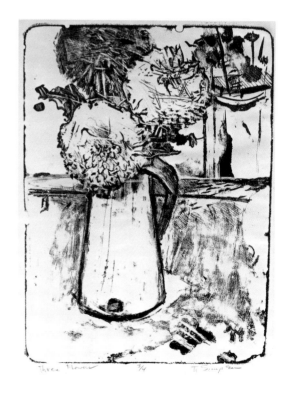

THREE FLOWERS

1962
Lithograph from stone on Arches paper
16" x 12"

Still captured by flowers!

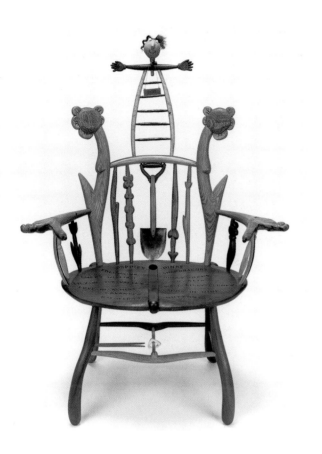

GARDENER'S CHAIR

1985
Mixed woods, leather, metal
32" x 26" x 45"

The chair is an homage to
Linnaeus (1707–1778), who
created a system of binomial
nomenclature for plants.

WOBBLY WOCKER

1982
Natural and painted wood
72" x 36" x 40"

There is a farm scene painted
on the seat of this three-
person rocker. The flower arms
are something to hold on to as
life rocks us back
and forth.

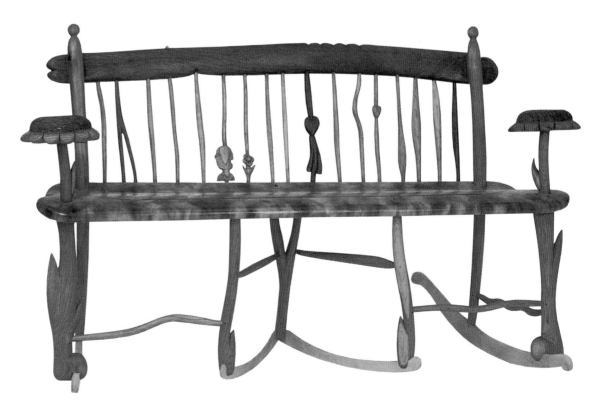

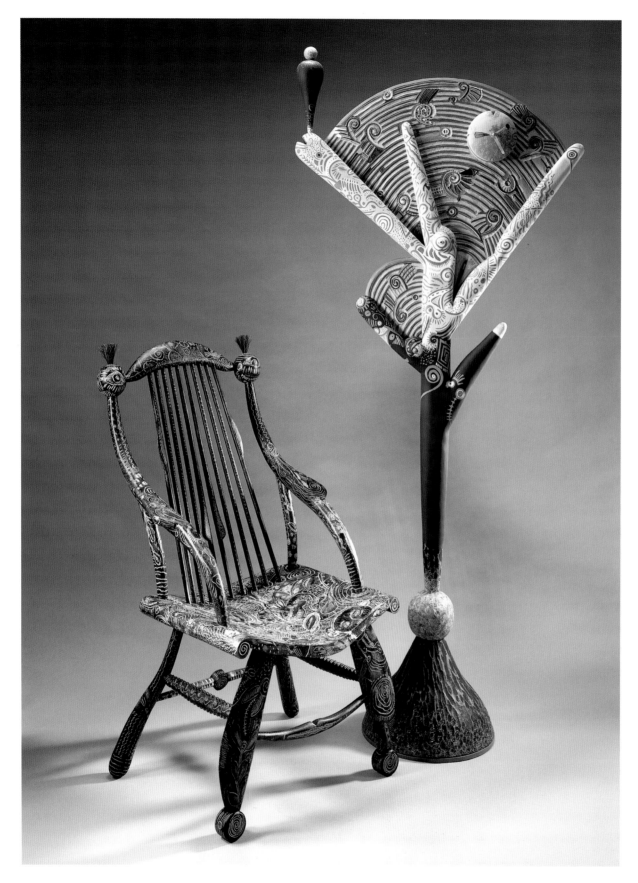

SEAT OF STORIES

1996
Painted wood
44" x 25" x 28"

Stories must come from somewhere; if you sit here you're bound to find one.

HAWAIIAN TREE FAN

1996
Painted and carved tall clock
78" x 34" x 16"

When I was eighteen years old I worked construction in the hills of Hawaii, a lush, tattooed memory.

OPPOSITE:
COSMIC GARDEN

1994
Painted wood with glass
42" diameter x 20"

With meteors crashing into the planet Jupiter, it wasn't long before the curtain went up on the galaxy's newest SMASH HIT!

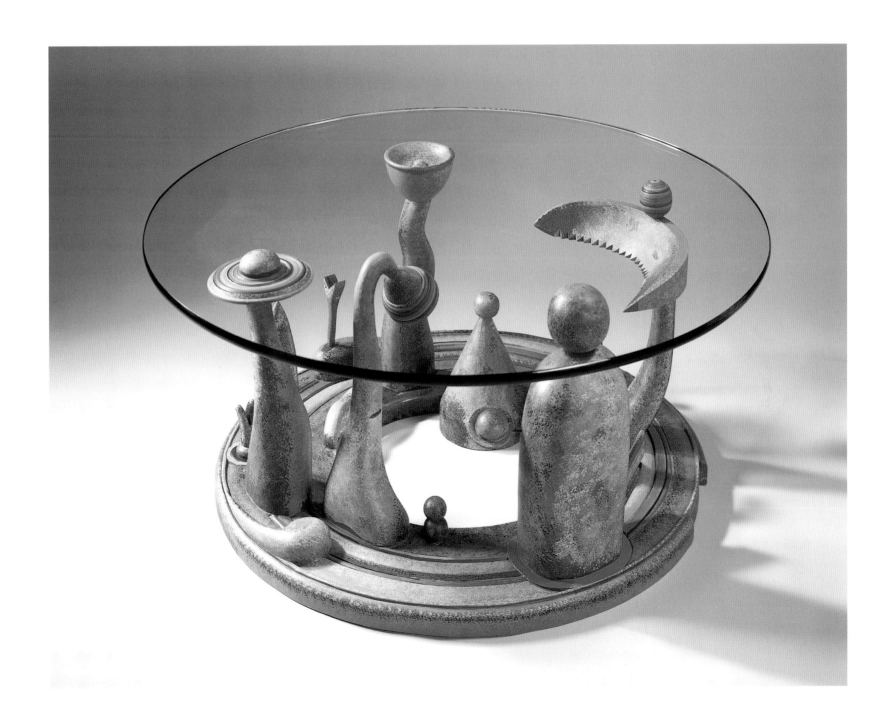

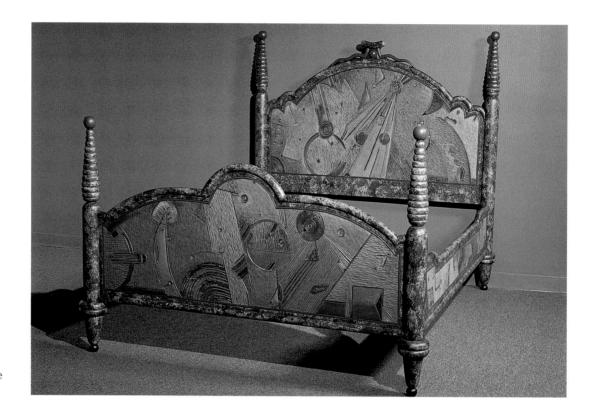

BUZZING BED

1993
Painted wooden bed
62 ¹/₂" x 67 ¹/₂" x 88"

When the bees are
buzzing, this is the place
for you.

TREE DESK

1974
Painted wood
66" x 45" x 20"

I photographed this piece
in the backyard, with
natural sunlight and a
borrowed camera. The
cupboard was bare and
life was close on my
heels. Making a living
from my artwork was like
"pushing a rope up a hill
backward."

OPPOSITE:
ADOBE DOMUS

1992
Painted wooden bed
67" x 64" x 84"

*Hot sun
blue sky
and rivers of delight
makes a home for
the earth*

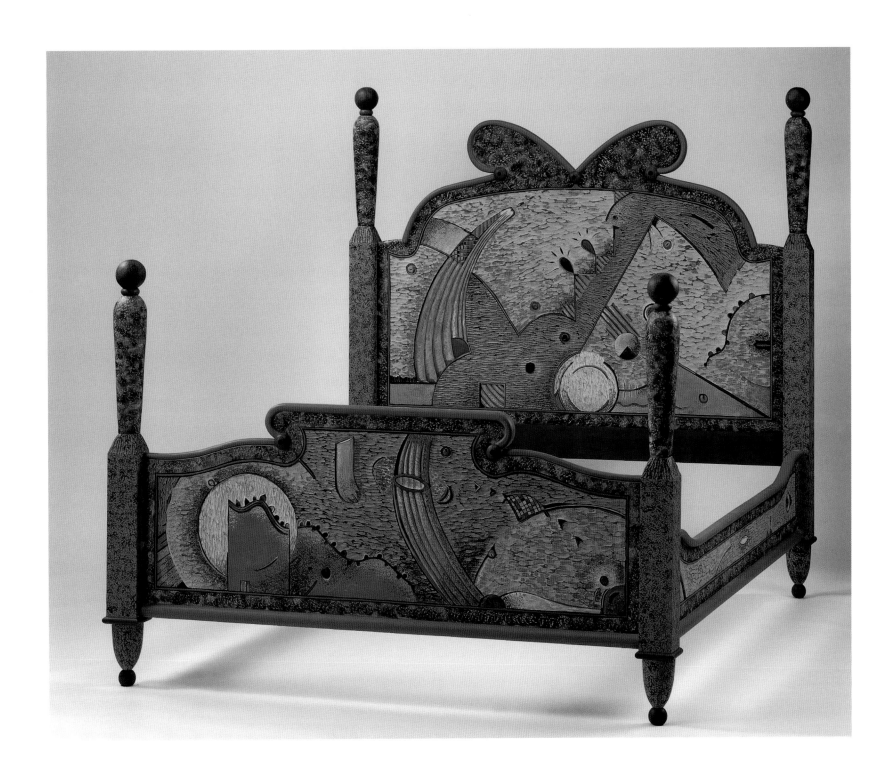

Box elder trees make great locations for tree houses

if you can ignore the insects common to them. The tree behind our home supported our tree house, which was large. It even had a roof and a knotted rope that dangled from the trapdoor. All it needed was something special. Jerry's folks had an oriental rug rolled up on their porch. Using a wagon, we hauled the rug twenty blocks to our tree house, where we used a knife and carpet tacks to make a cozy interior lining — our "coup de grass."

Since then, every time I see a box elder bug I look over my shoulder for Jerry's parents.

SNOW GARDEN

1997
Painted wood cabinet
76" x 30" x 17"

Once time was upon opening
a full fall gathering of flakes
* coming down to bushel basket the cold nose day*
between its handles bent
Then, waiting to be lifted silently white and melting
Came the snow
* Came the snow*

It was cold, with a mist in the air.

It was an away game in Wheaton.

That night we greased our forearms and calves with "red hot," an analgesic balm, to keep our toes and fingers warm. During the second quarter, a hand grabbed my face mask, and my nose started to bleed. To the bench for a wet towel, a quick wipe, and back to the football game. We lost!

While I was taking a shower, the guys told me I had a split in the center of my schnozzle — unbeknownst to all until then, a fingernail had gashed my nose. Luckily, my father had come to this game. He was contacted and met me in the locker room. No school bus ride home this time — that night Dad drove me to his office. He sewed me up with twenty tiny stitches, telling me, "It won't hurt," as I gripped the chair, "Just one stitch more," which seemed to go on forever. Done! Later the threads were removed, and a fine job it was.

I remember the intimacy the most — a father repairing his son. His education and experience gave me restoration in a very personal way. I can still see his handiwork in the mirror every morning.

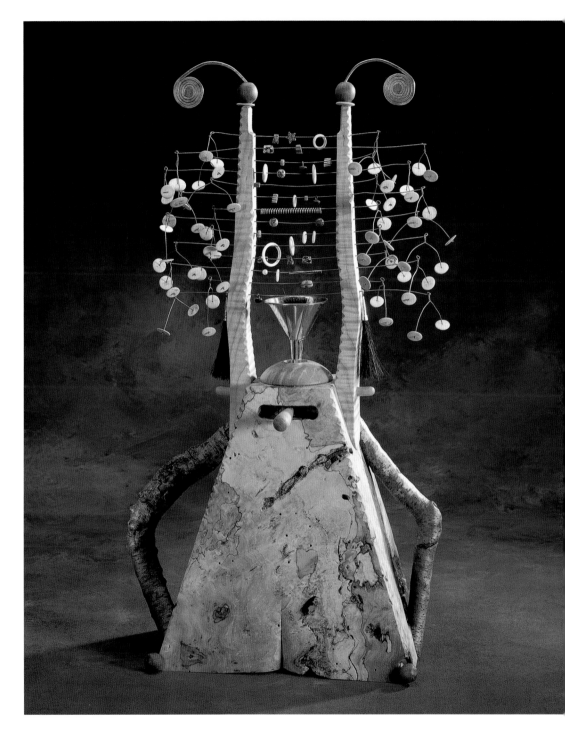

LIGHTS UP

1995
Mixed materials, wood, turquoise, coconut buttons
23 $^1/_2$" x 14" x 5 $^1/_2$"

When your face shines it funnels light all through you.

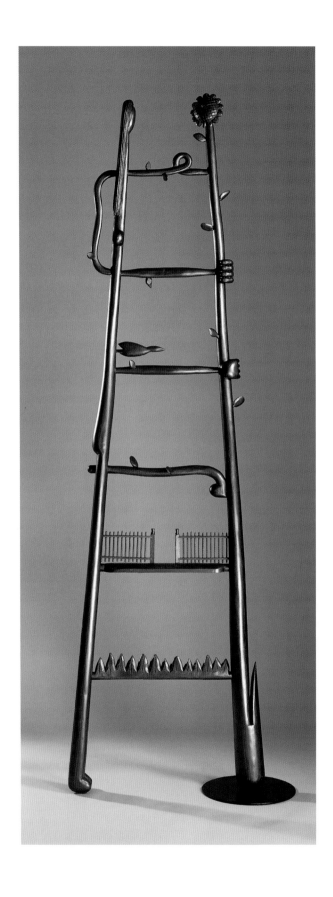

While walking by the lumberyard a few blocks from the river on a hot Saturday afternoon, I heard loud scuffling and cussing coming from behind a huge stack of boards. As I stepped around the corner of the main shed to investigate, I saw three older boys pulling the pants off a small kid. The boy was my age. He was pissed, humiliated, and scared — all at the same time. Once the deed was done, the boys laughed as they ran off. I was frightened and heavyhearted. I climbed a ladder to the second-story gangway and walked over to where they had thrown his pants. *RETRIEVED*. The boy put them on — his face said it all. I would be happy never to see that expression again. I was caught unprepared. I was totally flummoxed. Bravery or prudence? Action or passivity? Or was the right reaction perception, concern, understanding? What was needed? My young age had not known what to do. I knew I didn't want to end up a kid-sized victim, nor did I want to be a source of pain and misery. My thought of *"Just make it end"* was the order of the day. This incident was like a flash card held in my face — *"This is not for you. You don't live here!"* This sign, strangely, may have worked on my subconscious, directing me toward other choices, another world, a place where I have a say. A cruel deed like this seemed somehow to give me permission to seek my own nature.

LEFT:
SHADOWS IN BLOOM

1997
Graphite painted wooden ladder
85" x 24" x 4"

As Leda had her swan, lady darkness has night, planting her bed with vines.

OPPOSITE:
KNIT ONE, PEARL TWO

1984
Wood, metal, fabric, knitted mitten
40" x 28" x 9"

This is an "ash-can school" crucifixion scene, with a mitten and two pairs of long johns hung out to dry. The resurrection shovels and the hand of God are pleasant reminders of medieval religious paintings.

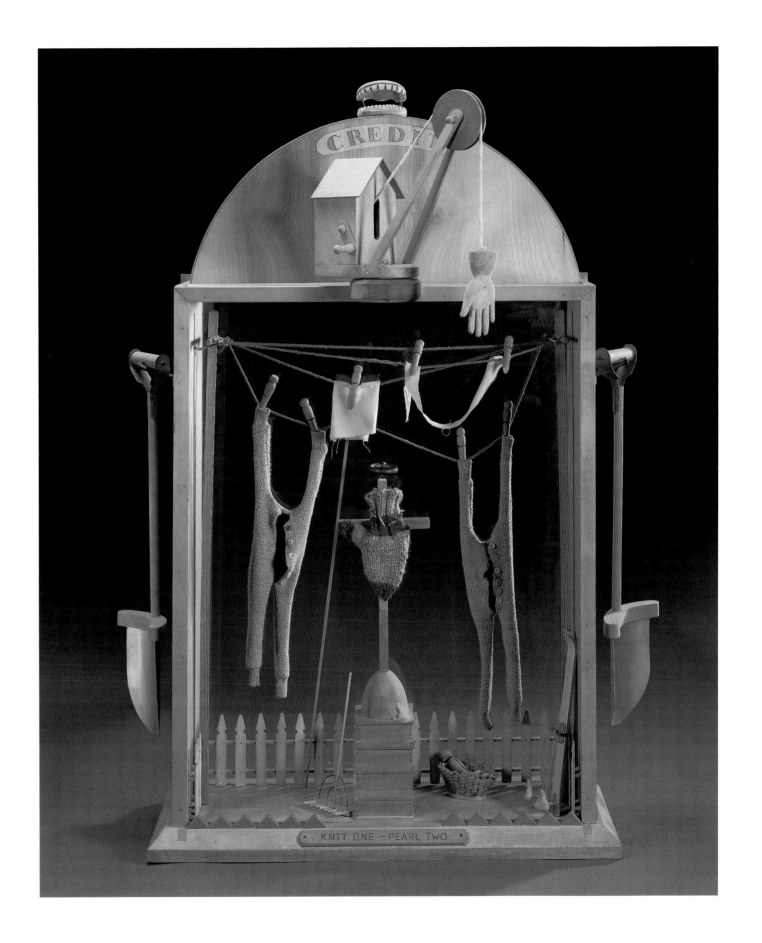

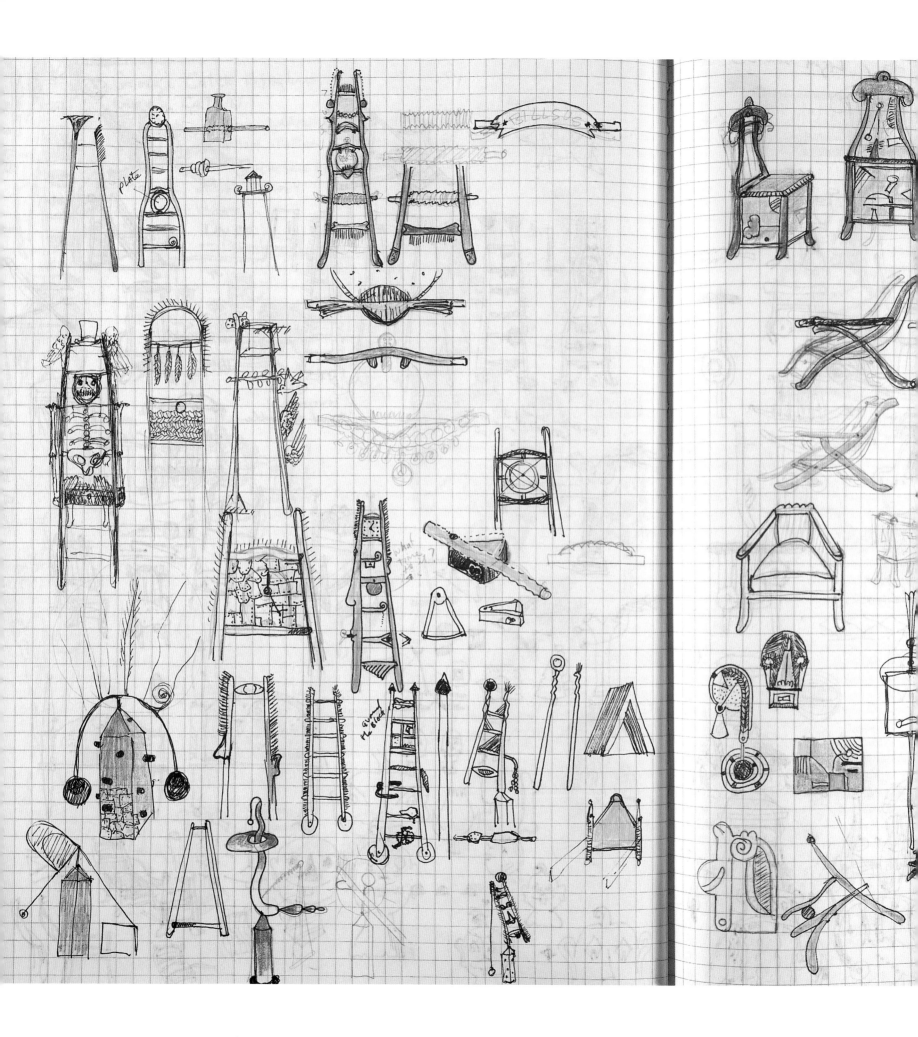

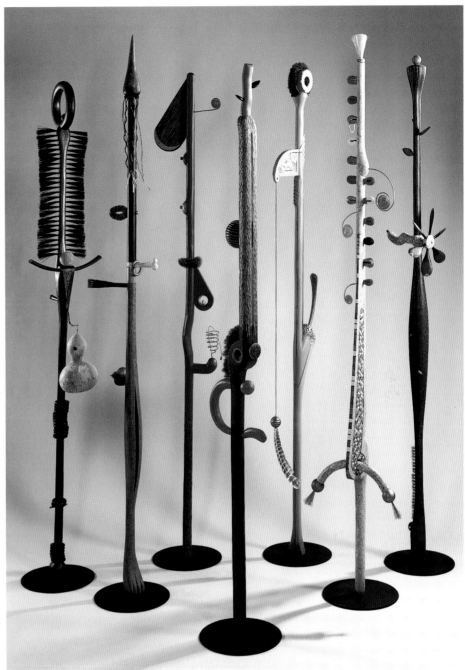

TOTEMS

1997
Mixed media
84" x 12" x 12"

Staffs for a new tribe.

SHOE BOX

1986
Mixed media
16" x 18" x 6"

One of a pair of road-traveled shoes.

CHARMED HEIGHTS

1993
Mixed media
25" x 10" x 5"

Many mixed messages.

HORSE HANGER

1995
Mixed media
20" x 12" x 5"

A toy sea horse hanger.

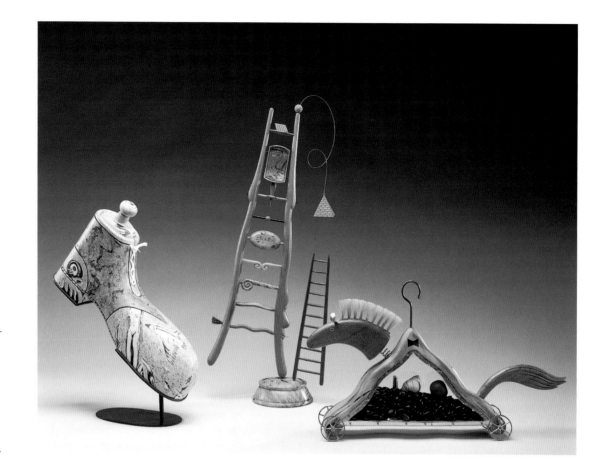

TWISTED ARROW

1995
Mixed media
24 1/4" x 15" x 8 3/4"

Based on early Christian imagery: example, the fish, the cross.

TRUCKING YOUR STUFF

1995
Mixed media
21" x 24" x 4"

Strutting coat hanger.

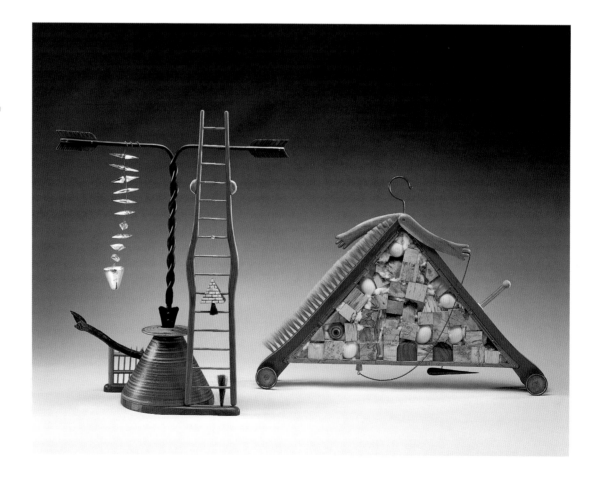

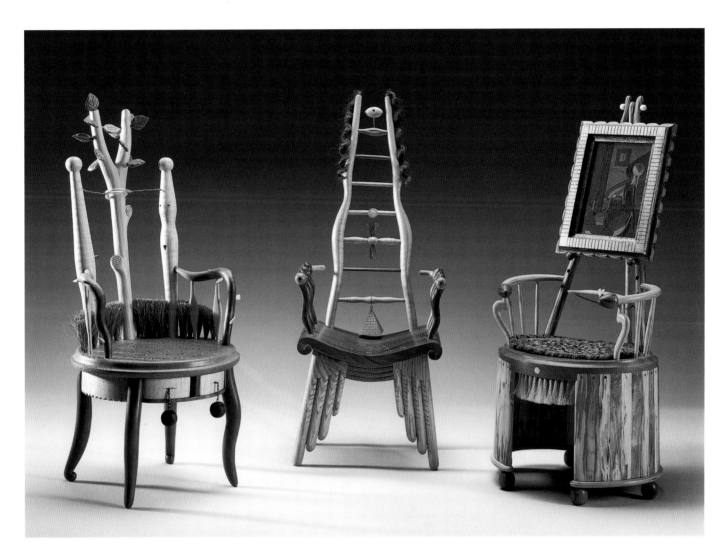

ADAM AND EVE

1993
Mixed woods, brushes
24" x 11" x 5¹/₂"

New plantings need
staking out.

CLEOPATRA

1993
Mixed woods, hair
23¹/₂" x 11" x 9¹/₂"

A tempting ladder
to climb.

WHISTLER'S MOTHER

1993
Mixed woods, brushes,
braided rug
24" x 11" x 9¹/₂"

A parlor chair arranged in
black and gray.

Sunday school was in the basement of the church,

and this week we were celebrating Beverly's birthday. The thought of this event brought some relief from the stiff collar cutting into my neck and those polished shoes pinching my little toes. At the end of the service the children went down to the lower level to sit on metal chairs. Once we were seated, our teacher disappeared behind a heavy curtain and then reappeared with a huge, white, three-layered apparition — a cake with a halo of glowing gold candles. We all sang "Happy Birthday" to Beverly. When we finished singing I silently moved forward from the last row for the long-awaited deliverance, the sweet cleansing. But, as I approached the cake, I found it to be made of plaster — one designed to last through the Rock of Ages. As I walked the two "sore-foot" blocks home, I knew this hardening experience was telling me something. Perhaps a lesson? Perhaps a parable? I kept hearing voices that said,

> To wear starched shirts, you flirt with danger.
> Things that last may not satisfy the present.
> Asking for deliverance begs surprises.
> Expectation doesn't always cut the cake.
> But as much as I try, the voices remain
> bringing forth question upon question
> with no replies.

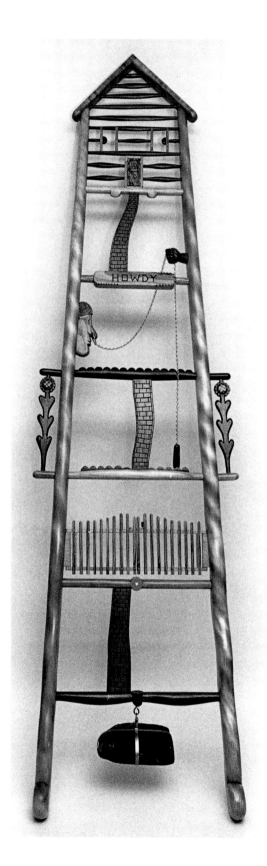

DOWN THE GARDEN PATH

1988
Mixed woods, stone, metal chain
86" x 24" x 4"

Each path has its nose rings with an accompanying chain. This walk gives you a pleasant view and a paved path before you knock on the door. Good luck.

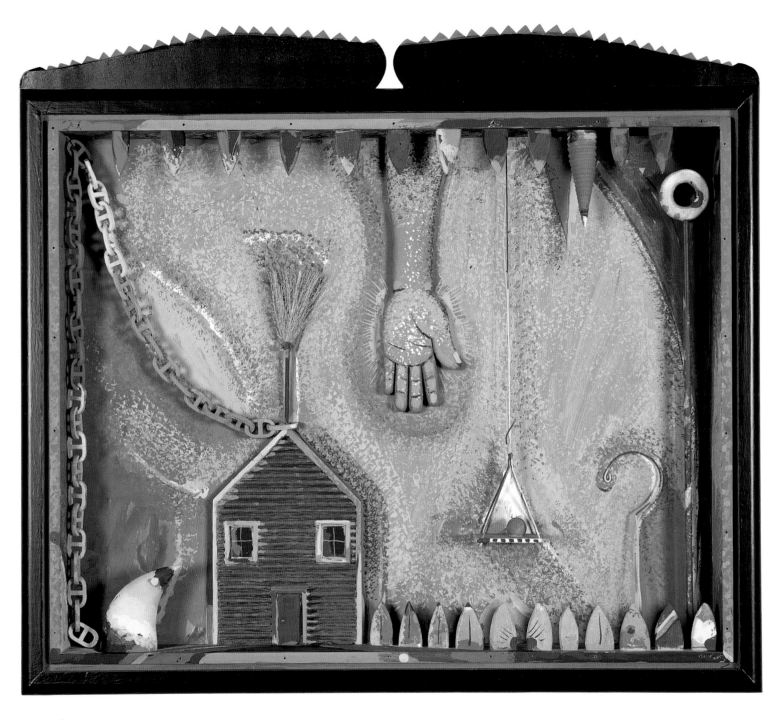

SAILOR'S ANCHOR

1989
Painted wooden box
30" x 26" x 3"

I hear Jonah had a red clapboard house
on the coast of Maine near Portland.

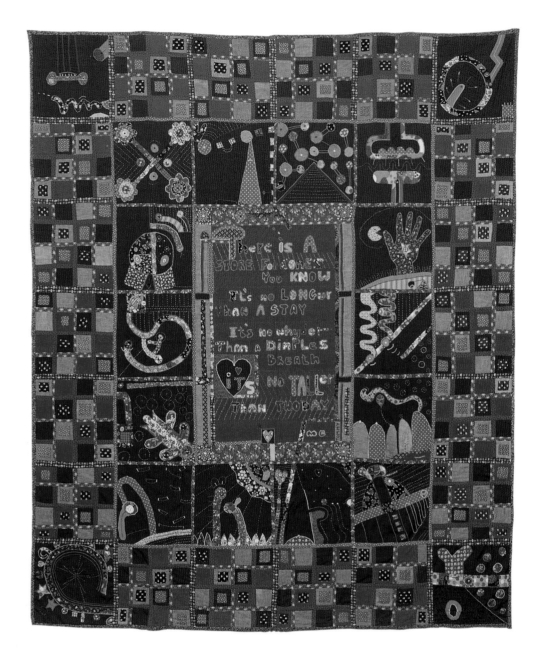

COMFORTER

1972
Cotton quilt
69" x 80"

I always liked things that kept me warm.

There is a store for comes you know
It's no longer than a stay
It's no whyder than a dimple's breath
It's no taller than two day

OPPOSITE:
ROMEO AND JULIET

1980
Painted wooden box, wire, steel wool
40" x 32" x 4"

(When arrows fly — love's on the wing.)

When our bodies are just between us
 The sea counts its drops
 Silken sounds finger the pure
 and words float the wind
Thoughts plump buttered breasts
 Starbells twinkle
 as limbs tighten two
Eyes sing of tender frails
 and our love touches
 between us
Are softer than a stay

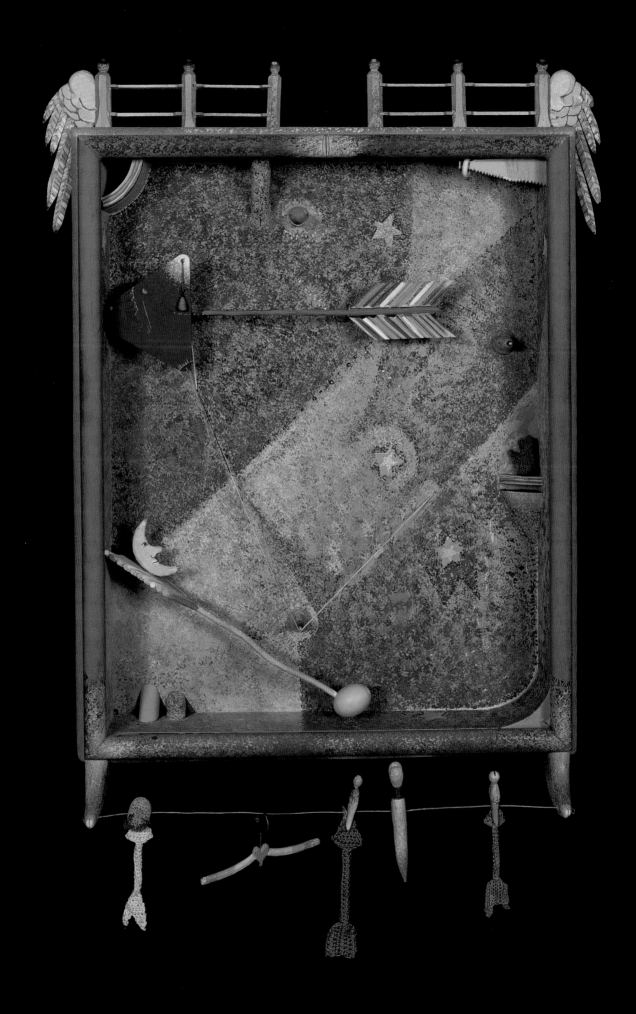

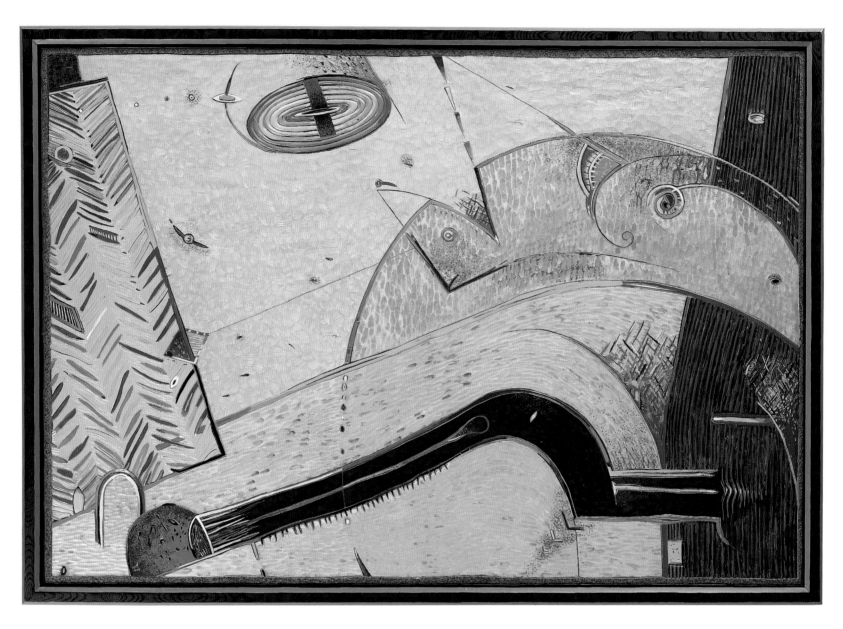

BROWN PATH — BLACK FOOT — AND FREE

1992
Carved and painted wooden panel
61" x 43"

Down in the canyons, the walls speak in millennium;
if only I could read their stories, what fun it would be.

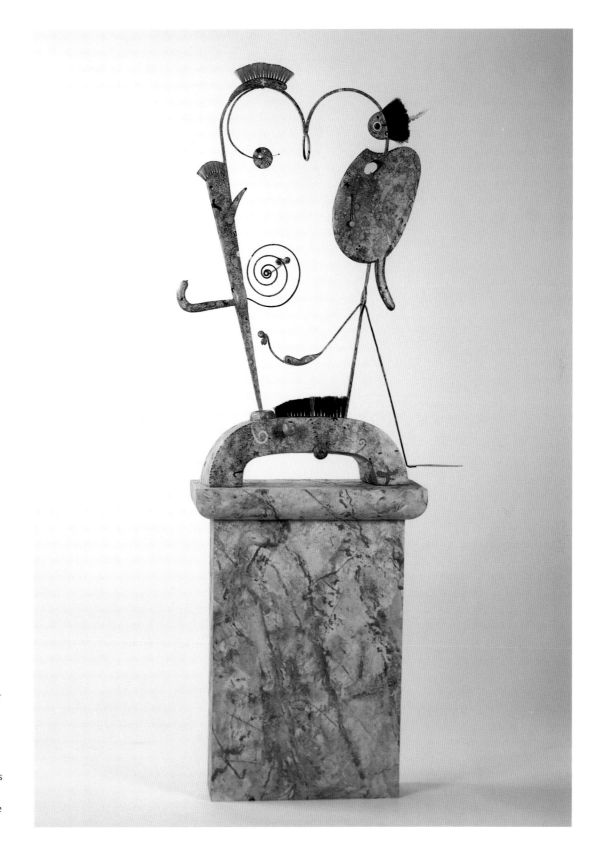

PLEIN AIR PORTRAIT

1996
Mixed media sculpture
82" x 34" x 11"

To those plein air artists
who juggle palettes on
their heads and balance
easels on their laps.

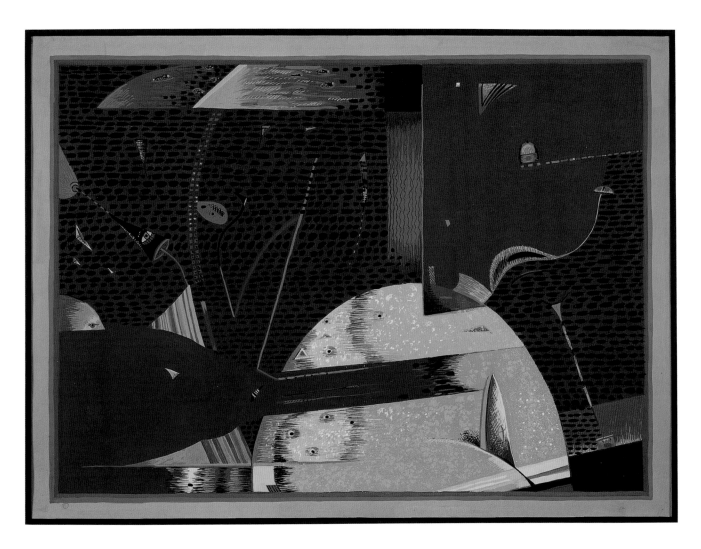

NIGHT DREAMS

1996
Gouache paint on paper
14 1/2" x 10 3/4"

When blown forth gathering openings pressed
 My warmward arms touch taste
 bringing heated currents
 to squeeze the edge
 and hold the presences till
Then loop rolling
 I dent the air
 arching over rounded corners
 sliding
 down
 until
 up sucked by the milk-seed dispersal

OPPOSITE:
A SPIT IN THE OCEAN

1992
Painted wooden box
21" x 22" x 3"

With full breath
 spreading outward bellowing glances
The opening tug-bends the ears
 to catch all corners by surprise
Then white sails out from the see-face
 sliding a course of rounds and fills
 holding forth its all-ways

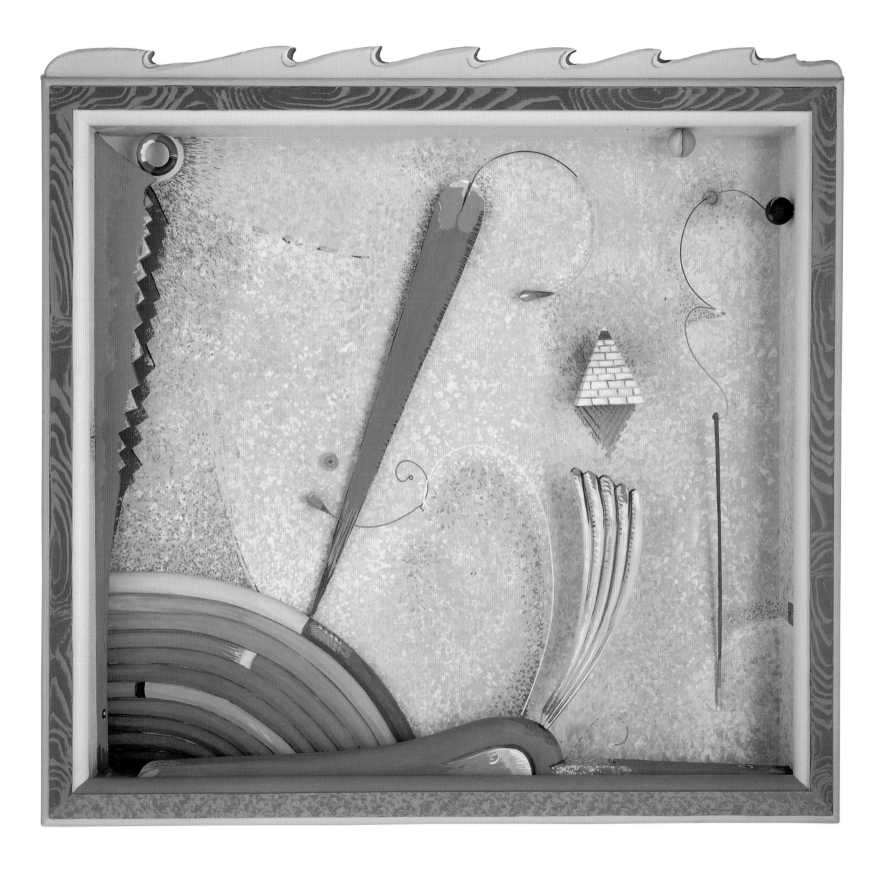

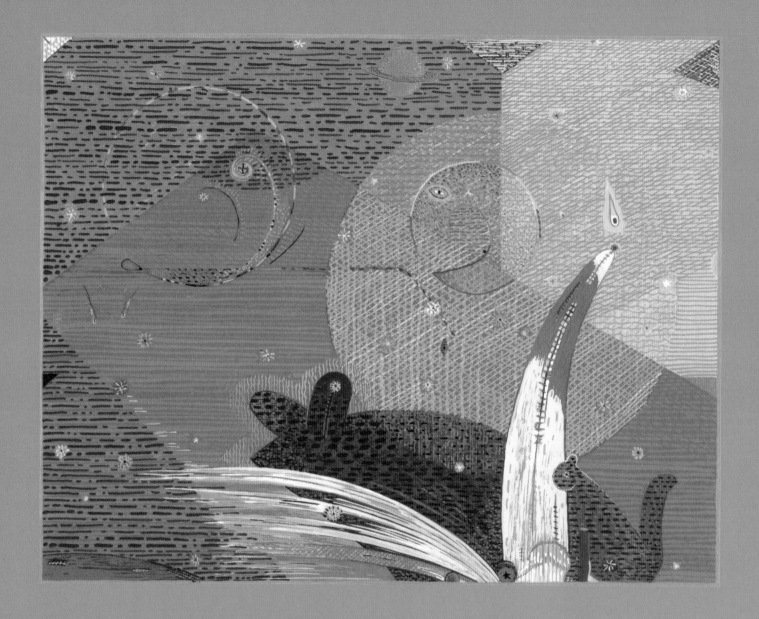

As twilight reveals her sweetness in shadowed form
 fresh worlds appear in the fields
 fireflies dance buttering the air
 enlighting kinder-pockets with dreams
racing hand and feet
 Open
 trying to capture the magic of stars
 before the word dinner!
 alters our vision-course

invention methodology
religion art mind-styled
organization skeleton
escape bones power
life cycle renewal

HARVEST

glory female male

twilight

playing field format
happening vista
nature design
character
anthropomorphic
value price nest work
security image
materials wealth stage
tools time support
oasis

VENUS

1989
Painted wood
74" x 16" x 16"

Classical Roman statuary has become a common friend to many art museums. For who could resist paying tribute to the goddess of love? Even if she has gotten a little plump.

SKETCHBOOK

1990s
Ink and colored pencils

Chairs, tables, and cabinets, oh, my! Chairs, tables, and cabinets, oh, my!

Six rows wide and five rows deep was my fifth-grade classroom.

Ignoring the windows on the left and the door on the right, I sat in anxious anticipation of that *pink, sugar-frosted, heart-shaped Valentine's Day cake*. Our classmate Carol K. had volunteered by way of a generous spirit to bake this *"montagne du cœur"* for the fourteenth of February's exchange of Valentine cards. This tower of toothache sat on the teacher's desk, as fetching as any Delilah's fruit. It only took a short time before we were all properly tempted and it was cut and passed around on six-inch plates, including the piece a few of us brought to the principal's office. It didn't take long to hear *cough cough, gag gag, spit spit* — whatever it took to get that cake out of their mouths — coming from our classroom. *What the *!#@!* Carol's brother had substituted some salt for sugar!!

Meanwhile, back in the office next door, Principal Sutfin graciously accepted his Greek gift, bit, chewed, and swallowed without a smidgen of expression. He then gave his "thank-yous" and returned to work.

Well, upon our return to our classroom we saw scattered platefuls of half-eaten cake — the look of disaster was everywhere. I must say that due to these revelations, my admiration for our undaunted principal increased considerably. I took this display of courage under fire as a sign of what it must take to qualify for and maintain some stations in life, and thought it prudent to be on my best behavior for the rest of the school year.

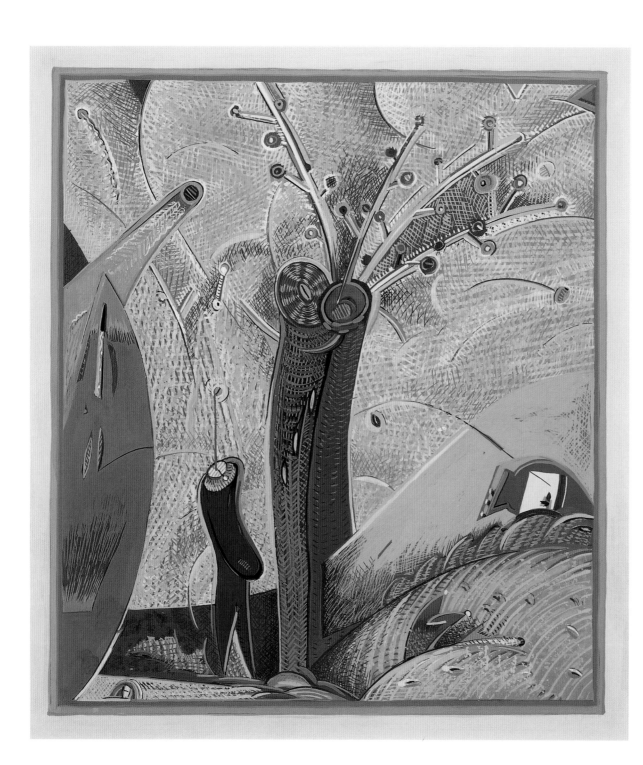

CLOSE KISS

1996
Gouache paint on paper
10" x 9"

Close-kiss
beckons round moons
to give up their secrets
and feather the sky
with wilds and wonders

OPPOSITE:
ON THE SOFT SIDE
OF THE MOON

1996
Carved and painted wooden panel
50" x 50"

There was a time
when the dust from stars settled softly
behind the heart
on the down side of the moon
There my amber grew smooth
melted my time with yours
cast our history
and storied our pushes and pulls
This was a place where
matters quiet
traversed walled stones
caressed fire and salt
and licked wonder behind the ears
So do I now look
to the vast
to the open
for that dawn of time
when the powder from planets
hearted my dreams

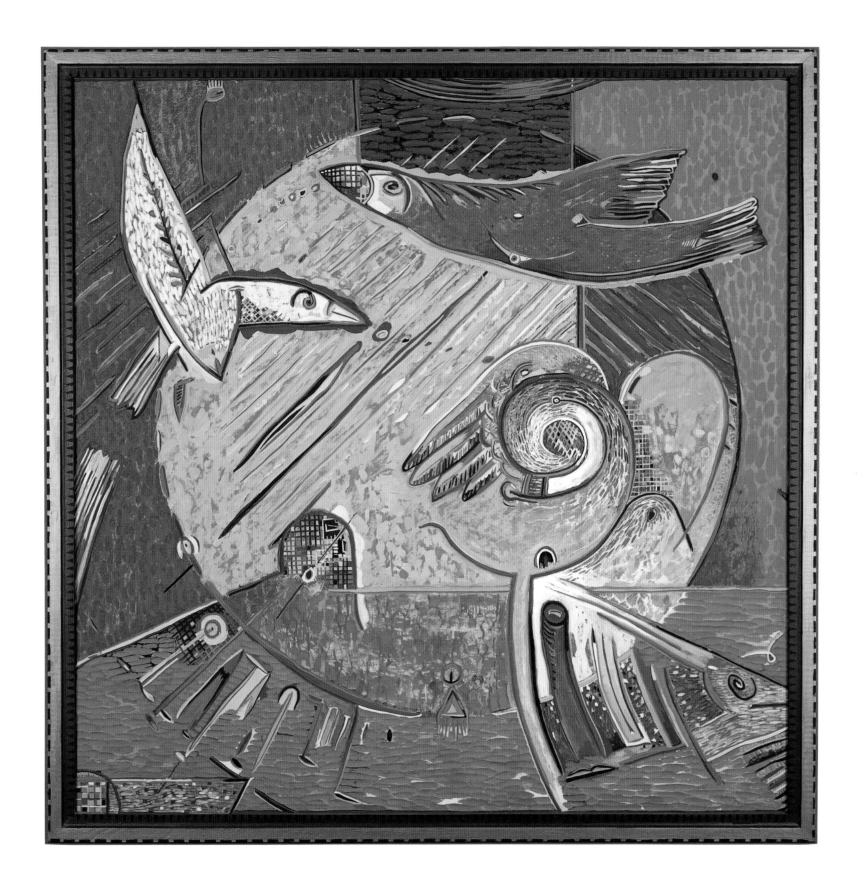

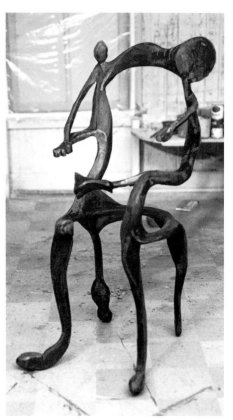

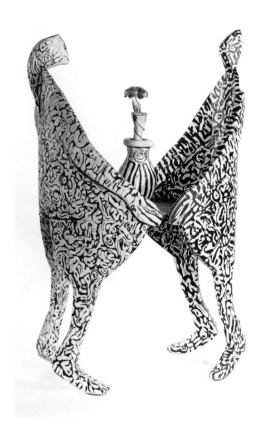

TWO BLUE

1965
Painted and carved wood
36" x 20" x 18"

Two people walking with
their arms around each
other.

From the top to the bottom
From the left to the right
From the past to the future
and out of sight
To the opening of a door
To the in to the out
back and forth
round about
Say it be from now to then
only once around again
I'll see but one
in this world round
that gives but life
to up and down

I am fresh out of graduate school,
preparing for my first New York show.

ABOVE, RIGHT:
LAURA DAVIDSON SEARS
MUSEUM, 1965

My first job as an "artist in
residence," my first frustrations as a
teacher. It only lasted a year; I didn't
teach for another four years.

TWO PEOPLE CARING THEIR
SEX AROUND

1968
Painted wooden table
62" x 48" x 24"

If you twist the flower in the vase, a
music box plays the tune "High Lily,
High Lily, High Low."

SLOP HILL STUDIO, 1967

RIGHT: A sketch in time saves nine.

FAR RIGHT: This photo was taken for my *Fantasy Furniture* book (Reinhold, 1968).

BELOW:
LBJ

1966
Painted wooden floor lamp
70" x 40" x 28"

This piece was made for a show in Chicago about President Johnson. The lamp illuminated the stars-and-stripes landscape as well as the presidential ears and nose of LBJ.

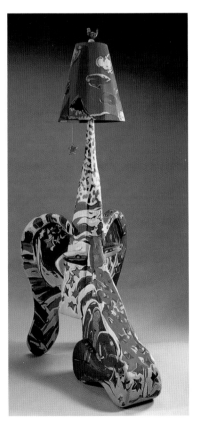

RIGHT:
REALLY BIG SHOE

1983
Wood and metal

The shoe industry gave in-house awards to the best stores and advertising. This is a trophy they asked me to make for such an occasion. I sure needed the money!

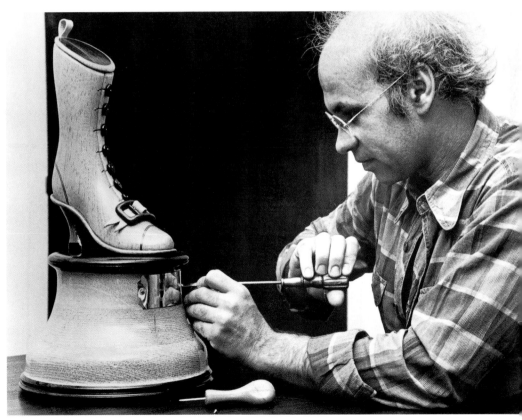

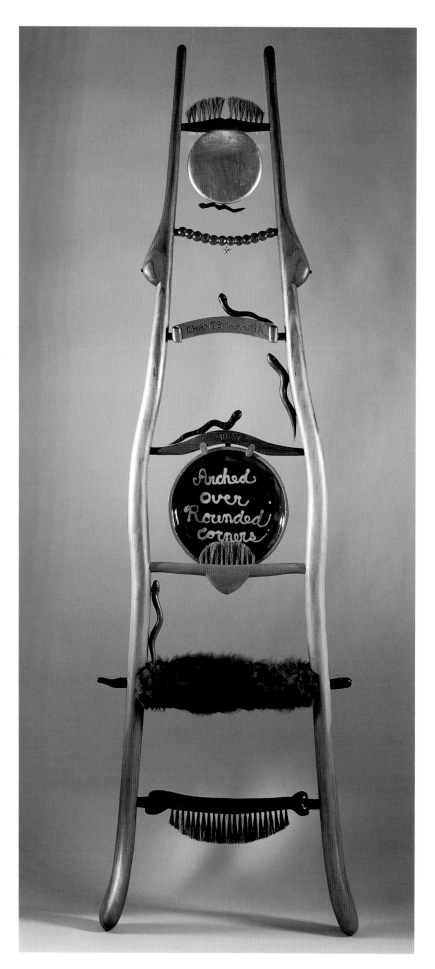

THE SNAKE CHARMER

1993
Natural wood and porcelain
84" x 29" x 5"

The French painter Henri Rousseau painted *The Snake Charmer*, now in the Louvre, in 1907. This mysterious, sensual canvas gave rise to a Tommy interpretation. A female ladder with a moon face and close brushes with snakes. The saying on the ladder is "Time chants warmth when arched over rounded corners."

OPPOSITE:
MIRÓ AS A COURTESAN

1993
Painted wood, zinc, wrought iron
32" x 26" x 6"

I made this portrait using colors, shapes, and spaces that seemed prevalent in Miró's work, and what a beauty he was.

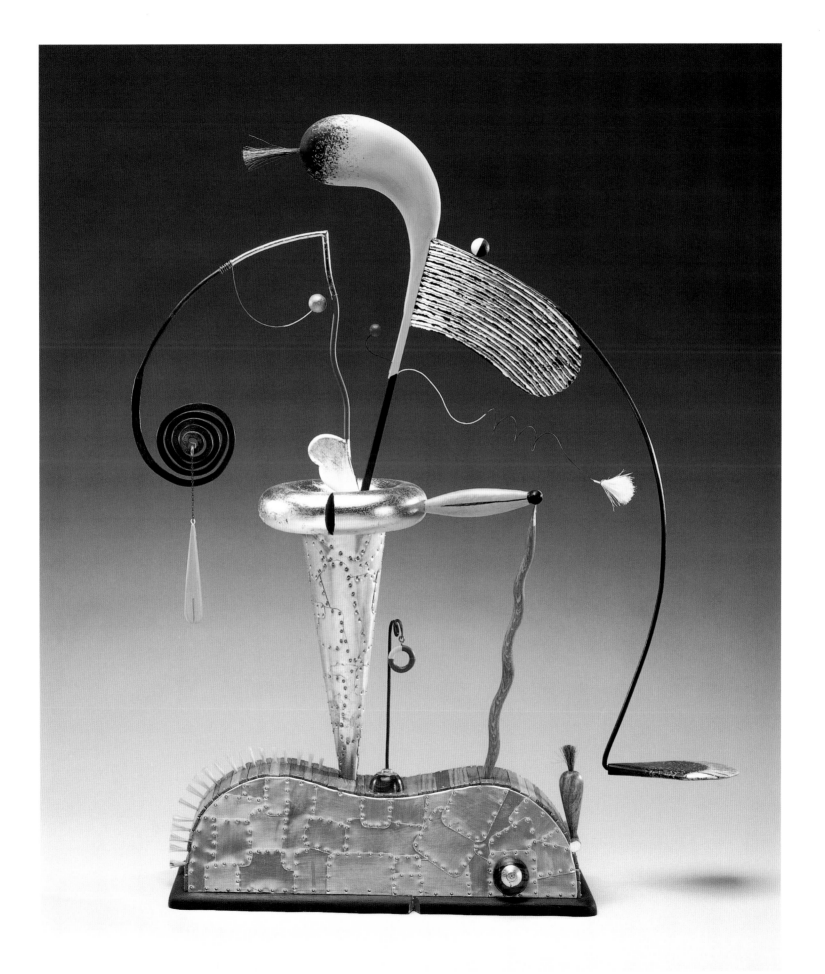

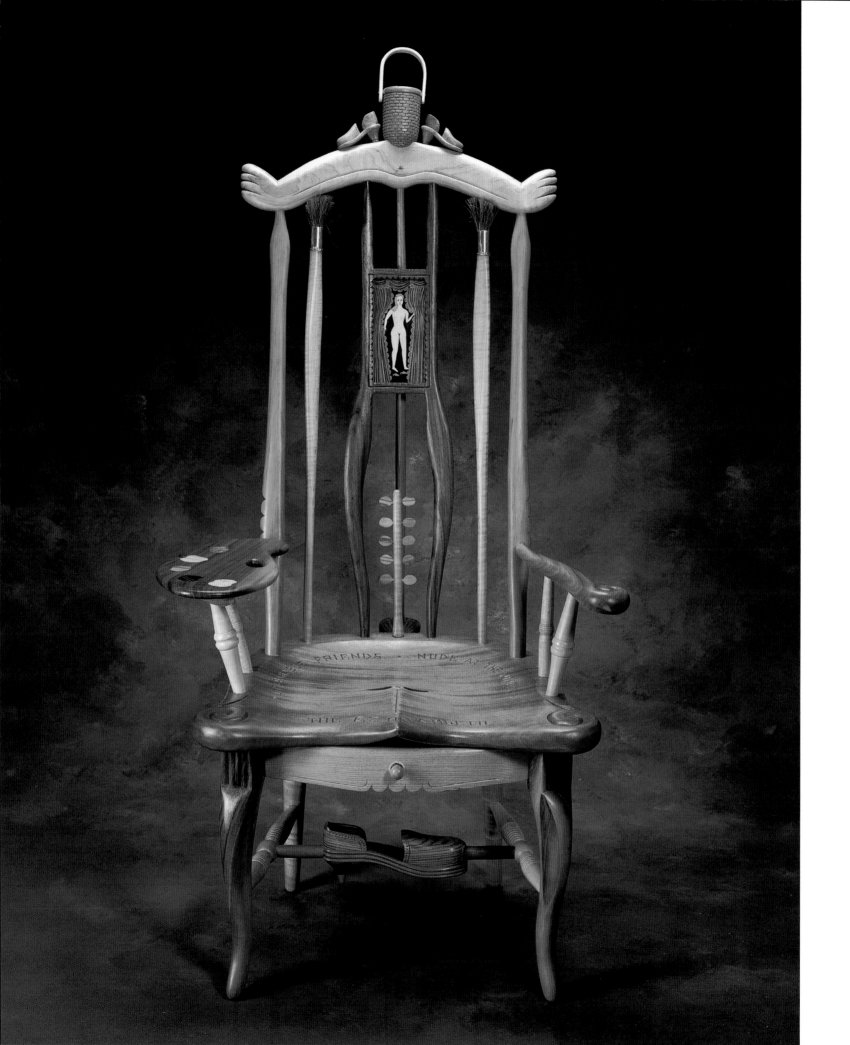

HANDS TO WORK —
HEARTS TO GOD

1989
Mixed natural woods,
broom straw, brush,
buttons, wrought iron
45" x 24" x 24"

An homage to the
Shakers' industry and
invention. The chair's
bonnet-shaped back is
the same shape as the
Shaker bonnets the ladies
wore. The seat is carved
with the Shaker hymn
"Simple Gifts," the flower
is for their seed
packaging, the broom
straw is for their flat
broom invention.

OPPOSITE:
THE E.Z. WALK
MFG. CO.

1988
Mixed woods, gouache
paints
45" x 28" x 26"

This chair was made in
fond memory of folk
painter Morris Hirshfield,
who found painting in his
later years. The little
painting on the chair
back is a copy I made of
his painting *Nude at the
Window*. Other motifs on
the chair are taken from
other Hirshfield
paintings.

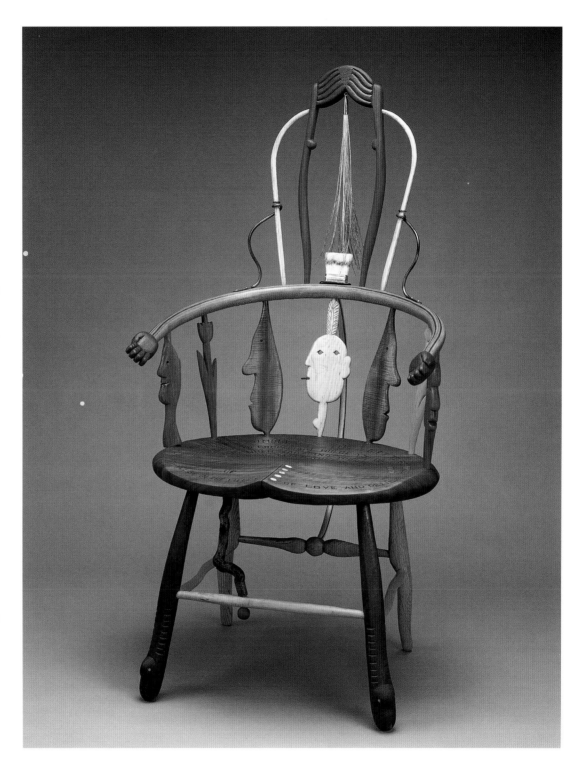

Around the end of July, when I stood ear to ear with the corn and the Fox River's

rock bones were showing, the carnival reappeared in East Dundee like Brigadoon. This was an opportunity my buddy John and I wouldn't miss. During the day the tent flaps were down, the rides were still, and the plaster dolls were napping, but as the sun rounded the corner, the cotton got candied, Ferris became a wheel, rats and turtles ran races, and quarters flew. This was a metamorphosis by the twilight's magic dust; this sprinkling had cast its spell.

RIGHT:
SLOP HILL STUDIO, 1968

The feather on my head is to mimic the cabinet on my left, which is called *Man balancing a feather on his nose.* Serious silliness.

LORD'S PARK STUDIO, 1969

A cabinet I built for Sarah as a playhouse.

Onto the park, good-bye
Kicking leaves crackling high
Mat, Sarah and Angie, too
Seeing the once around the zoo

The three little pigs stuck to fun
push, wait, tumble and run
they're looking for the quacking moo
seeing the once around the zoo

Then, to the hill they climb
giving back turn for turn
* time for time*
Mat, Sarah and Angie who
saw a once around the zoo

We vacuumed down our dinners, grabbed our bikes, pedaled like mad, and were at the festival in minutes. The first pocketful of change went fast. Now we held onto the remaining coins to pay for what we came to see — the fights!! Around eight o'clock we heard the wail of the hand-cranked siren. We walked over to the large brown rectangular tent where the crowd was gathering. Outside the tent stood a platform measuring about ten feet long, five feet deep, and five feet high — just high enough for our noses to be on an even keel with those tall, red lace-up boxing shoes. The promoter came out promptly, followed by the house pugilist — clad in a Sears Roebuck bathrobe and itchy wool trunks, with cauliflower ears and a face that could only be described as "some kisser" — the man to beat. They climbed the stairs to the viewing stand. The showman picked up the megaphone and began his spiel, praising the wonders of his

house hero. *Harry "the Wind" Kowalsky, just returning from his Chicago tour . . .* caressed the air waves. *Champion of champions . . .* More caressing. The object was to get some local yokel to challenge the Wind to three two-minute rounds of boxing. If the challenger could stick it out, he'd get twenty bucks.

Well, there was always some young stud whose body had outpaced his brain in growth. To get to this mug, they used the tactic of name-calling. Just point to some clear-eyed rube and start yelling. *Hey, fat boy! Lard head! Beer butt! Goofball!* If the need be, up the ante: *Mama's skirt licker! Panty-waisted chickenshit! Clodhopping, lily livered!* Sooner or later a provoked, cow-sized young man would stumble forward out of the crowd. I might add that these colorful insults were a rich source of phraseology for us to squirrel away for future occasions, for which I am indebted.

The throng pressed toward the ticket booth. John and I plunked down our quarters. Inside the tent was a boxing ring covered in canvas, two stools, and water containers. The tent corners had drapes hung diagonally to form two triangular dressing rooms for the fighters. When the makeshift canvas auditorium was jammed with faces, out came "the spider and the fly." The interesting thing was that more often than not, experience won over innocence, for naïveté usually got caught by a left jab. The show was never stylish, pretty, clever, or beautiful in the conventional sense. More than likely it was crude, clumsy, foolish, and downright sad. There were moments of being alive, moments of being on the edge, but they never quite got to the *"Did you see that!"* category. Of course, after filing out of the tent,

we did an about-face to wait for the next bout. We did this until the money ran out. I guess they knew something about young boys — the appeal of sweat, brutishness, smoke, swearing, folly, and the anxiety of "sink or swim." These pubescent stimulants flared young nostrils and grew pubic hair. No one every really got hurt, just a few bloody noses, black eyes, and, mostly, hurt pride. That night two boys fulfilled a time-honored obligation to see danger, travel to far-off places, and participate in their journey to manhood. A path thrust upon them by some unknown universal force. Mind you, we didn't put up much of a battle. Mother Nature had predestined our attendance at these events of struggle, the result being that we were leveled off, mellowed out. We were christened into ancient man's need for savage blindness, survival. That night, the wee hunters found a contented sleep in their enlarging world.

Good night, John.

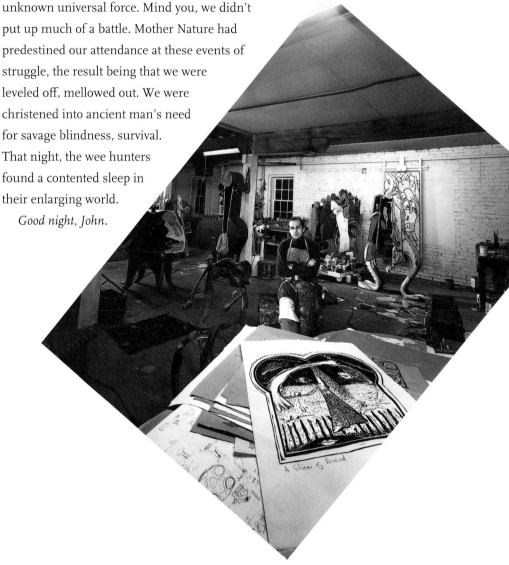

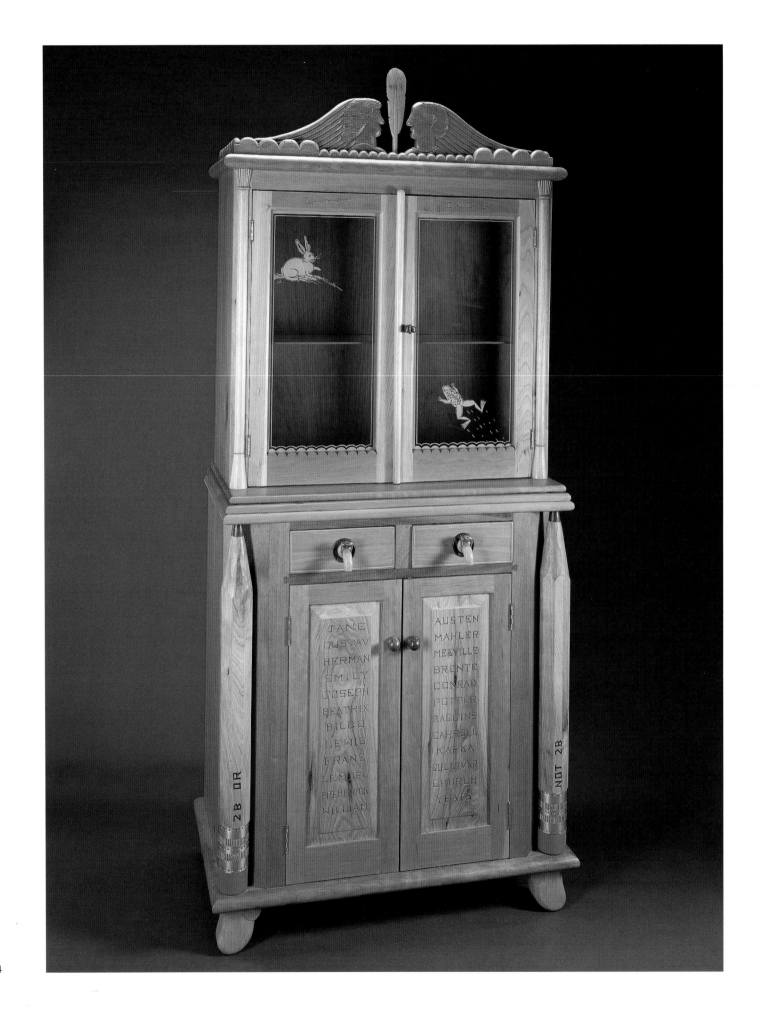

FLORENCE, MUNA, AND MARY

1981
Mixed woods
42" x 36" x 28"

A fond remembrance of three sisters who flew through my life.

OPPOSITE:
WRITER'S CABINET

1985
Mixed natural woods, glass, zinc sheets
78" x 36" x 18"

The owner of this cabinet loved books and their writers. The two figures on the cornice are scribes with their quills. The rabbit is for John Updike, the frog is for Mark Twain, the pencils are for Shakespeare, the other names are for your own discovery and delight.

Through the holes of warming sight
pass the authors of delight Carroll,
Baum, and a touch of Lear, Burgess, Potter
and many I seer. They are the clouds
of holy smoke passing by to tole the folks

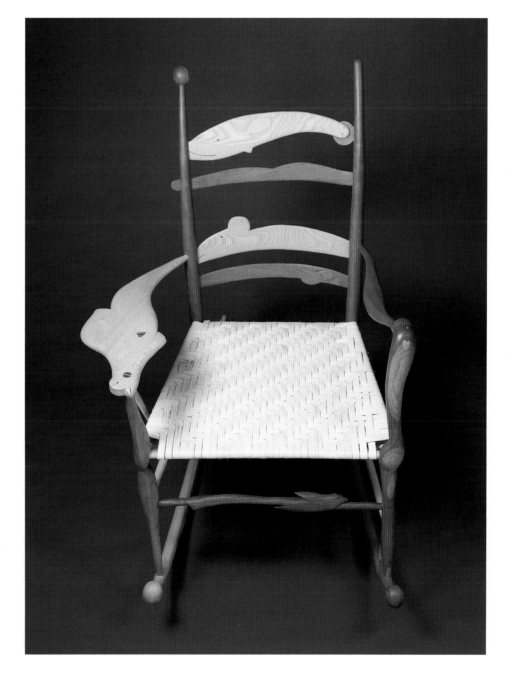

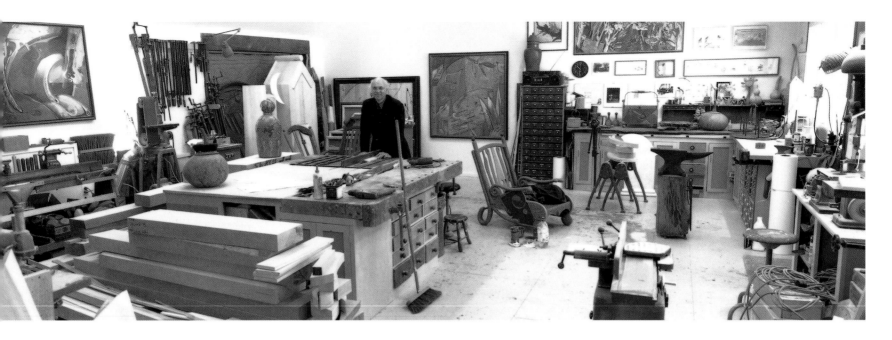

WORKSHOP, 1998

Panoramic view of Connecticut studio.

When the morning is up and waiting
the window woman breathes soft
> *breasted light*
>> *into my world*
>> *casting shadows*
>> *riding my mind*
>> *with lures of nippled seeks*

She pumps me full sun
>> *heating my wants*
>> *to ride the day*
>> *producing quickened images*
>> *that muse and fly*

Deplete
>> *I hear twilights sweet whisper*
>> *so, I return*
>> *to room my thoughts*
>> *and gather strength*

WING OF LIGHT

1996
Gouache on paper
12" x 11"

In the Uffizi Museum, Florence, there are two wonderful annunciation paintings, one by Leonardo da Vinci, the other by Sandro Botticelli. Nowadays we get those messages by telephone. My painting was a thank-you for being able to see these glorious objects.

OPPOSITE:
WORKSHOP,
CONNECTICUT, 1998

The woodcut of an owl hanging on the back wall is the first artwork I made in school.

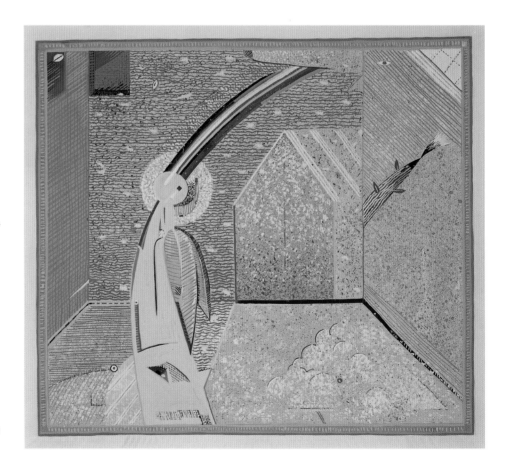

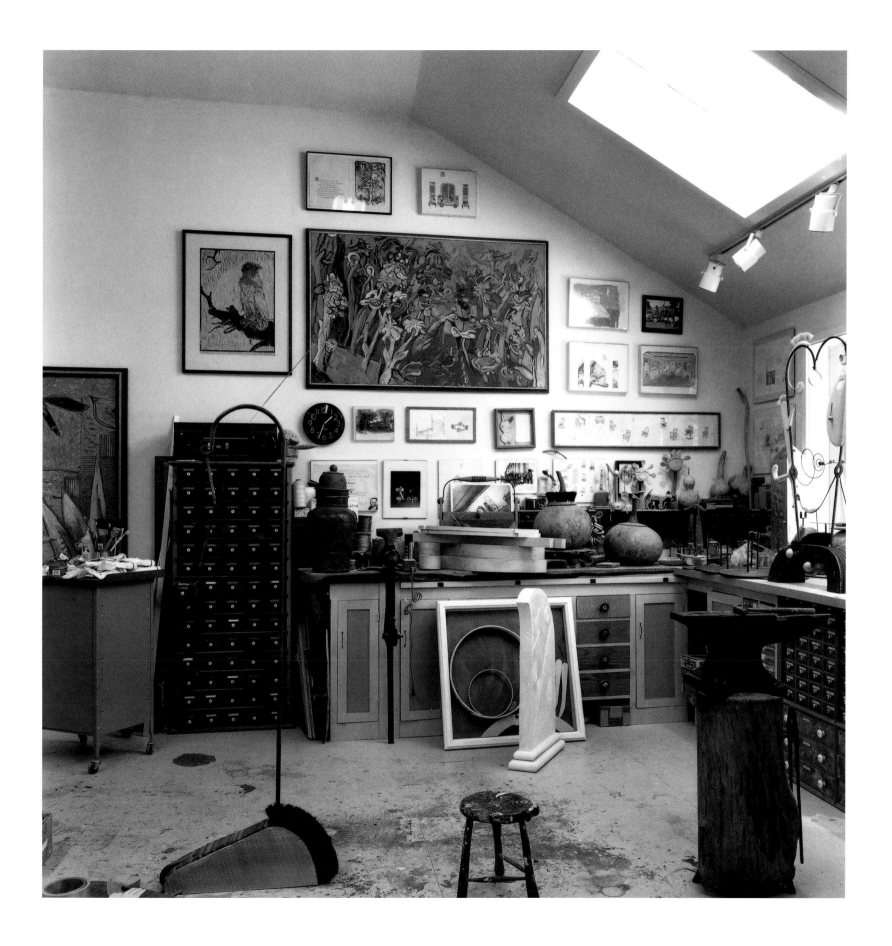

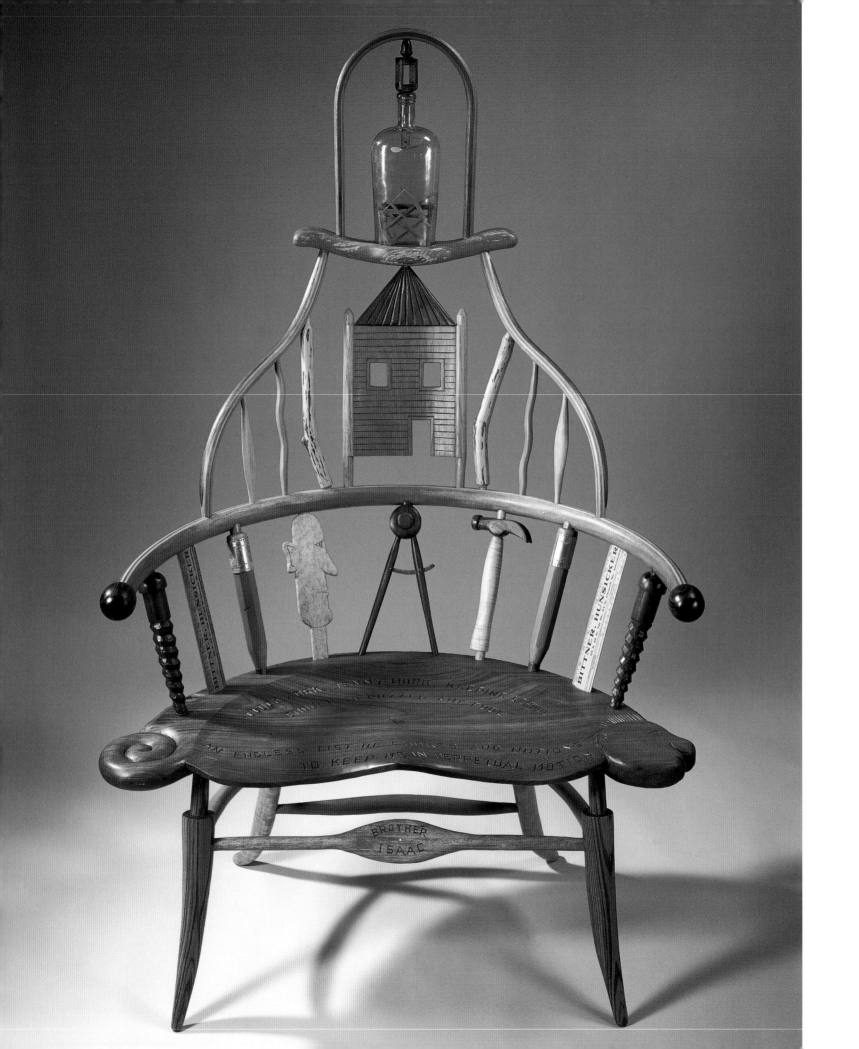

1991
Mixed woods
46" x 26" x 27"

The patriot's chair has various American historical references. The left chair arm has Lee carved into it, the right arm has Grant. On the top rail rests Jefferson's monument; on the back of the seat sits a bust of George Washington. The back slats are red-and-white-striped wood with inlayed stars throughout the chair. On the surface of the seat is carved: "When there's a shine on your shoes," also various historical names, such as Thomas Alva Edison.

OPPOSITE:
CARPENTER'S CHAIR

1991
Mixed wood and media
56" x 36" x 24"

Folk sayings that are carved on the seat:

*clock work, Jenny work
keeping school
enough to puzzle any fool*

and

*an endless list of chores
and notions
to keep me in perpetual
motion*

Brother Isaac was a Shaker woodworker.

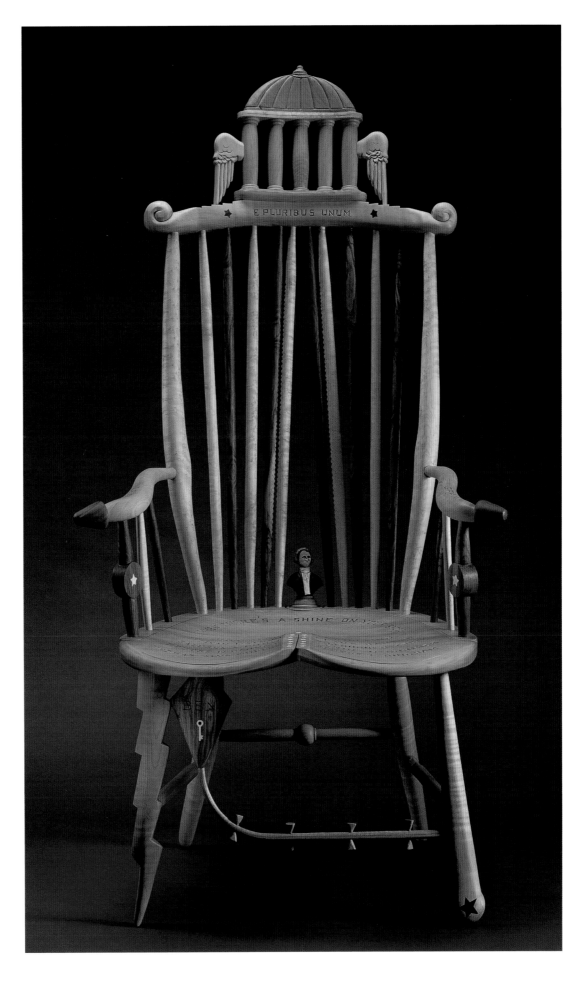

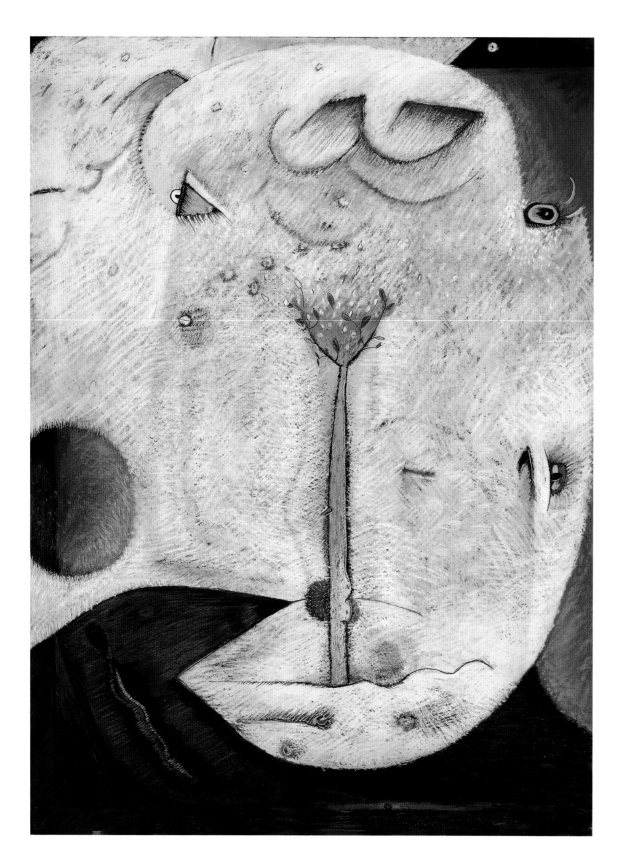

A TREE TAKES A WALK

1991
Pastel
32 1/2" x 39 1/2"

Trees seem to walk all over the faces of some lucky people.

OPPOSITE:
CLIFFACE

1992
Carved and painted wooden panel
60" x 40"

This painting came about after rambling through the hills around Santa Fe, New Mexico. The sky was everywhere, and the peoples of the past flavored all visions.

In the evening
the day's closing thoughts
 expose wide smooth smiles
 relaxing their shapes
 into familiar valleys

cloud swallows
 ride the river hues
 charming my eyes with water ghosts
 who race me
 home home home

peace harvest
culmination quiet
appreciation time
understanding clarity
resolve completion

MAKING-ME

hold closeness
tenderness comfort

evening

work belief daydreams
active spirit flow
function kisses release
forgive reward enjoy
exchange touch
friendship care
accomplished trust
faith secure flavor
thoughtful

My first fall away from home was my freshman year at the University of Illinois. It brought many new challenges and events. One of these included pledging into a fraternity. I was one of eighteen greenhorns in this house of brotherhood. The majority of my classmates came from large urban areas like Chicago — unlike the small town I called home.

As school progressed there was lots of horseplay and lots of work. Weeks passed. One evening, when a bunch of us were sitting around exhausted after a long day, we got to talking about our lives at home. Somehow hayrides got mentioned. I was surprised that no one but me had ever been on a wagon of hay and suggested that during school break they all bring their girls for a country hayride, with horses, straw, vittles — the works. They all enthusiastically agreed. The date was made for November 20.

The next task was to pull the party together. I arranged for a horse, wagon, and wagoner from nearby Howard Farm, found a large tub for iced drinks, and bought food from town. The night spirits were kind, for it was a beautiful evening — perfect for hunkering down in the aroma of hay for warmth. All the goodies were spread out on the kitchen table in fine order. The nest was ready, and the hills were beckoning. My date and I sat on the back end of the wagon — five o'clock, six o'clock, seven. Not one person came — not a sandwich eaten, not a phone call; no sound of hooves from Old Bill. Just a glorious, starry night full of harvest smells and rosy cheeks.

Somewhere that pain of disappointment still rides her wagon through the streets of my being, to be seen on occasion when least expected. Luckily for me, I found out the next day that I had the same hands, the same feet, the same me — thanks to a mother's full-bodied support. Now the years have passed. During this time my friends have shared their discoveries, they have shared their feelings, and they have painted pictures from their hearts — they have shown they are a god-sent, wonderful invention.

TATTOOED
NAVIGATOR

1996
Painted wooden cabinet
with etched glass table
72" x 26" x 24"

When we probe our
unknown universe we get
tattooed by many strange
experiences; many of
these images stick to us
but can only be seen
by others.

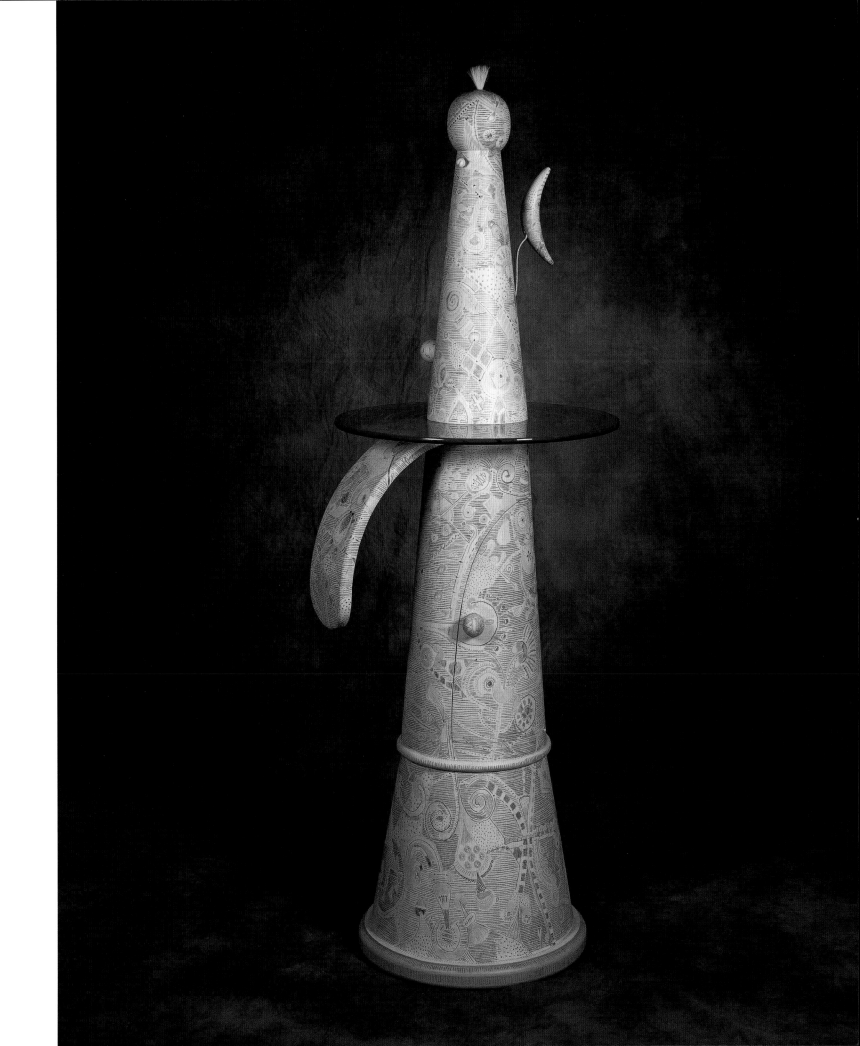

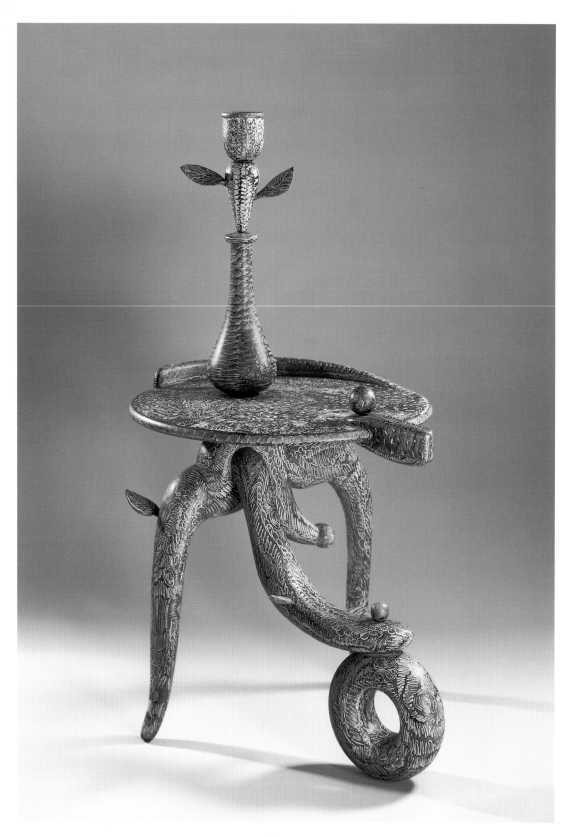

LET'S VASE IT

1997
Painted wooden side
table
46" x 28" x 24"

A graining medium tinted
with oil paints was
applied to the table, then
I scratched through this
medium with a pencil
eraser to expose the
underpainting.

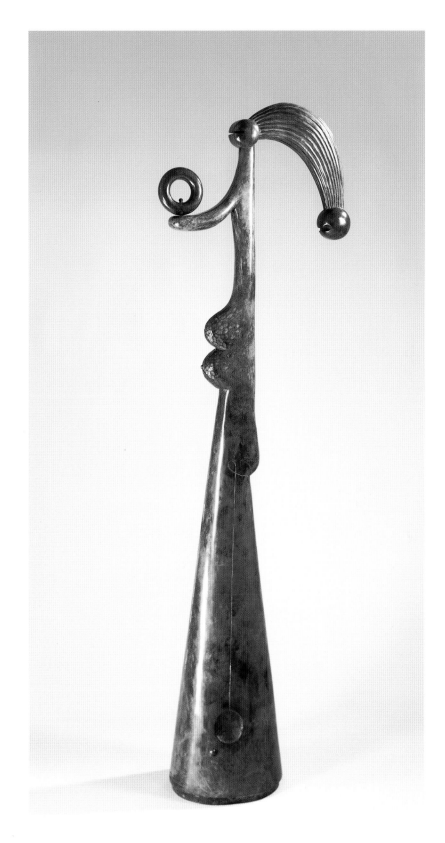

THE GIFT

1998
Bronze
76" x 24" x 12"

Flowers come
Flowers sow
>*Seasoned by their time to grow*
>*when the seed is resting snow*
>*distanced from its summer glow*
>*It lays its blossom-petal-show*
>>*beneath the crust of eyes that know*
>*seekers to this special sew*
>*can air the warmth from winter's toe*
>*finding the flowers' hidden row*
>*filling heart, hand, and so.*

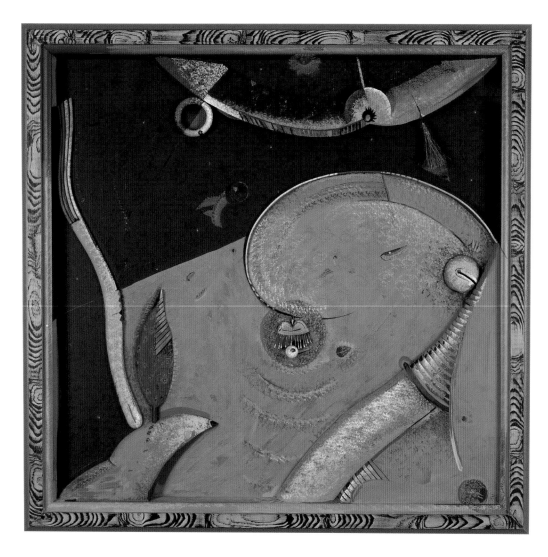

INQUIRY OF A GREEN HILL KISS

1996
Painted box
31" x 31" x 2¹/₂"

When the land rolls up to kiss our eyes,
the magic of this green planet
is most powerful.

OPPOSITE:
RADHA'S RAIN

1996–98
Carved and painted wooden panels
60" x 60"

Due to my love of Indian miniatures, this is a picture of
seated Radha; she is being washed in the blue rain of
Krishna — soaked with love.

Blue Feather
Blue Feather
 Where have you been
 Over the mountain of delicate skin
Blue Feather
Blue Feather
 What is the word
 The songs of air caressed by a bird
Blue Feather
Blue Feather
 How have you seen
 With sprinkles and grit and all in between
Blue Feather
Blue Feather
 When could you tell
 When the heart doth ring as a fragrant bell
Blue Feather
Blue Feather
 Did you not taste
 Halos of joy found in her face
Blue Feather
Blue Feather
 When did you feel
 As the love of another sent me to reel
Blue Feather
Blue Feather
 Where are you now
 In the kisses of clouds
 and under her spell
 do tell

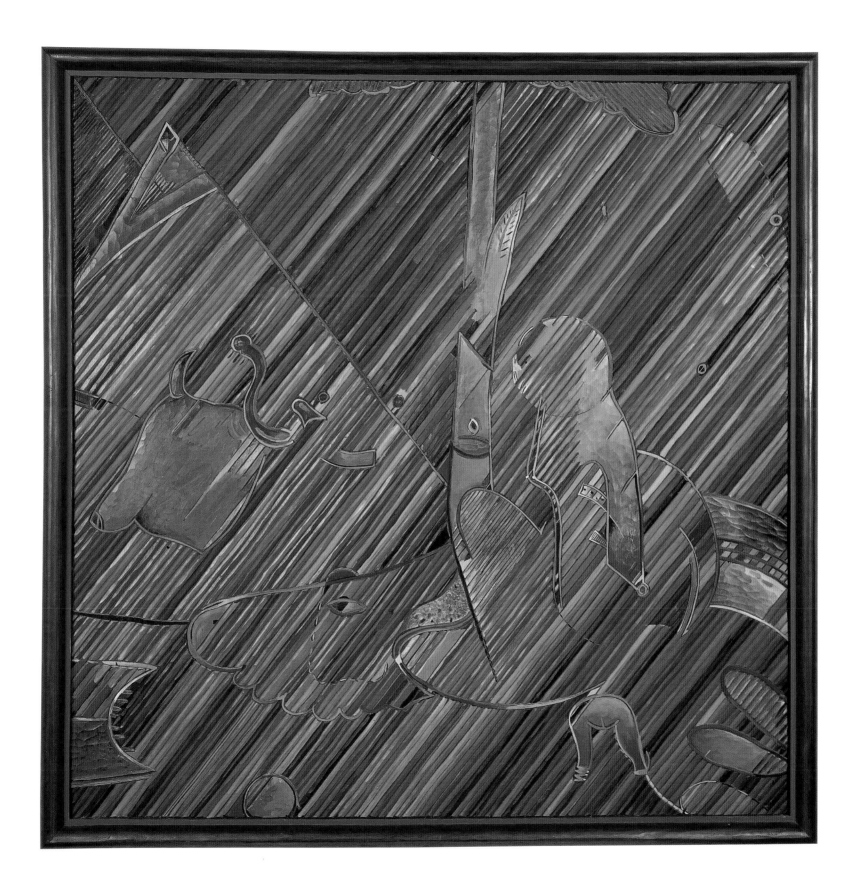

BIRD

Dave was farm tough and lived on the east side of town. By bicycle it was up the hill, past the church, past the graveyard, then one long, thirsty distance, ending with a bumpy gravel driveway to finish off the ride. Thankfully, lunch was waiting on arrival. Wonder bread, mayo, and bologna served on a clean, circular white plate — a sandwich devoid of all ornament or pretense, a "farmer's delight." After a treat of pie served on the same plate, same ornament, we began to explore the barn, where, together, we tackled Dave's afternoon chores. First, we put feed out for the cows; next, we cleaned out the milk room — in the meantime in wandered various dogs and cats to see if we were small enough to eat! By the middle of the afternoon, when your shoes take on that digested, earthy fragrance, we found ourselves over by one of the corn cribs, throwing lost ears back into the bin. There among the kernels we came across a baby wren — lost, lying helpless on the ground. Ever so carefully, the two angels of mercy gently scooped it into Dave's hand. *SAVED!* Now — what do we feed it? Where to keep it? We needed help, and ran over to Mr. McClung, who was repairing the fence near the barn. With urgency and outstretched hands, we presented the infant and our dilemma. Mr. McClung listened patiently, then accepted the bird into his hand. His fingers slowly closed around the tiny creature. *CRUNCH!* He crushed the bird in one decisive movement, gave it a toss, turned, and went back to his work!

We walked away, nothing said, just blood racing through our bodies. What I had felt was raw, potent, visceral — an unforgettable bruise.

NYMPH OF LAUREL

1996
Carved and painted
wooden cabinet
76" x 31" x 21"

In Greek mythology, Daphne was turned into a laurel tree to escape Apollo's advances. The turned-up arms and the crescent moon are goddess symbols.

I wonder if the expression "Knock on wood" came from this story.

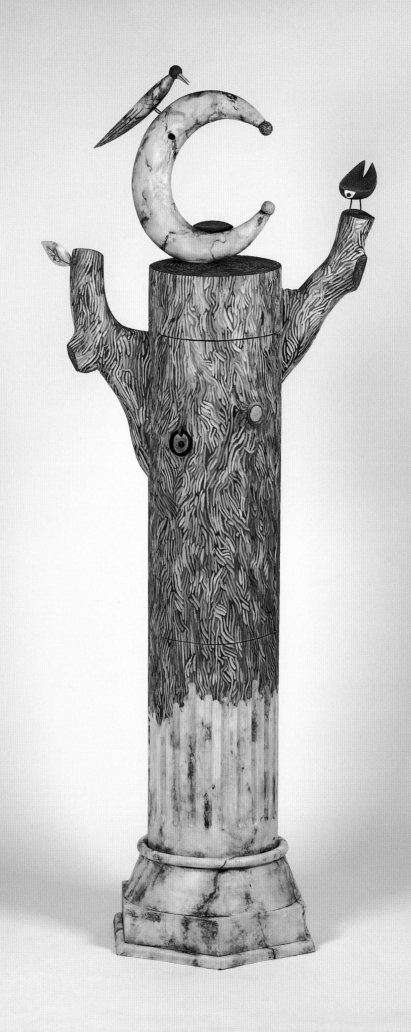

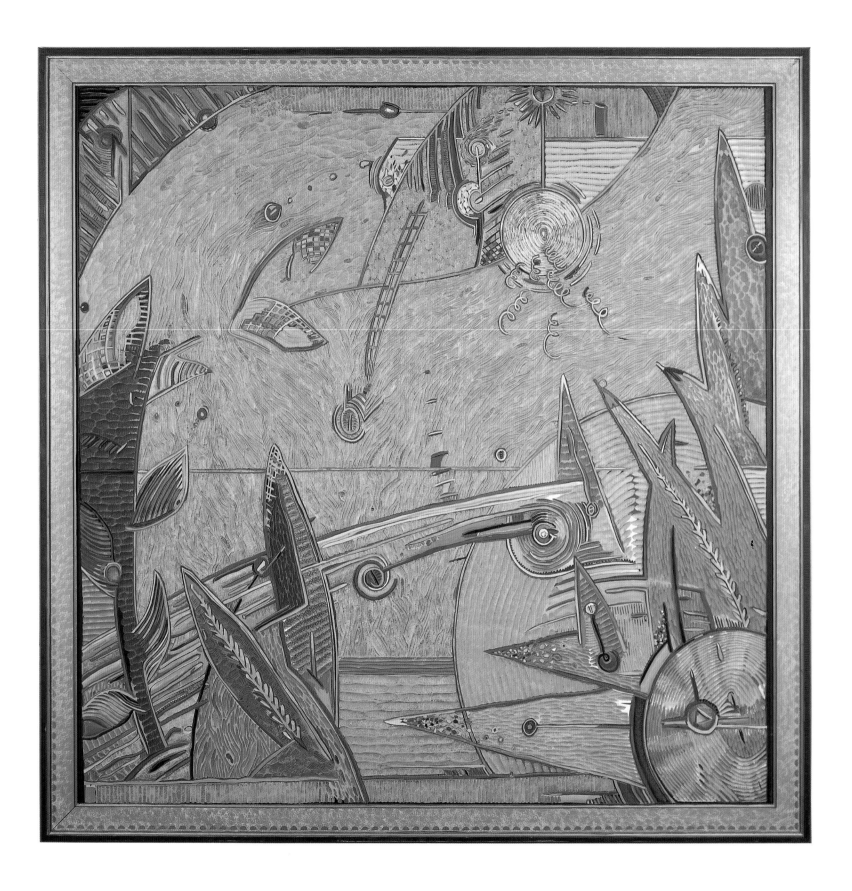

BAT FEATHERS

1996
Gouache paint on paper
9" x 9³/₄"

at dusk the
black lines of night
weave patterns
to catch the
bat feathers of the wind

OPPOSITE:
SUNDOWN MEADOW
SKIES

1998
Carved and painted wood
panel
66" x 66"

As the fields cozy under
their blankets, the in-
betweeners come forth
to dance and sing,
bewitching lady night to
let down her hair.

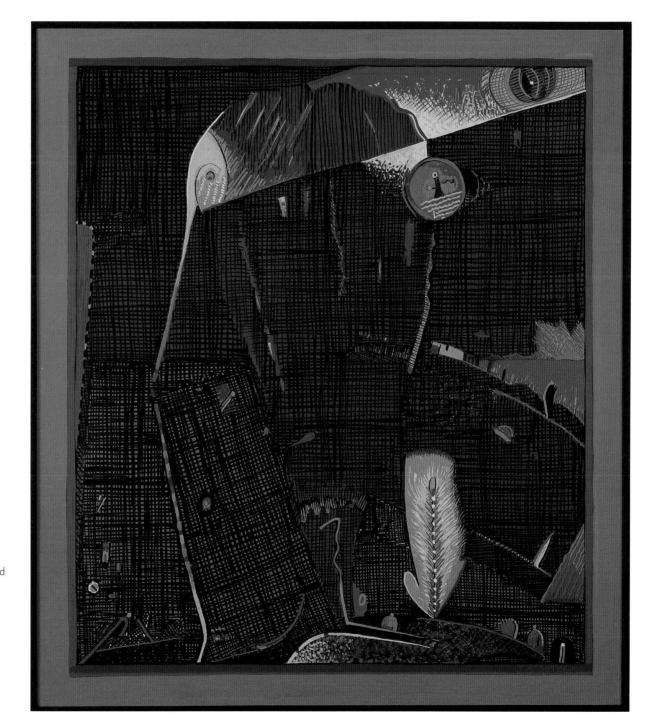

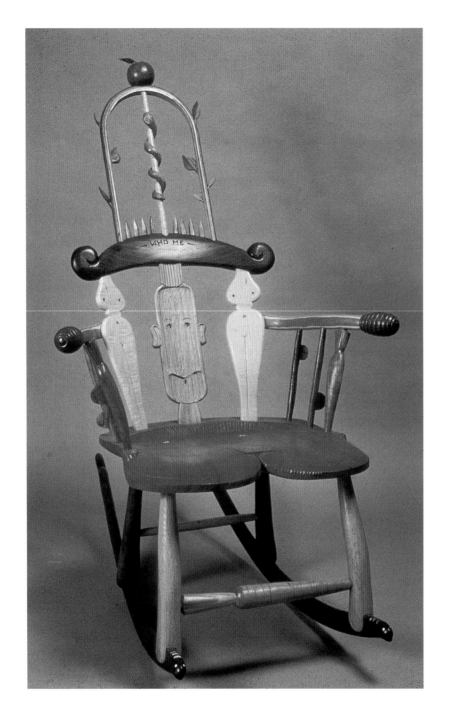

ADAM AND EVE

1987
Mixed woods
46" x 28" x 36"

When the carrot of temptation falls upon us,
the answer "Who, me?" doesn't always suffice.

OPPOSITE:
THE NIGHT FEATHER TICKLES MY STILL

1993
Mixed woods and wrought iron
45" x 34" x 28"

It was the time
> *in my boy green youth*
> *when no songs were among the words*
> *when nest shadows darkened my path*
>> *and thin fences fooled the sky*

Little did I know
> *of open doors*
> *with shafts of light*
> *of mystery*
> *or of tills*

Little did I sense
> *that a cold day meeting*
> *would be a heart long view*
> *an end-ways walk with time*

Surprisingly, thankfully
> *my love discovery*
> *would hold me to the full sun music*
> *not letting*
>> *dutiful dreams*
>>> *swoop-blacken my days*

Slowly it came in time
> *of many tears*
> *my greens turned to filling hues*
> *my ghost winds had pushed my balance*
>> *toppling my head*
>> *to face my face*
>> *to return to that open entry again*

Again, I found
> *hand in hand*
> *eye to eye*
> *heart with heart*
> *love circling love*

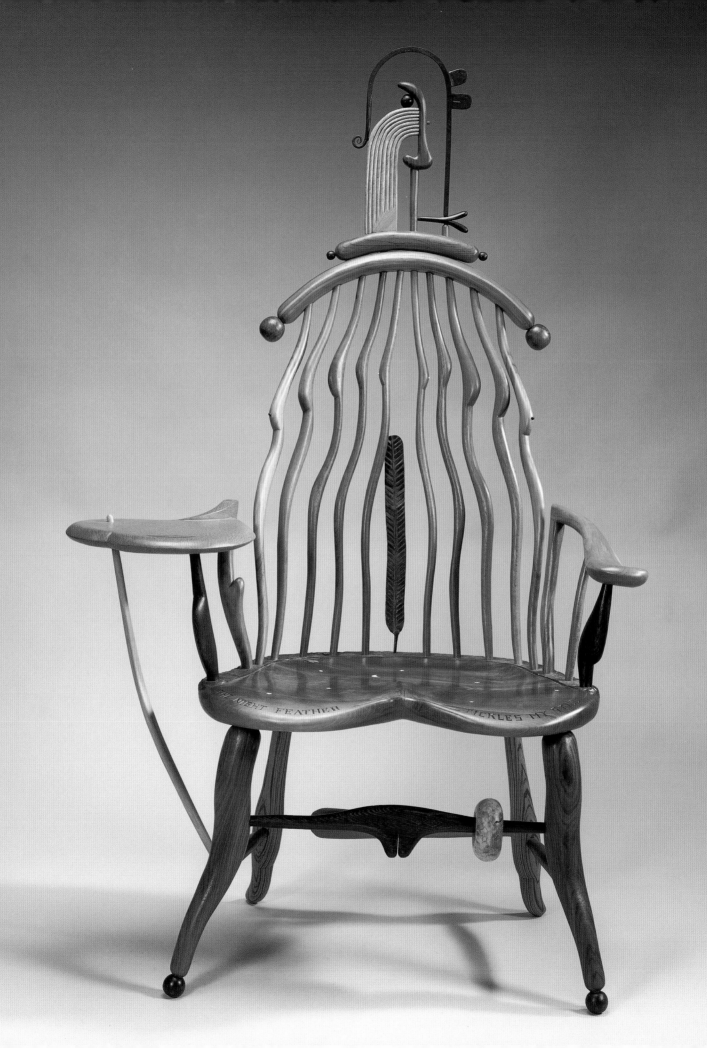

BUTTERVILLE IS A PLACE ON EARTH

1982
Porcelain platter
18" diameter

I made this slip-cast porcelain plate at Kohler's Art and Industry program, Sheboygan, Wisconsin. It is modeled after English antique alphabet plates for children.

GARDEN POTS

1994
Redware ceramic flowerpots
8" x 10" to 20" x 24"

The end of the day shines on some garden pots David Rubenstein and I made at his pottery. The pot with screws and saws decorating the sides is for the front walk leading to the wood shop.

OPPOSITE:
ARTIST'S BEDROOM, 1993

Containing the new and the old. The mittens and quilt are old, the carpet and bed are new. The plates are new, but the ladder is old.

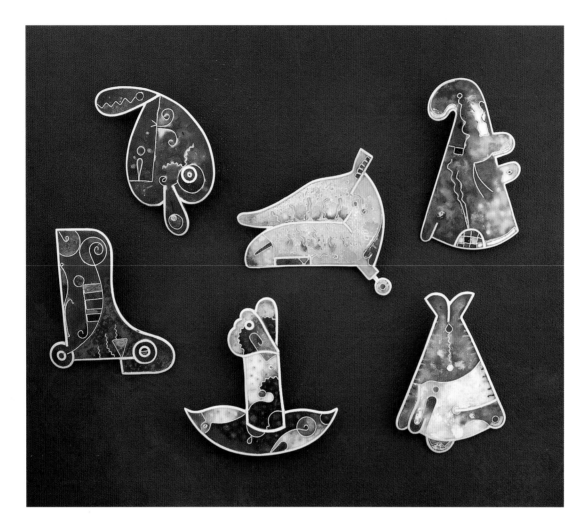

SILVER AND ENAMEL
PINS

1993
Approximately 2" x 3"

Seeing what these
characters look like by
themselves instead of in
their usual home in a
painting was one purpose
for these pins.

OPPOSITE:
CHRISTMAS CHEER,
1994

The act of giving in to
your passions is a
holiday. These much-
relished ornaments came
from many sources:
Tommy and Missy, fellow
artists, family hand-me-
downs, antiques, newly
made from around the
world. A true American
experience.

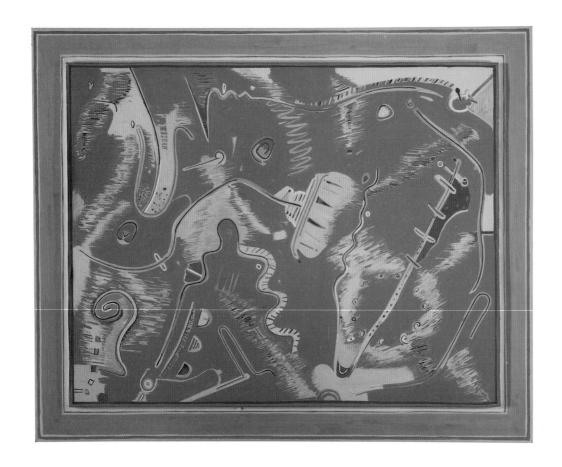

THE SEA

1998
Handmade wool rug
(gouache painting
design)
5' x 7'

On one occasion in my
youth I slept rolled up in
a rug, hot-dog style, all
night.

JUMPING WILLICURS

1998
Handmade wool rug
(gouache painting
design)
5' x 7'

Now, years later, it's nice
to have a rug underfoot, a
roof overhead, and
harmony within.

SUMMER HILLS

1998
Handmade wool rug
(gouache painting
design)
5' x 7'

I would consider any of
the decorative arts fair
game for an artistic
undertaking.

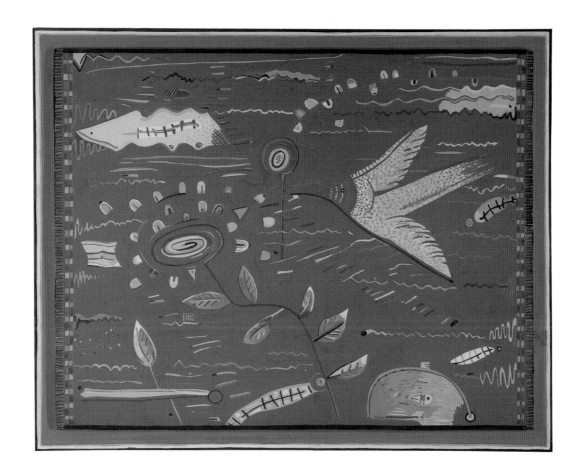

SUMMER HILLS

1998
Handmade wool rug
5' x 7'

This is a Nepalese rug
maker's interpretation of
my painted design.

*You lose something
you gain something
what fun!*

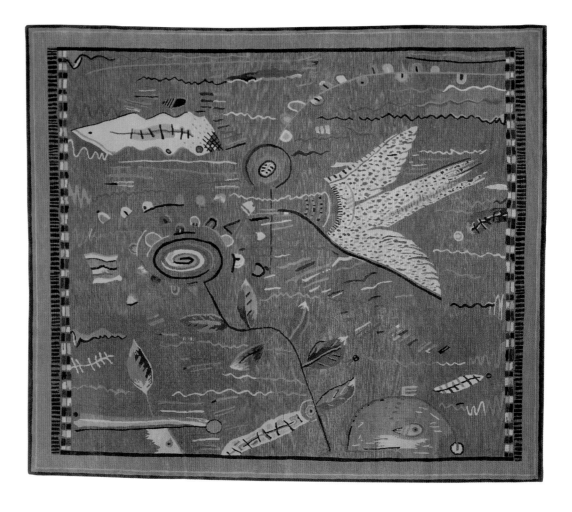

When the days got long, flat, and hot on both ends,

the heat lifted John's thoughts and mine into flight, catching the daydream thermals that sailed out over our daily routines, over our doldrums, even beyond our mothers' requests. We were caught in the pull of a prehistoric "call of the wild." This was all it took to start us packing our knapsacks and practicing a little light-fingered pilfering of the home larder. *Let's see: peanut butter, spuds, cans of soup, sleeping bags, hatchet, Twinkies, fishing gear, candy bars, potato chips, Velveeta, pop, canteens of water, Oreos, and, oh, yes, pup tents. At last!* We bundled up our goodies and closed the kitchen door, leaving some of the parental advice lying on the table under a napkin, to be found the next morning. *All set!*

With our humble permission asking behind us, we were on our way down Oregon Street, headed toward Mr. Simon's garage. It contained the green wooden Boy Scout canoes. Upon arrival we put down our gear, picked up the closest canoe, and wrestled it some distance to the Fox River's edge, returning for our gear and paddles. We pushed off onto the river, leaving our footprints on shore for our return. Paddling north against the current, we approached the old West Dundee Bridge. She lay low to the water, wide and cool, shadowing our echoed shouts, which traveled downriver, frightening the mallards into flight. Ahead was the footbridge where on the Fourth of July we announced to a quiet village "Independence" with wet-wicked cherry bombs. An hour more

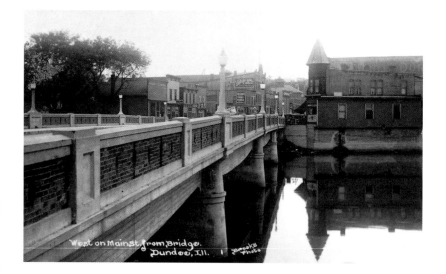

of paddling got us to the Illinois Iron and Bolt Works buildings at the foot of the C'ville Dam. Two men fishing with bows and arrows pointed to the portage path. It was steep but short!

On top of the dam is where our civilization ended; the uncharted lands of the Algonquins lay ahead, known for their uncertain cows and mysterious woods. We now put down deep strokes to get clear of the dam, bringing up bubbles in our wake. As they burst we could hear the meows from the giant catfish below. After stroking hard for some time we looked for quiet waters, to slip over the side for a cooling off, mindful to keep the craft from floating downstream. Our spirits refreshed, we pushed ahead, stopping only to water-soak our hats, cooling our sun-baked heads. The appearance of the Fox began to change. Marshes appeared, festooned with cattails; red-winged blackbirds embroidered loops in the sky; and a rubber-back turtle poked its nose up for air. The willow trees were now at the water's edge; their overhanging branches allowed us to pull ourselves along through their

DUNDEE — FOX RIVER, EARLY 1900S

I've gone over, on, or under this bridge a million times (I guess), for school, fun, sporting events, bringing home babies, and mourning deaths. The bridge always got me to the other side, even though one of her lights was frequently burned out.

silhouetted water images. Dragonflies dive-bombed the muddy shore, looking for lunch. *Ah! Yes!*

After our *"dejeuner en nature,"* the pace slowed down, and attention went to exploring anything that moved. We turned over half-submerged logs, flipped rocks with our paddles, watched crayfish make dirt clouds in the water, and spotted clusters of frog eggs floating in rainbow-lustered puddles. As the day swiftly grew into late afternoon, a sandy outcropping we called Pismo Beach came into view — informing us it was time to set up camp.

The old oak grove was ideal for our needs, a clear understory, plenty of dead wood, rocks for the campfire, and on the fishing edge of the river. A little exploring was in order between tent raising, unpacking, and the evening meal. An up-the-hill discovery was the old abandoned Boy Scout lodge. Within its broken walls was a stone fireplace, furniture remnants, and the faded words *Thrifty, Reverent, Brave, Clean . . .* These words suggested a course of action still believable to our green minds.

The idea of food soon started climbing out of our stomachs into our heads. So, John and I returned to build the fire and prepare the grub. Rifled field corn soaking in the river for steaming, potatoes for the coals, grilled cheese sandwiches made in a circular iron clamshell device that cut off the crusts, capturing all inside for a toasting. A hatcheted can of soup simmered in the flames, reminiscent of Lewis and Clark. As we finished dinner we lay back against our gear, the fire's glow making two moon faces in the dark sky of the woods. The willow sticks skewered with toasted marshmallows helped sugar our dreams,

melting any ill winds before the morning's calm. *To sleep!*

The crack of dawn found us fishing for bass and bluegills, but no luck! We returned to camp to pull up stakes, which meant burying the trash, dousing the breakfast fire, and general packing up. One last, unbridled gesture found us standing on a high oak branch to pee the long arch, sealing our youthful claims. Now, south for home. Meandering in the river current got us at our doorsteps close to dinnertime. Although we arrived dirty, smelly, roughened, and tired, the quest was ours, conquered and secure. That homecoming night we were content with the midnight dance of the river bugs pirouetting through our reveries. We didn't know then what we would come to understand in our lives, that when the head, heart, and body are in the same place at the same time, it is the best of being alive.

C'VILLE DAM, 1940S

Several summers the water flow dropped to where we could walk across this dam without getting our feet wet, and the shallows abounded with crayfish. The river's perfume soaked our shoes, pants, and all after a day's crawling her banks. She was one seductive lady!

THE END: BROTHER FRED AND TOMMY, 1941

GARDEN
OF THE HEART

Hundreds of years ago, in the arid landscape of Persia, came the idea for a walled oasis, an ordered space plentiful with treasured flora from near and far, watered by mountain brooks. These brooks were channeled by hand-dug *ganats* from the mountains to the cities. The Persians called this enclosed captivating world *pardes,* from which the word *paradise* is derived. The *pardes* was traditionally divided into four parts by streams of water, symbolically depicting the four corners of the earth, the four seasons, and the four winds of heaven. An adorned pavilion frequently rested near the center of the garden, a site for the entertainment of the senses. This sheltered garden captured fragrance, pleasure, sensuality, vision, order, and delight all in one cool, lush, touchable Eden.

My awareness of nature's greenery first started in the farm fields of home, where local families worked the earth, toiling away their daylight hours. My town also nurtured colorful patches of flowers planted in bathtubs, tractor tires, and inspired driveway borders. But not until I walked through the beautiful gardens and museums of Europe, and saw how floral magic was illuminated through art, did I lose my heart to this gathering of vegetation called the garden.

This alluring spirit of old has put me to work building my own garden, one made of wood, paint, fabric, and metal. Inspired by those ancient gardens of Persia and Mughal India, I am creating *Garden of the Heart,* a thirty-by-forty-foot sculptural garden, in my Connecticut studio. Within this fenced domain will be six benches and an eleven-foot-tall, eight-foot-wide pavilion with cushions for lounging. The garden will also contain two bubbling water fountains, eight wooden

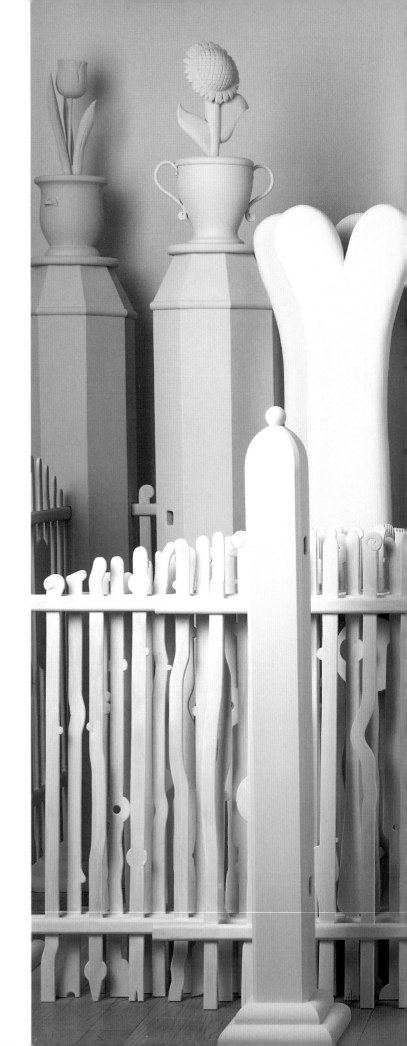

FENCE

1998–99
Work in progress
Primed and unfinished
wooden fence and gate
140' x 91"

The shadow mysteries
from a new quest bring
forth the juicy flow of
finding new paths for
looking and walking.

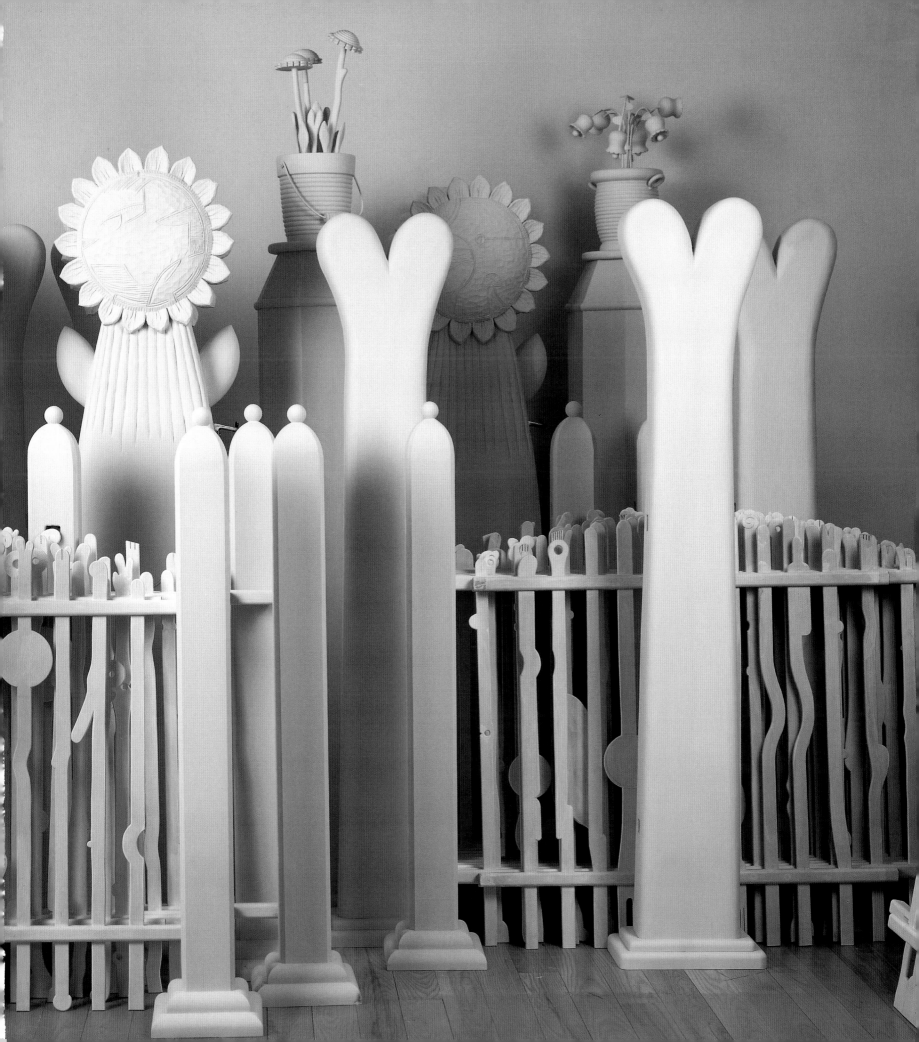

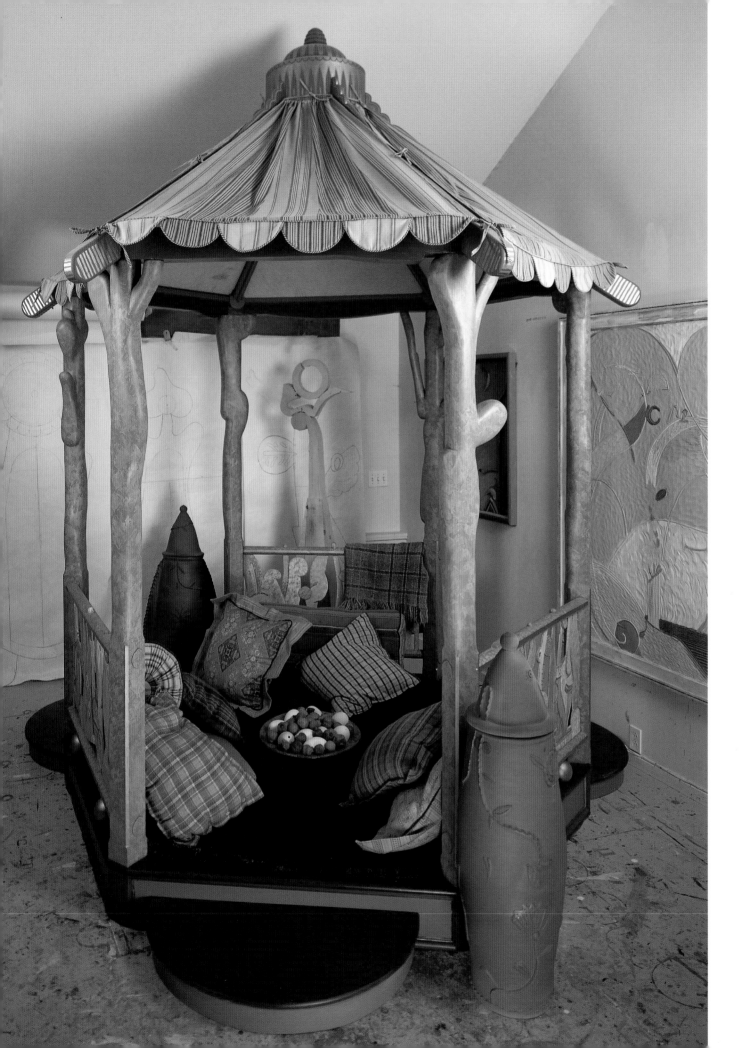

PAVILION

1998–99
Work in progress
Painted wood and
fabric pillows
11' x 96"

As for all works in
progress, there are many
changes ahead, some
being a small table at the
seating center for tea,
a set of sconces for
ambient light, and
ceramic planters on each
side of the steps.

BUTTERFLY BELLS

1999
Gouache paint on paper
12" x 10"

A carved and painted
wooden ceiling intended
to ring with ease, calm,
repose, harmony,
and peace.

trees, 140 feet of fencing with gates, numerous large plant containers, and some twenty-five carved flower forms. All this is to be a visual paradise that acts as a stage for the romance of love. It will be a place

> *where confusion and contrary are kept at bay,*
> *where romance kisses her favorite charms,*
> *where notions are gathered, tumbled,*
> *and shaped,*
> *to be seen full bloom with enticement and*
> *enchantment.*

To achieve this sumptuous illusion, I needed the aid of original music, vibrant dancers, and sensuous costumes. Pilobolus Dance Theater will employ its wonderful talents to create and per-

form an extraordinary terpsichore in this garden. The American Craft Museum in New York City will unveil *Garden of the Heart* in the summer of the year 2000 before it travels to various venues in the United States.

I, too, as the ancient gardeners, have looked to nature's abundant designs to recompose my world. In this search I have discovered that walling in a garden seems very similar to the making of my art, for I find an appropriate format and scale it down to workable size. Then I take this framed space and within its borders I create new worlds with objects and pictures embodying my sense of paradise — a paradise of imagination where love may be tempted to linger, seducing the passers-by.

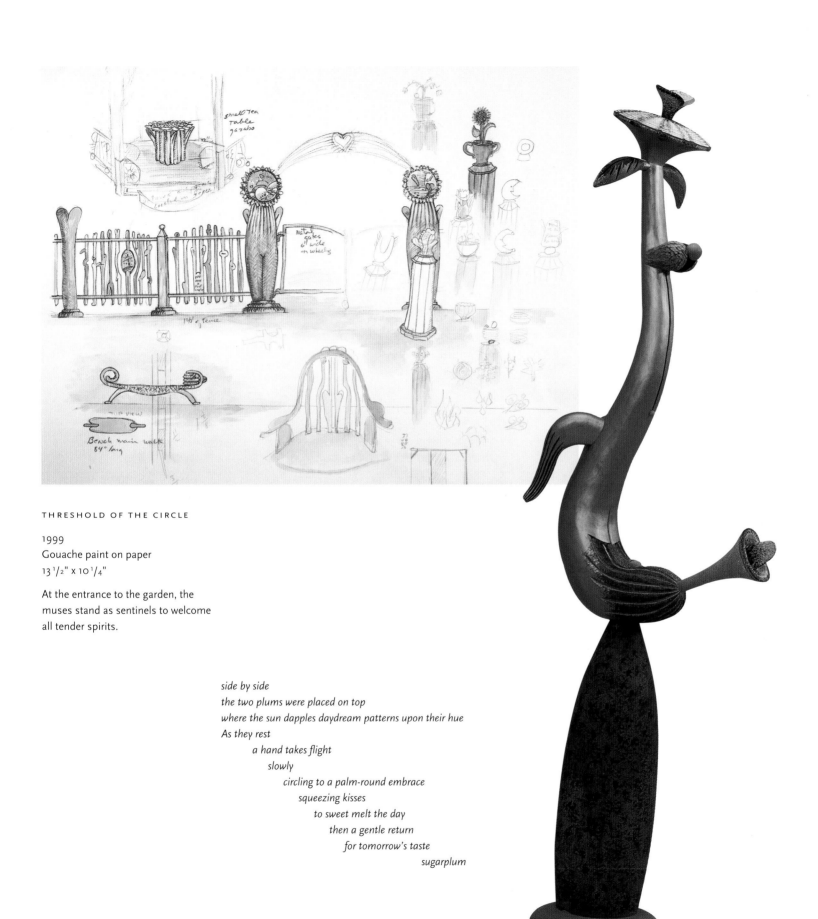

THRESHOLD OF THE CIRCLE

1999
Gouache paint on paper
13 1/2" x 10 1/4"

At the entrance to the garden, the
muses stand as sentinels to welcome
all tender spirits.

side by side
the two plums were placed on top
where the sun dapples daydream patterns upon their hue
As they rest
 a hand takes flight
 slowly
 circling to a palm-round embrace
 squeezing kisses
 to sweet melt the day
 then a gentle return
 for tomorrow's taste
 sugarplum

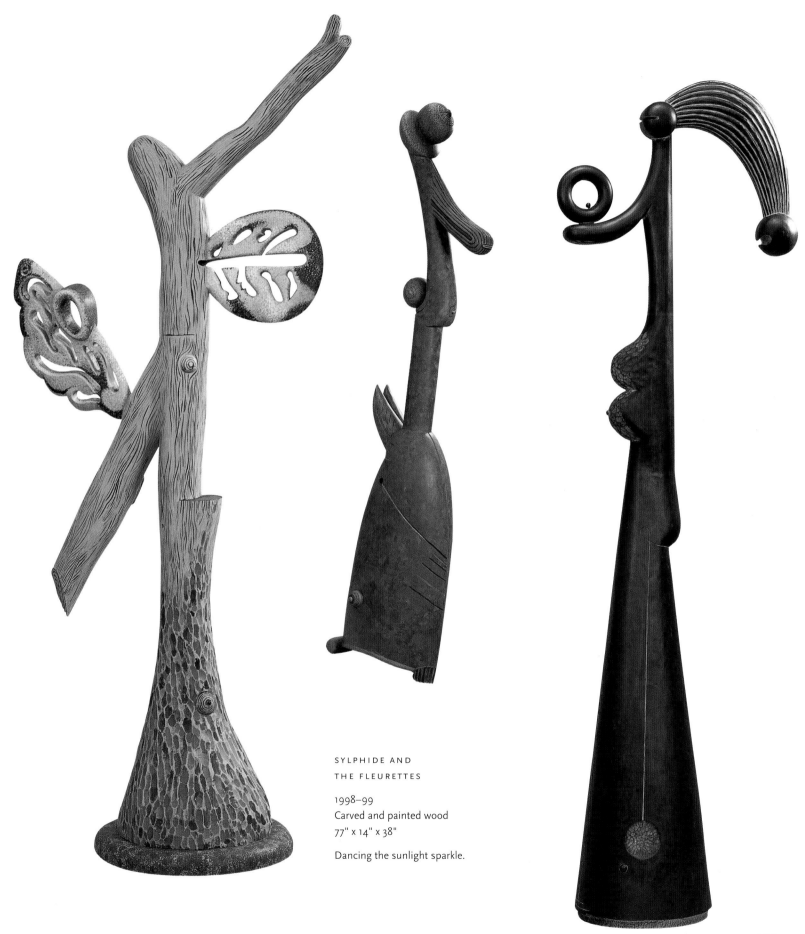

SYLPHIDE AND
THE FLEURETTES

1998–99
Carved and painted wood
77" x 14" x 38"

Dancing the sunlight sparkle.

If I had a kite
 white tied with tales
I would let the string
 taught the wind
 and pull me out
fresh and warm
Flying till seen
 so to hug the eyes
 of a love I cannot see
If I had a kite

A girl's face is a face of green
purple, pink, and in between
 and a twist of orange
 ting-a-ling-ling
A girl's face is a face gone
 times remembered
 in a frog pond
 and yellow rings
 asked
 but, no reply
 ting-a-ling-ling
 ting-a-ling-ling
 a-ling-ling

GARDEN OF THE HEART

1998
Gouache paint on paper
16" x 10"

Where the heart trips and
rolls headlong into amour's
passionate devotion, to be
mended ONLY by the
tender caresses of thy
beloved, so reigns love's
spell in this garden.

ACKNOWLEDGMENTS

Many thanks to:

Father, for making it possible for me to walk my
 own path
Mother, for her anecdotal stories of Dundee, filled
 with spice and flavor
 and for their steadfast love and support
Fred Simpson, Susie Doyle, Jon Simpson, for their
 recollection of hometown events through
 other sets of eyes
Pam Koob, for her generous writing, her
 insightfulness, and her helpful
 encouragement
Janet Bush (editor excellent), for her guidance, her
 good sense, and her romantic notion that
 heartfelt books are still viable
Susan Marsh, a design wizard who can spin straw
 into gold
Tiffany Reed, for dotting all the i's, tucking in the
 corners, and having more answers than I
 have questions
Regina Ryan, whose belief in this project was a
 wonderful gift
Martha Sutfin, Ellen Beverly, Mary Ann Martin,
 Dundee Historical Society volunteers,
 for not only being the keepers of a town's
 history, but for their generous hearts and
 irresistible spirits, which are the real
 accounting of a place

John Sutfin, Barbara Olin, their spirits have been
 with me longer than my own hair!
Jan Vern, Michael Anderson, for listening to my
 mutterings and giving back constructive
 suggestions
Missy Stevens, for her time, energy, help, food, and
 all the concerns that go into a project like this
 that no one ever sees
Klindt Houlberg, Robert Eagerton, for support,
 suggestions, and their generous housing on
 my trek for artistic origins
Joan Root Ericksen, whose help and wisdom are in
 all corners of this book. Without this pumpkin
 there wouldn't have been a pie
Sarah Hardiman, for her loving support and hands-
 on help building *Garden of the Heart*
Brian Trudeau, for his good hands and great help in
 building *Garden of the Heart*
Bill Seitz, Bibiana Matheis, Garry Burdick, John
 Kane, Sally Andersen Bruce, David Caras,
 Michael Meken, Gretchen Tatge, picture the
 best, and they probably photographed it
John Koegel, for heartfelt counsel and advice
Connecticut Photographic, for technical know-how
Paul Brown, *Stone Flowers* portfolio consultant
Leo Kaplan Modern Gallery, for their aid in research
 and records. If I couldn't find it, they could

STONE FLOWERS

A big thank-you kiss to the sponsors of the *Garden of the Heart*. Their foresight and generous spirits have made this museum installation/performance a heartfelt reality. Thank you, thank you.

Jose and Mille Andreau
Bob and Gayle Greenhill
Mark and Deborra Howard
Warren Rubin and Bernice Wollman
Henry and Linda Wasserstein

The images and poems at the beginning of each of the first six chapters in *Two Looks to Home* are part of a portfolio created by Tommy Simpson in 1997. This boxed portfolio was issued in a limited edition of fifty copies and produced at the Herron School of Art/IUPUI, Indianapolis. Six 15" x 11" iris giclee prints represent one day with a small boy, small town, Midwest. Each one of the prints includes an image and a poem by Tommy Simpson that reflect, as he explains, "A remembrance of those brief, flowered moments of youth that one had thought evaporated in time, only to find that these treasures are the foundation stones upon which we have built our lives."

COLLECTIONS

Unless otherwise noted, artwork is in the collection of the artist. Pieces are listed by page number.

TOMMY'S SKETCHBOOK, 1980S

BOOK DESIGN BY SUSAN MARSH

TYPESET IN SCALA AND SCALA SANS

PRINTED BY SOUTH CHINA PRINTING COMPANY, HONG KONG, CHINA